The Photographer's LIGHTING TOOLBOX

The Photographer's LIGHTING TOOLBOX

A COMPLETE GUIDE TO GEAR AND TECHNIQUES FOR PROFESSIONAL RESULTS

BRIAN STOPPEE

Photography by Tracey Lee, Mike Pocklington,
and Brian and Janet Stoppee; illustrations by Janet Stoppee

AMPHOTO BOOKS
AN IMPRINT OF THE CROWN PUBLISHING GROUP/NEW YORK

[Note]

As you can see from the examples throughout this book, the four of us shoot with Nikon dSLRs. We have been shooting digitally since 2005, when the Nikon D2x became widely available. The D2x introduced the CMOS sensor (pronounced as "see moss"). In September 2004, Nikon introduced it into its line with the capability to produce an image of more 12 megapixels, and there was now nothing to hold us back from enjoying what we had been doing with film, scanners, and Adobe Photoshop since 1990. Nikon dSLRs have come even further since 2004.

We know that not all of you are shooting with Nikon dSLRs, but to the best of our knowledge, the dSLRs of most other brands have similar capabilities and can do everything we do with our Nikons.

Published in the United States by Amphoto Books, an imprint of the Crown Publishing Group, a division of Random House, Inc., New York.
www.crownpublishing.com
www.amphotobooks.com

AMPHOTO BOOKS and the Amphoto Books logo are registered trademarks of Random House, Inc., New York.

Library of Congress Control Number: 2010925512
Stoppee, Brian.
 The photographer's lighting toolbox : a complete guide to gear and techniques for professional results / Brian Stoppee ; with the photography and illustrations of Janet Stoppee and photography of Tracey Lee and Mike Pocklington.
 p. cm.
 Includes index.
 ISBN-13: 978-0-8174-3965-1 (alk. paper)
 ISBN-10: 0-8174-3965-X (alk. paper)
 1. Photography--Lighting. I. Stoppee, Janet. II. Lee, Tracey,
1950- III. Pocklington, Mike, d. 2007. IV. Title.
 TR590.S759 2010
 778.7'2--dc22
 2010013084

ISBN 978-0-8174-3965-1

Printed in China

10 9 8 7 6 5 4 3 2 1

First Edition

WE DEDICATE THIS BOOK TO THE MEMORY OF MIKE POCKLINGTON,

who in April 2007 lost a relatively short battle with cancer, which he fought with gusto while working on this book. Mike was a creative and technical inspiration to us. The four of us—Brian and Janet Stoppee, Mike Pocklington, and Tracey Lee—worked and played together over three decades.

None of us will ever surpass Mike's photographic style. His images and ideas have helped thousands of photographers develop their careers. People from all over the country sought him out for information on how he made his images—and as busy as he was, Mike was always glad to help. He also worked with us in our interaction with the manufacturers of photographic, computer, and software gear to conceptualize, beta test, and revise many of the tools we all enjoy.

Mike was a true gentleman, a loyal husband, and an adoring father, and was a joyful force in the image-making industry; he continued to explore new technologies until his final weeks. We hope that this, Mike's final photographic work, inspires you to grow, to flourish, and to always love to express yourself through fantastic images. And may you do so with as much exuberance as Mike brought to these artistic efforts.

CONTENTS

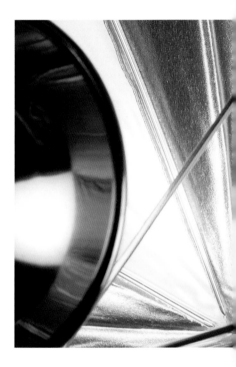

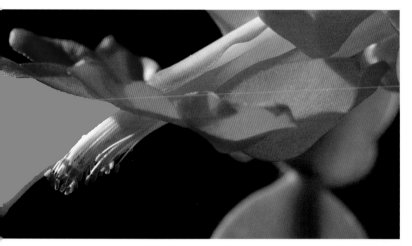

CHAPTER 1
THE PROPERTIES OF LIGHT 11

The Temperature of Light	12
Light Throughout the Day	14
Directional Illumination	16
How We See Light and Color	17
Neutral Density	18
Angle of Incidence = Angle of Reflection	19
Reflections	20
Surfaces	21
Highlights and Shadows	22
Subtractive and Additive Control	24
Brightness	26
Tone	27
Hue	28
Contrast	29
High-Key	30
Low-Key	32

CHAPTER 2
EXPOSURE 35

Time	36
Sensitivity	38
Volume	40
Depth of Field	42
White Balancing	47
The Dragged Shutter	49
Exposure Value	50
Through-the-Lens Metering	51
Exposure Bracketing	52

CHAPTER 3
READING LIGHT AND COLOR 55

How to Use a Meter	56
Incident Measurements	58
Size and Distance Factors	60
The Inverse Square Law	62
The Flash Meter: Essential Hardware	63
The Spot Meter	64
The Color Meter	65
Light Ratios	66

CHAPTER 4
USING NATURE'S LIGHT 69

Early Morning	70
Softening a Woman's Light	72
Hardening a Man's Light	74
A Child's Light	76
Midday	78
Early Afternoon	80
Late Afternoon	82
Firelight and Candles	84
Night Light	86

CHAPTER 5
MODIFYING LIGHT 89

How Nature Does It	90
The Illuminator	92
Reflection Tools	94
Diffusion Tools	95
Flagging Tools	96
The Diffusion Frame	98
Fabrics and RoadRags	100
Light Tents	102
Tiny Reflectors and Diffusers	104
Shutters and Top Hats	105
Umbrellas	108
Multiple Umbrellas	110
Light Banks	112
Speed Rings	114

Soft Box and Umbrella as One 116

Banking Big 118

Banking Small 120

Triolet Starter 122

The OctaPlus 124

The Lantern 126

Filters 128

Diffusion Media 129

Reflection Media 130

Polarization Media 131

CHAPTER 6
SUPPORT AND SAFETY 133

Which Stand Does the Job? 134

C-Stands, Crates, and Risers 136

Boom Arms 137

Safe Counterbalancing 138

Weights and Bags 139

The Grip Head Legend 140

Magic Fingers, Mafers,
and Matthellinis 141

Flexible Arms, Knuckle Heads,
and MiniGrips 142

Which Tripod Does the Job? 144

The Safe Tilting Column 148

Ball Head or Off-Center Ball Head 149

CHAPTER 7
CONTINUOUS LIGHT 151

Daylight Fluorescent 152

So Easy, It's Almost Cheating 153

Simple Soft Light 154

The HMI Advantage 156

PAR 158

Spots and Floods 160

Gobos and Projection 161

CHAPTER 8
FLASH ILLUMINATION 163

The Smart Flash 164

Bouncing the Flash 165

Off-Camera Flash 166

The Wireless Battery Flash System 168

Macro Flash Tools 170

The Big Studio System 172

A Watt Second? 173

Flash Sync: Wired and Wireless 174

Recycling, Output, and Duration 176

Modeling Lights 178

Symmetrical and
Asymmetrical Control 179

Bare Tube Heads 180

Reflectors 182

Monolights 184

The Slave Trigger 185

Copying Flat Art 186

CHAPTER 9
MIXED LIGHT 189

Lighting Multiple Rooms 190

Flash, Diffusion, and Natural Light 192

Balancing Accent Spots
and Ambient Light 194

HMI with Studio Flash 196

INDEX 198

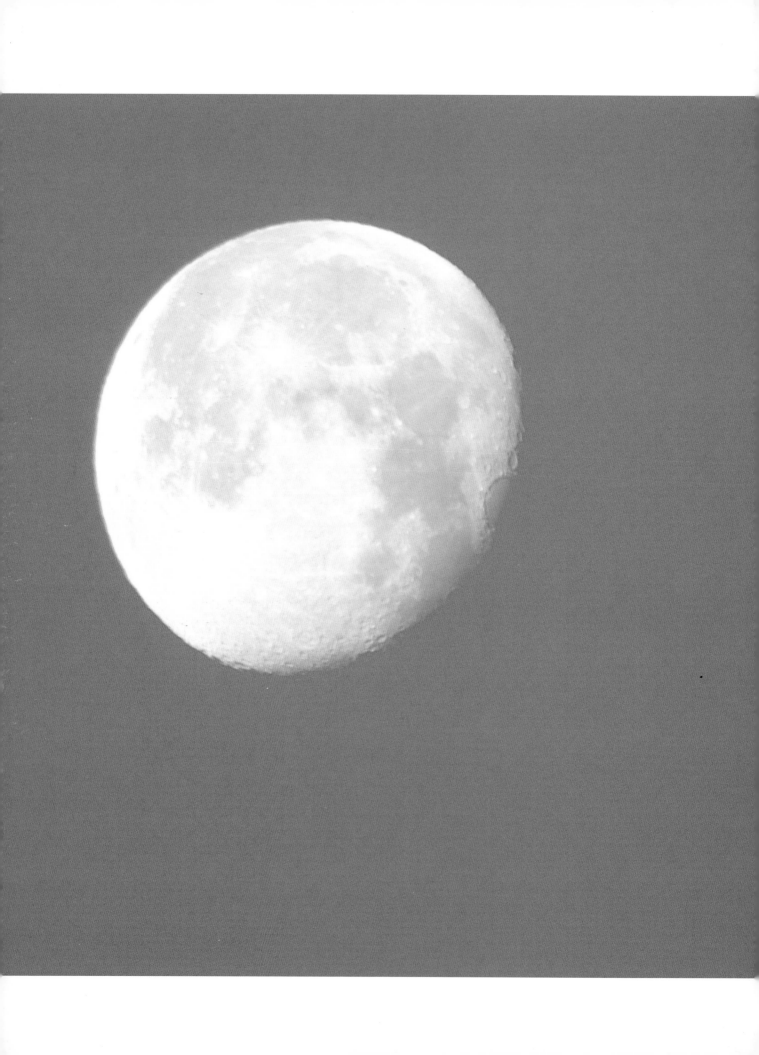

CHAPTER 1

THE PROPERTIES OF LIGHT

Our first goal is to improve your comprehension of natural illumination, a crucial element in your ability to interpret what is "found" all around you, twenty-four hours a day, 365 days a year, without the presence of artificial light sources.

Natural illumination can be direct sunlight or the sun's light bouncing off the moon and reflecting back to Earth. No matter how long you have been a photographer, there's always something new to discover. Part of what makes the creative process so invigorating is that nature is there to assist you in your quest for visual stimulation. Light's energy is all around you and continually changing. The light at noon today in Washington, D.C., looks very different than the light at noon in Beijing, regardless of the weather conditions in the two cities. The same is true of the light at your home on June 15 as opposed to December 15. There are scientific reasons for this. However, what's of utmost importance is that you train your eyes to detect these differences. As a creative communicator, you want to be able to see and understand what is around you, in nature, before you begin to manipulate the light or "create" it with artificial illumination.

The light of the moon is a reflection of the sun's light, just as there are reflections from this light source throughout the solar system. Here, the moon is easily captured with a Nikon DX series camera and an AF VR Zoom-Nikkor 80-400mm f/4.5-5.6D ED lens. This provides a 35mm equivalent focal length of a 600mm lens.

THE TEMPERATURE OF LIGHT

We could not survive without the energy the sun provides. Yet the sunlight that we encounter every day is neither constant nor consistent. As we discuss on page 14, the angle of the sun varies throughout both the day and the seasons. Sky conditions also alter how sunlight makes its way to our shooting locales. There's the ever-changing cloud cover, and in some places on some days, man-made particulate matter in our air. All of this alters the light that strikes our subjects.

For some situations, descriptive terms such as "it's a little blue" or "it's kind of warm" is enough to communicate the color of light. For others, however, a more definitive assessment is needed.

TAKING LIGHT'S TEMPERATURE

Just as we put a thermometer under our tongue or in our ear, we can take the temperature of the color of light.

On page 65, we'll show you how to use a color meter. Until then, let's use the graphic on the opposite page to gain an overall understanding of how the Kelvin color temperature scale works.

We think of something that is warmer to be a bigger number, and something cooler to be lower, as with Fahrenheit and Celsius temperatures. In those terms, the Kelvin scale is a bit counterintuitive: "Cooler" (bluer) color temperatures are expressed with higher numbers, while "warmer" (redder) temperatures are lower in number. A clear sky is in the 12,000 K (for Kelvin), cooler range, while a 75-watt incandescent lamp is warmer and more like 2,800 K. Even more confusing, for the Kelvin scale we say "fifty-five hundred degrees," but in writing we express that point as 5,500 K and skip the degree character we're used to seeing on a thermometer.

That reading of 5,500 K is something of a baseline for photographers. It's around what occurs in the middle of the day when the sky has no cloud cover. In the days of film, that light was considered to be "daylight." Later in the day, as the sun nears the horizon, the Kelvin temperature changes to a warmer 4,500 K and eventually reaches a glowing 3,000 K.

Flash units create light that is often in the range of 5,000 K to 6,000 K. An overcast sky can tend toward a cool 7,000 K to an even cooler 9,500 K. Some household lamps will be as warm as 2,800 K, but professional incandescent light sources can be cooler, in the 3,400 K range.

COMMUNICATING LIGHT'S COLOR

Advanced photographers communicate the end result of their image-making in relationship to the response the photo evokes. Hues of red, pink, orange, and yellow commonly convey warmth, while colors of purple, blue, and green evoke cooler feelings. We think of sunlight as a source of warmth because of the energy it offers, but the sun provides the full spectrum of color, from the time it appears on the horizon until it sets in the western sky.

Try to identify the variation in light throughout the day. Find out what time the sun will rise on the next day that's forecast to be relatively cloudless. Set your alarm for at least an hour before sunrise. Grab your cup of coffee or tea and carefully observe the sky as it evolves. Notice the color of everything on the Earth and how it changes almost by the minute. Then do the same from an hour before sunset until an hour afterward. These exercises are relatively easy compared to observing the color of light from midmorning to midafternoon, yet the changes are there for you to observe them as well.

On page 17, we'll get into how we see light, which will help us understand why the color of light in our living room when it's dark outside isn't as warm as the Kelvin temperature professes it to be.

AVERAGE KELVIN TEMPERATURE OF COMMON LIGHT SOURCES

CLEAR SKY	12,000
HAZY SKY	9,500
OVERCAST SKY	7,000
SMALL BUILT-IN FLASH	5,800
COLOR-CORRECTED FLASH SYSTEM	5,500
MIX OF SUN AND SKY	5,500
CARBON ARC LAMP	5,200
2 HOURS AFTER SUNRISE	4,000
2 HOURS BEFORE SUNSET	4,000
1 HOUR AFTER SUNRISE	3,500
1 HOUR BEFORE SUNSET	3,500
QUARTZ LAMPS	3,400
FLOOD LAMPS	3,200
SUNRISE AND SUNSET	3,100
100-WATT INCANDESCENT LAMP	2,900
75-WATT INCANDESCENT LAMP	2,800

The color of light can be measured as a Kelvin temperature. The more you familiarize yourself with these temperatures the more quickly your eyes will be able to identify them.

LIGHT THROUGHOUT THE DAY

Even on the clearest day, sunlight must travel through air molecules before it warms our flesh. The more molecules the light strikes along the way, the more it scatters. As sunlight scatters, its color changes.

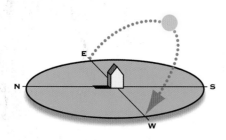

The sun's angle changes every day of the year. Each day opens up new opportunities to capture a different color of light and shadow length than the day before.

SUNLIGHT AND THE TIME OF DAY

The sun at midday is more directly overhead than it is at the beginning and end of the day, so at noon sunlight travels a shorter distance to reach Earth than it does at dawn or dusk. In the early morning and late evening, sunlight has hundreds of additional miles to travel and must pass through more air molecules. At dawn and at dusk, these molecules filter out some of the blue wavelength, and we are left with the remaining wavelengths, which are primarily an orange or peachy color. Some photographers refer to these times as the "golden hours." They are magical and fleeting, sometimes lasting only a few minutes. A photographer needs to be ready to act fast to capture those moments at their best.

SEASONAL LIGHT

As Earth orbits the sun, with its axis tilted, it sets up new possibilities for light's angles and colors.

In spring, each day includes around twelve hours of shooting time, and with nature coming back to life, it is a favorite time for photographers. Earth's surface has yet to overheat, and the air is often crisp enough (meaning it contains fewer moisture particles than it does at other times) to communicate an even color.

The light of summer, when it is humid and the air contains more moisture particles, is often hazier. As the light scatters it takes on warmer hues. Particulate matter hanging in the air can soften the scenery at greater focal lengths; the greater the distance, the more particulate matter gets in the way.

Fall foliage offers brilliant arrays of color, and as summer pollutants dissipate, it's easier to capture longer vistas.

In winter, moisture in the air can give rise to early morning fog. Winter also offers excellent opportunities to capture the cool tones of snow, reflected from a bright sky above. Barren trees create long, cool shadows in the snow.

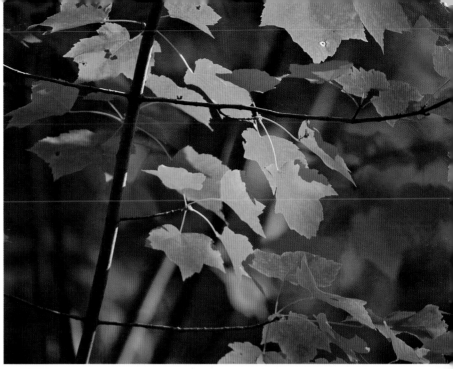

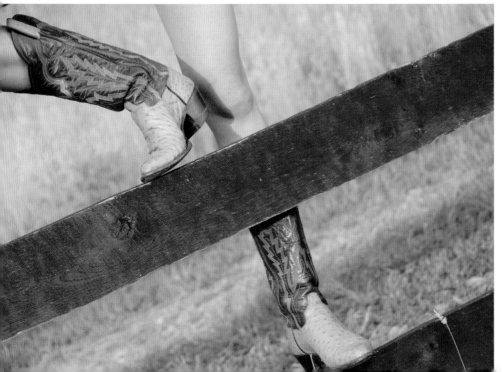

Top Left: Winter's foggy mornings are perfect for capturing cool light, as on the aging monuments in a cemetery.

Top Right: Janet's autumn leaves depict the return of longer shadows.

Center: As shown in Janet's image of spring flora, shadows change as new blossoms develop.

Bottom: Tracey's shot of long legs in boots illustrates how the summer's late daylight, filtered through haze, produces a warmer, more yellow light.

DIRECTIONAL ILLUMINATION

Natural illumination means that a photographer depends on whatever light the sun provides, while artificial light sources put the photographer in control. No matter what the light source may be, however, there is always the direction of light to examine and manipulate.

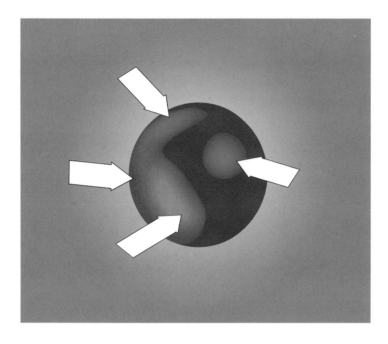

When light strikes a round surface, it creates a partial highlight while leaving the rest of the subject in shadow.

As shown in the illustration above, light strikes a surface from various angles. Unless the surface is flat, texture will lead to variations in highlights and shadows (see also page 22). Although there are an infinite number of angles from which light can strike a three-dimensional object, you can generally think about five key angles of illumination:

1. FRONTAL: Some photographers feel frontal illumination is too harsh and looks flat. Other photographers love it because it "blows out" many imperfections.

2. OVERHEAD: Light that comes from directly overhead can be troublesome because it creates deep shadows. However, if you vary the angle even a little, such light can be quite dramatic.

3. SIDE: Photographers in search of dramatic light like illumination that comes from one side. It has an air of mystery to it—one side of the subject is fully revealed, while the other has hidden details.

4. RIM: Also called "hair light," rim light is illumination that comes from behind the subject, providing a three-dimensional look. As we explore in chapter 5, one option is to use a light bank in a rim position as the main light in combination with a reflector as a fill light.

5. BACKLIGHT: This term usually refers to a light source that illuminates the background of an image. Backlighting is great for silhouettes as well as for popping out the background so the prime subject does not appear isolated.

HOW WE SEE LIGHT AND COLOR

Many photographers complain that cameras in Automatic Exposure mode will not allow them to interpret an image as they see it. The fact is, their eyes and brains are in collusion in preventing them from seeing things as they really are. What we see with our eyes is rarely represented in our image, and the problem is not always with our camera gear. It instead comes from how human sight works.

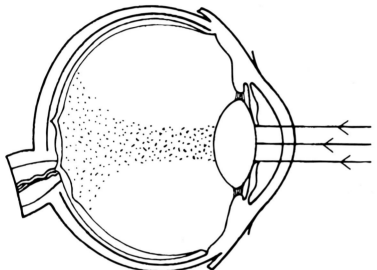

Think of your eye's retina as a camera's sensor. It's where the image appears before it goes onto the brain for processing. The lens of an eye is much like a camera's optics. The pupil is the aperture.

Our cameras are much like the human body's optical system, starting with a lens that is the light's entry point, comparable to the human eye. The eye's pupil is much like a camera's aperture, opening in low-light situations and closing a bit when the light is bright. The back of the eyeball houses the retina, which is a data collector, much like film or a digital camera's sensor. The retina (our body's sensor) doesn't interpret the data, but our brains do. That's where things get a little murky.

If you have ever used daylight film (5,500 K) to photograph a subject illuminated by an incandescent lamp (2,800 K), chances are the image looked a bit yellow. It was off by 2,700 K. The same thing will happen if you use a digital camera with the white balance set to daylight. What looks to you like a red tomato on a white table appears on film as an orange tomato on a yellow table.

However, when you look at the scene more closely, you're likely to see that the color in the image is correct. The perceived discrepancy is because of "chromatic adaptation," a term for what your brain does to the image it receives. Your brain knows that a tomato is red and not orange, so it adapts the data received from the retina. This phenomenon, similar to your camera being set to auto

white balance, is called "color constancy." Your brain is attempting to allow you to perceive colors as we suppose them to be.

That's all well and good for how your body works, but as an advanced image-maker, you have to understand light the way your camera's sensor sees it. You cannot allow your brain to fool you. That's why professional photographers rely on color meters, the metering systems in their advanced digital cameras, and software such as Adobe Photoshop Camera Raw and Adobe Photoshop. With these tools, you have the chance to take raw files and reshape the image.

NEUTRAL DENSITY

If we were to distill all the colors in an image down to a single mono-tone, on average we would end up with 18% gray.

In years past, many photographers grumbled that the meters built into their cameras didn't provide the correct exposure. Many of these early cameras read the light reflected from a subject and averaged everything in the viewfinder to 18% gray. They often hit the exposure on the mark. However, when a small light subject is positioned on a big black background, chances are the subject's details would be washed out. Or the details "blocked up" (got lost) when the image was of a dark subject on a bright white beach. The reason for the latter is that most light that strikes a bright white surface is reflected. Conversely, most light that strikes a dense black surface is absorbed. White and black surfaces are very different from one that is 18% neutral density gray. Attempting to accurately read the white or the black examples like the gray one will not work.

For that reason, the next chapter covers exposure while chapter 3 discusses reading light with a handheld meter. It is imperative that you study both of chapters carefully.

A white card reflects the majority of light that falls on it. A black card, however, absorbs most of the light. The 18% neutral density gray card represents the average exposure.

ANGLE OF INCIDENCE = ANGLE OF REFLECTION

Understanding a little bit about physics helps in understanding a great deal about lighting.

The reflection on the flashlight tells the story of the illumination that comes from the light bank. The angle at which the light emanates from the source equals its angle of reflection into the lens.

In the illustration above, the flashlight has a shiny black surface, with a significant highlight on one side that's a reflection of the light bank illuminating it. Since the flashlight is cylindrical, only a small portion of the cylinder records the reflection of the light bank. If, instead of a cylinder, the subject were a small flat surface, the light bank's reflection would either flood the entire surface, cover a portion of the surface, or the reflection would not be seen at all. It would depend on the angle of the subject.

The angle of light that strikes the surface (the angle of incidence) must be equal to the angle, as perceived by the camera's viewfinder, of the light reflected from the surface (the angle of reflection). In the case of our flashlight, if you moved the camera a little to the left or right, the position of the reflection on the flashlight would shift, too. If the camera angle changed significantly, the reflection might completely disappear.

This principle can be applied to many things that you photograph. If you are directly in front of a building with mirrorlike glass, you are probably going to appear in the photograph. However, if you move to the left or right of the building, your reflection will no longer be seen and the camera will pick up the reflection of something else instead.

If you photograph a white car, the surrounding conditions play only a minor role in what appears on the car's surfaces. When you photograph a black car, however, everything around it plays a supporting role. If you shoot the black car with a fixed, in-camera flash, a highlight of the flash, in the form of a white glitch, will appear somewhere on the car. It would be better to use a light bank around 40 feet wide (such as the Chimera F2), which would flood the black car with an even illumination, depending on how you angle it. On page 186, we apply this principle to copying flat artwork, minimizing reflections by how we place the lighting units.

REFLECTIONS

The more polished a surface is, the more reflections it displays. An extreme example is intense light on a highly polished mirror, which is impossible to look into safely. Photographing reflections entails its own set of challenges, and many professional photographers rise to them with relish.

Many examples illustrate the importance of understanding how light reflects. One might be the need to find the best angle for photographing someone wearing glasses. Many wedding photographers have captured brides preparing for the wedding in front of a big, full-length mirror. An enchanting photographic story can be told by the reflection of an inquisitive child's face in a puddle of water as raindrops accent the reflection.

It's not easy to capture reflections in crystal, but we've had success using a highly focused, extra-small light bank. It was not easy to find the proper angle of incidence and reflection to capture the brand name in the stopper.

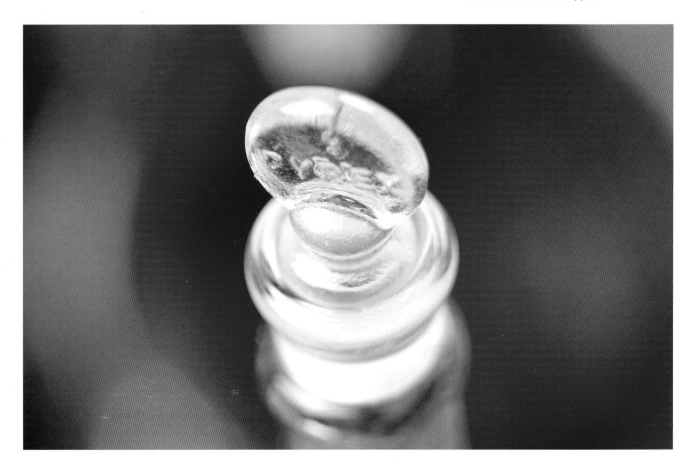

SURFACES

Lighting a flat surface is usually easier than working with a three-dimensional one, but that's yet another enjoyable challenge of using light to your advantage. Taking photographs involving flat and multi-dimensional surfaces is all the more challenging when textures are involved.

Textures both absorb and reflect light, and textured surfaces are everywhere. You find them on all kinds of fabrics, and even on the skin that wraps human muscle, bone, and fat. Consider all the surfaces and textures of a face. Each one is different; the nose, lips, eyebrows, cheekbones, forehead, chin, and eye sockets all play a role in how light wraps around a face. Consider the texture of a baby's skin as opposed to that of a ninety-year-old who has spent his life working outdoors.

Light strikes a smooth surface and quickly moves on. We can call that a "direct reflection." On rougher surfaces, light bounces from here to there as it reflects. Surfaces play an important role in a viewer's ability to quickly understand what an object is. And if, in making a photograph, we change the angle of the illumination, we create a different feeling.

Compared to a piece of smooth paper, this woven basket is a severe texture. Some of its surfaces reflect highlights, and some prevent light from finding its way through, creating shadows. All of the surfaces play an important role in the viewer's ability to quickly understand what it is.

SPECULAR AND DIFFUSE REFLECTIONS

When we can see the shape of the light source in a reflection, the reflection is called "specular," which means "mirror-like." It's easier to see a specular reflection on a smooth surface. If the light source is a window and the subject's surface is shiny, we see the shape of the window on the surface. When the surface of a subject is coarser, we still may see a specular reflection, but because the light scatters once it meets the surface's texture, we refer to it as a "diffuse reflection." Human eyes are often points of specular reflection, and hair is a point of diffuse reflection.

Each surface is a challenge; each surface is a joy. They are fresh canvases for you to light. How you express what you see is all about your creative energy. Other than specific requests from your subject, the rest is at your discretion.

HIGHLIGHTS AND SHADOWS

There's a great deal to learn about highlights and shadows. Photographers even use special jargon for them, as with "specular" and "diffused reflections," described on the previous page.

When highlights are washed out, they are said to be "hot," a term that means the details are lost. In Janet's image of Alexis Terry and Kaitlynn Connor, below, some of Alexis's blonde hair is purposefully allowed to go a bit hot, whereas backlight creates the perfect exposure for Kaitlynn's darker hair.

SPECULAR AND DIFFUSE HIGHLIGHTS

A photograph's hottest spot that still holds good detail is called the "specular highlight" and is usually the photo's attention-getter. Every shot also has a neutral zone that is neither specular highlight nor shadow. This zone, called a "diffused highlight," is the on-the-money spot to take an exposure reading. In the image below, the diffused highlight would be the girls' facial tones.

SPECULAR FORM AND EDGE

Every specular highlight takes on the shape of the light source that creates it. That shape is the "specular form." Between the specular highlight and the diffused highlight there is an area of transition. That "specular edge" is the transition from one area to the other.

SHADOW EDGE AND SPECULAR SHADOW

The same is true for shadows. There's an area of transition from the diffused highlight into the penumbra of the shadow, and then into the shadow's umbra. In Tracey's photo of Marion Easter, far right, the side light soars across Marion's face, creating gentle areas of even transition from the specular highlights to the neutral areas and on into soft shadows. The image conveys an air of mystery and adventure in the posh bar scene. Yet the way the highlights and shadows play with Marion's facial features keeps them feminine. We get the sense she is standing next to a black wall that absorbs light, creating a "specular shadow."

Below: The blond hair is this image's specular highlight, and the facial tones are the diffused highlight.

Opposite: A light bank creates a gentle transition from the specular highlights on one side of the face to the specular shadow on the other side.

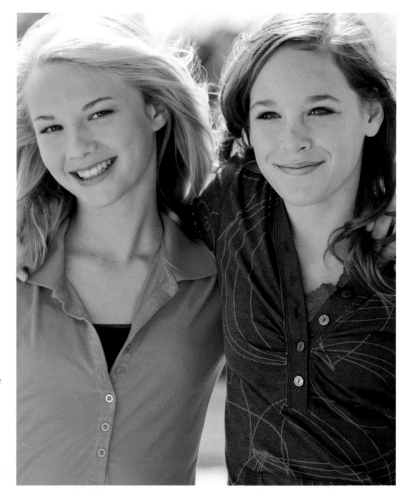

SUBTRACTIVE AND ADDITIVE CONTROL

Successful photography is all about taking as much control of the image as possible. At times you may feel that you are at the mercy of what nature has to offer, but often you are more in control of what you do with an image than you may think. Many photographers prefer to create and control the highlights and shadows.

KEY LIGHT

Your main light source is referred to as a "key light." In most cases, a small key light creates a small specular highlight. A larger key light in close proximity to the subject provides a broader light source, bathing the subject in a bigger, more diffused highlight. Larger light sources lead to softer illumination.

SUBTRACTIVE AND ADDITIVE LIGHTING

Light naturally strikes some subjects directly and bounces onto others. Often the natural illumination gives us what we need for a shot. However, there are times when the only way we can create the effect we want is by subtracting some of those reflections. This is often best accomplished by placing a black card on the side of the subject that you want to darken. The card not only blocks light from reaching the subject but absorbs any light that strikes it.

To get the opposite effect, make that same card a white one. The light that strikes the card bounces back onto the subject and adds more light.

SURFACE EFFICIENCY

The color of the surface also plays a significant role. The lighter its tone, the more reflection is created. Combine that with the texture of the surface and you have two sets of variables (for controllable conditions) or fixed surfaces (when you can't control them), which together determine the efficiency of the surface.

Unlike the efficiency of a device that consumes a minimal amount of electricity and therefore saves you money, the most efficient surface is not always the most desirable. It all depends on whether you are interested in subtractive or additive control.

This street scene in Italy is an excellent example of how Mike Pocklington took control of his image, crafting it with both what he found and what he could manipulate in the camera. Though we are unable to see the light source, we get a hint that it's sunlight by what streams through the streets. A detailed look at the surface on the left shows a great deal of light bouncing around due to texture, creating a soft effect. Mike could have exposed the image a bit lighter to reveal the texture of the nun's habit; however, he preferred to convey the reverence and mystery of his subject by leaving her in soft shadow.

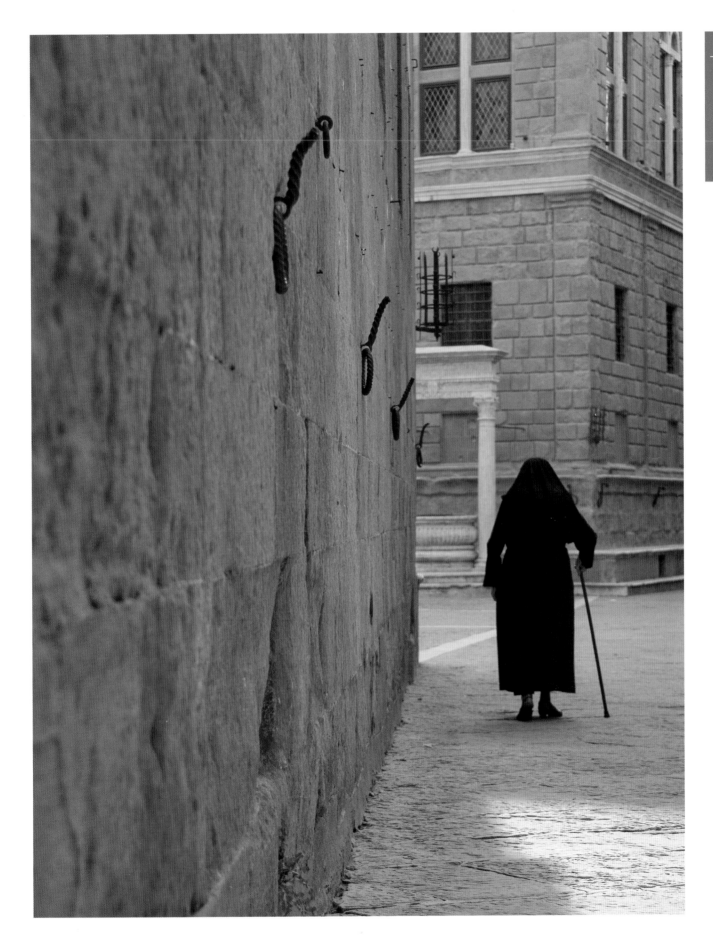

BRIGHTNESS

In digital photography, brighter is not necessarily better. A section of a digital image that is so bright that it is completely white lacks important highlight details. Those details cannot be retrieved, and there's not enough information to manipulate in postproduction.

So what do you expose for? As discussed on page 22, your diffused highlight is your neutral zone. It's the norm. That's the area you probably want to concentrate on for your exposure. In the example above, Tracey could easily have made the mistake of blowing out the details of this beautiful orchid; if she had done that, the bright white areas would have lost all of their detail.

The transition area from highlight to neutral is vast and gentle. The combination of tone (see next page) and color determine what is called the brightness range, which can be extensive. A brightness range runs from details that appear in a specular highlight all the way down to details that remain visible in the darkest shadow.

Tracey held the details in this orchid by not allowing the exposure to blow out the specular highlights.

TONE

Tones have a familial relationship and are interconnected. A tone can be defined as an area of uniform density, yet tones are also made evident based on other tones surrounding them. Think of your use of tone as the visual version of a masterful symphonic work. All the players must work in concert.

Look at the flesh tones of Joi Delaney and Joe Spagnolo, for example, below. There are no deep shadows on either face where details are completely blocked, yet each face displays a broad tonal range. There are pools of both specular and diffused highlights, and plenty of areas of transition.

The key light favors Joi, providing a more even range for a softer feminine look. This leaves Joe with a few more shadow areas on his face for a stronger, more masculine appearance. The backlight adds a dramatic three-dimensional feeling. Without it, the image may have appeared too flat. If you were creating an image like this with artificial illumination, that rim light would be referred to as a "hair light." (Please see chapter 5 for more on popular highlight tools.)

Tones can move gradually across a woman's face and create a flattering feminine look. A more rapid transition can appear more masculine.

HUE

Hue is a single color in its purest sense—like having the volume control on that color cranked up to 100 percent. If that color is blue, it's like blue cranked up to full blast. The color that you have captured is giving you all the blue there is to give.

In the example below, Tracey has captured a flower that is pretty much as fully saturated as it can be while maintaining a natural appearance. Yet the yellow, as gorgeous as it may be, has other colors mixed into it. We know that yellow in its purest sense can be more brilliant than it is depicted here. The same could be said of the green; it's not as vibrant as it could be.

Since this book is printed using four inks—cyan, magenta, yellow, and black—there is a limit to how vibrant some colors will appear. However, as photographers, it's important to understand that how we light our subject will determine how its colors are rendered in a photographic image.

When a softer light source is used, the path the light takes is scattered, making it more difficult to render colors at their fullest hues. A blue pitcher, red mug, and yellow kettle under direct light stand a better chance of displaying their full chroma—that is, their pure color devoid of gray.

Pure hues pop with brilliance and command your attention. It these colors could sing, everyone would stop and listen.

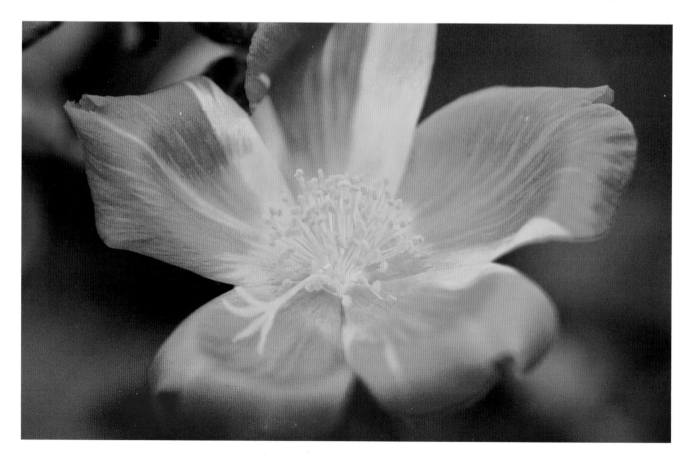

CONTRAST

Contrast is more easily identified in black and white than in color. This is exemplified well in Janet's photo, below, of a Christmas cactus. The contrast between the black and the white areas really pops. Though the flower's red is more like a magenta and the green resembles olive, the two colors have as beautiful a harmony as red and green in their full chroma. These two colors, normally represented at Christmas, are prime examples of color contrast.

In lighting, contrast is historically thought of as resulting from the use of a hard, singular-direction light source because it produces brighter highlights and deeper shadows. However, that characterization misses some of what contrast is all about. Just as we have been discussing hue as a "color volume" dial turned all the way up, we can also adjust the contrast dial. Under soft illumination we still have contrast. It's just that the transition areas are more gradual and the full range of tone and brightness are not always represented.

Bold contrasts also make a strong statement. Reds and greens side by side capture your attention, as do well-illuminated highlights next to maximum density black.

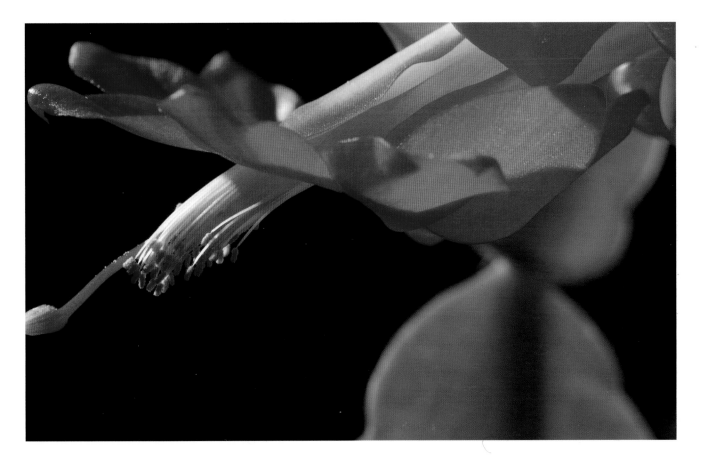

HIGH-KEY

Attend professional photography conferences and you will hear a great deal of discussion about "high-key" and "low-key" images. It's part of the daily jargon of some professional shooters, especially seasoned wedding and portrait photographers.

What they are primarily talking about are two concentrations of tonal contrast. High-key addresses lighter tonal contrasts. Think of a white knight charging through white sands on a white horse—that's a high-key image created with natural illumination (and maybe the assistance of a few large reflector panels). An example of a high-key still life in a studio situation might be a serving of oyster bisque in a white bowl on a white table. High-key is popular for photographing children, young couples, and a mother with a newborn. It has the feeling of a fresh, clean start.

To create high-key indoor portraits or full-length images, a great deal of lighting may be necessary. You'll need a fair amount of firepower for a key light, a fill light, some means of illuminating a background, and maybe a hair light, too.

Janet created this image of David and Morganne Wilbourne while outdoors, taking advantage of afternoon backlight for her hair light. The same light source struck a 42" x 42" Westcott Scrim Jim covered with silver fabric (see chapter 5 for more on Scrim Jims and fabrics). The silver reflection material bounces the light back onto the models, providing more than sufficient key light and not requiring a fill source. The result is perfect for these two fair-skinned children, rendering them in an almost angelic manner, which is part of what high-key is all about. The stylist selected light clothing to support the high-key effect.

Photos shot at the subject's home, often referred to as environmental portraits, capture people in their familiar surroundings. The environmental portrait is an excellent choice when you're doing high-key photos of children.

LIGHT SOURCE/MODIFIERS
• Novatron 1000 w/s Digital Power Pack
• Novatron Bare Tube Head
• Westcott 45" Gold/White Umbrella

SUPPORT
• Gitzo Explorer Tripod
• Gitzo Off-Center Ball Head
• Matthews C-Stand

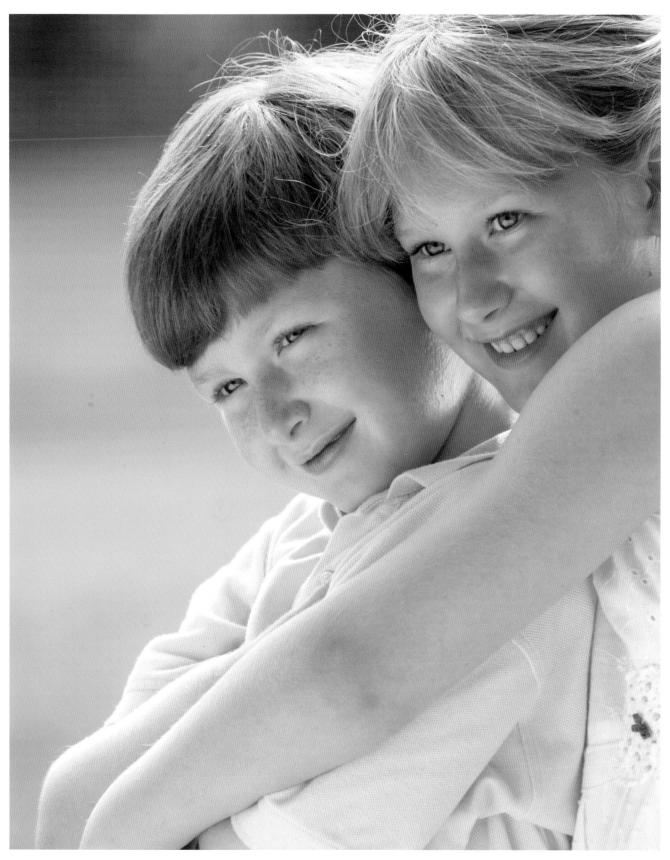

Nikon D2x, AF VR Zoom-Nikkor 80–400mm F4.5–5.6D ED at 300mm (35mm equivalent: 450mm), ISO 100, 1/125 sec. at *f*/5.6; processing in Adobe
Camera Raw and Adobe Photoshop by Brian Stoppee | Photo by Janet Stoppee | Styling by Sherrie Hagan

LOW-KEY

High- and low-key photographs can be thought of as existing on the opposite ends of the image-making spectrum, though this is not the entire story. Whereas high-key images are thought to make the subject appear saint-like, low-key images are far from conferring an aura of evil. In fact, they're popular for images of members of the clergy. Low-key imparts a sense of mystery. A pleasant-looking minister, for example, may appear knowledgeable about spiritual mysteries when shot in low-key.

Many great painters have used natural light to render low-key portraits, which are often accomplished with diffused illumination coming through a window. Typically, the background naturally went dark, and depending on the subject's placement in relationship to the window, the light either wrapped the face nicely or became a side light, illuminating one side of the face well and leaving the other in shadow.

Janet captured this classic low-key image of actor-musician Joel Lewis. The photograph was lit with a single flash head. Low-key portraits rarely require huge investments in lighting gear, so they're great for photographers who are just getting started. In fact, it's useful to hone your skills by learning what one light can do before moving onto bigger setups.

There's also a natural beauty to low-key in still life images. They, too, recall the master painters who rendered bowls of fruit or wine, bread, and cheese with window light streaming across a table. Low-key images are undeniable expressions of found light; they alert our senses to what is pure and real. They can also be a way of purposefully hiding something from viewers, leaving them curious to learn more about the subject.

This low-key image, with its typical shadowy side and dark background, keeps some of the visual details a mystery.

LIGHT SOURCE/MODIFIERS
• Novatron 1000 w/s Digital Power Pack
• Novatron Bare Tube Head
• Westcott 45" Gold/White Umbrella

SUPPORT
• Gitzo Explorer Tripod
• Gitzo Off-Center Ball Head
• Matthews C-Stand

Nikon D2x, AF VR Zoom-Nikkor 80–400mm F4.5–5.6D ED at 240mm (35mm equivalent: 360mm), Manual mode: ISO 100, 1/60 sec. at f/5.6, Gossen Starlite meter | Processing in Adobe Camera Raw and Adobe Photoshop by Brian Stoppee | Photo by Janet Stoppee | Styling by Sherrie Hagan

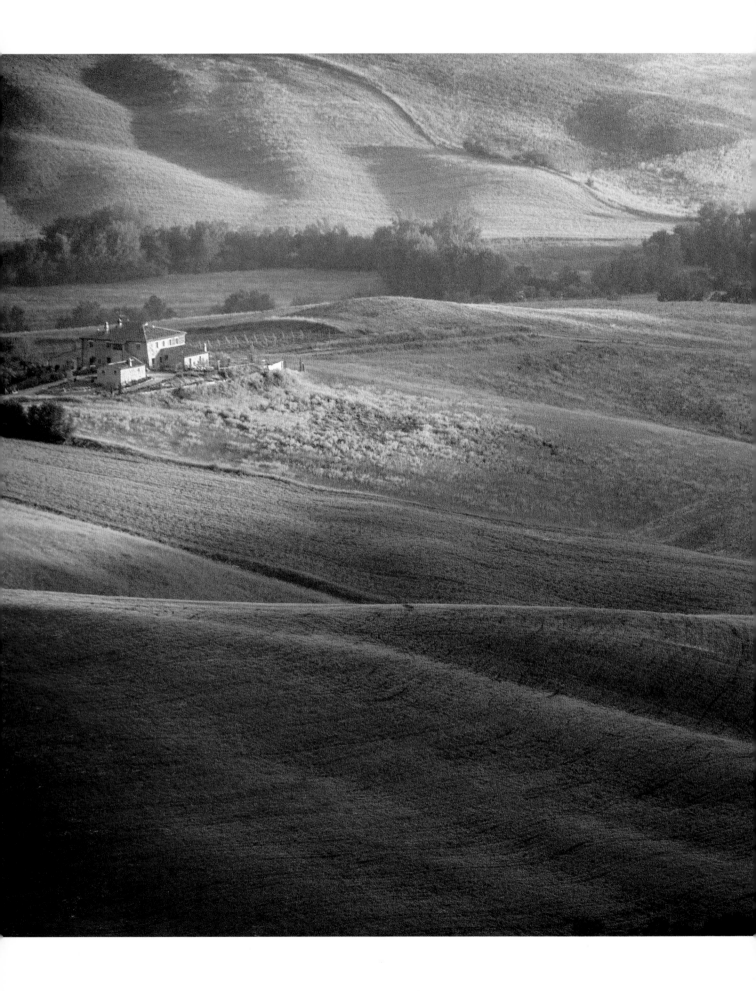

CHAPTER 2

EXPOSURE

This chapter and the one that follows go hand in hand; together they convey the fundamentals of manipulating exposure to your advantage.

Ever since automatic exposure cameras came onto the market, photographers have had an easy way out of critical exposure decisions. Sometimes automatic exposure works—and sometimes it doesn't. Yet even to successfully utilize today's advanced automatic exposure capabilities, you need to understand exposure principles.

Photographing with existing light means managing ever-changing conditions, as illustrated in this image by Mike Pocklington. We can easily envision the scene Mike confronted, with moving clouds keeping patches of sunlight in motion across the terrain. As the light moves, the exposure must change, too.

Think of exposure as one of your most creative tools. An f-stop or two in one direction makes for one creative expression, while an f-stop or two in the other says something completely different.

You must factor a trinity of elements—time, sensitivity, and volume, each inseparably joined to the other two—into your calculations as you decide on an exposure.

Mike Pocklington's photograph of the Italian countryside demonstrates excellent exposure techniques. The highlights and shadows hold their details. The total exposure range reproduces well in media, spanning the depth required for exhibit prints to the more limited detail needed for small JPEGs on websites.

TIME

We're going to assume that not all of our readers are 100 percent up to speed on shutter speed. Let's review the basics.

In the beginning, film was not very sensitive and cameras did not have shutter curtains. The photographer simply removed the lens cap for what we would consider an extremely long period of time during which the subject tried to remain still, and then the photographer replaced the cap on the lens, ending the exposure. Even without a shutter curtain, time played an important role in capturing the photograph.

On film single lens reflex (SLR) cameras, you could open the back of the camera and see how the shutter curtain worked before you loaded film into the camera's body. For slower exposures, you could see one curtain open, as if an exposure was being made, and then a second curtain followed, preventing more light from coming onto the film.

Typically shutter speeds progressed by either doubling or halving the adjacent shutter speed. So 1/15 of a second was followed by 1/30 and then 1/60. (In the digital world, shutter speeds progress in increments of approximately one-third. After 1/30, you can select 1/40 and then 1/50. The fraction is not displayed in the camera; you just see 30, 40, 50, and 60.)

Many advanced digital cameras use a shutter assembly that's a series of blades rather than two curtains, but the concept is the same. Most of them still open completely and then close completely for as long as 1/250 of a second. At speeds faster than that, the first set of blades opens and then the second set of blades follows, but before the first one has closed. It's as if the shutter curtain is really a fast-moving slit traveling in front of the camera's sensor.

For some exposures, you cannot shoot at shutter speeds faster than 1/250 of a second, because if the flash goes off while the shutter curtain is not fully open, a portion of the image frame will be dark. Fortunately, the flash happens in such a short period of time that this issue will not prevent you from creating great stop-action photography. Many Nikon Speedlights allow you to shoot at all shutter speeds, including 1/8,000 of a second.

SLOW SHUTTER SPEED PITFALLS: CAMERA SHAKE AND NOISE

One of the factors time influences is how well you can hold a camera through shutter speeds. Handholding a camera at slow shutter speeds may lead to significant camera blur.

Handholding a wide-angle lens is easier than doing the same with a telephoto lens. The more telephoto the lens is, the more difficult handholding becomes. Not only are longer lenses heavier, but the angles of view become narrower. Here's a trick to understand how much you can hold without a tripod: Convert the focal length number to the next-highest shutter speed number. For example, if you're using a 28mm lens, convert the 28 to a 30 and there's a pretty good chance you can handhold a 28mm lens for as slow as 1/30 of a second. On the upper end, you can probably handhold a 200mm lens at 1/250 of a second. The nice

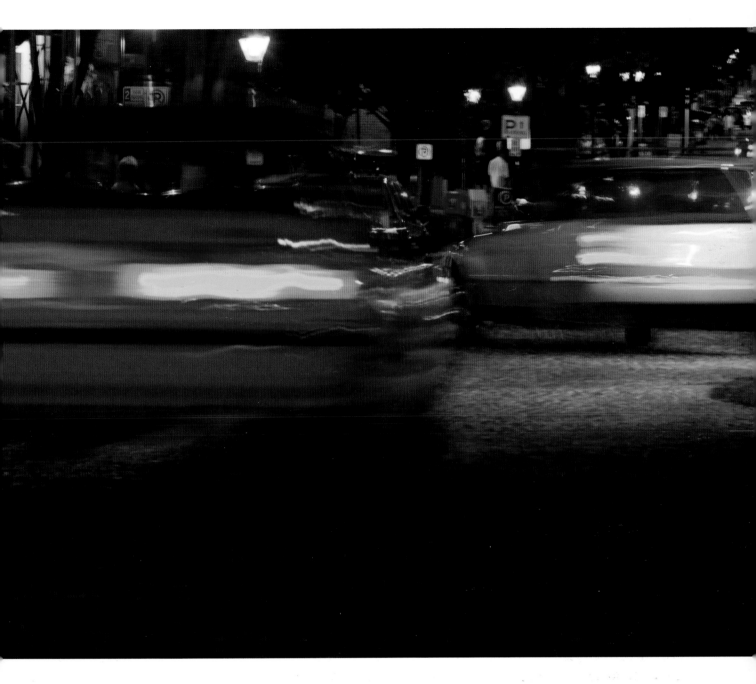

thing about flash is that it's so fast that when it's used in a controlled studio environment, you can enjoy handholding.

Another pitfall of slow shutter speeds is noise. Not all digital sensors are created equal. Just as with film emulsion, which ran into reciprocity gremlins if exposed to light for extended periods of time, some digital sensors do not respond well to long exposures and develop problems with "noise," which bears some resemblance to film's grain. For some images, noise is not necessarily a bad thing; just as with large film grains, sensor noise has a "look" of its own. However, in many instances it's an unwanted image quality.

By experimenting with various shutter speeds, you can achieve dramatic artistic effects. Here, a very slow shutter captures nighttime traffic. A tripod minimizes background blurring that can easily occur at such slow shutter speeds.

SENSITIVITY

It's easy to lose a great shot because your shutter speed is too slow. Maybe you can't handhold a long lens and don't have your tripod with you. Or maybe you have your tripod but the action is so fast everything will be a blur.

In the earlier days of film, sensitivity was all about ISO. (Some of us even remember ASA.) If we wanted fine-grained images, we used Kodachrome 25. (Kodachrome was introduced in 1935; Kodachrome 25 was discontinued in 2002 with Kodachrome 200 being the last to go in 2007). For faster action, we'd resort to Ektachrome 400 and put up with more intense grain. The downside was that we'd have to shoot all thirty-six frames before we could rewind the roll and switch to a different one. If we started shooting under bright light and then cloud cover rolled in, we had to rewind an unfinished roll.

In a digital environment, the sensitivity of the sensor is expressed as an "ISO equivalent." We can change the sensitivity on the fly, selecting a different one for each frame. We can also turn off the camera and remove the compact flash card, popping in a new one, at any time. If the light is low, we just change the sensitivity and keep shooting.

As with shutter speeds, sensitivity is indicated in steps. Film is available in ISO ratings of 100, 200, and 400—each doubling the number of the previous one. In the digital world, we have even smaller sensitivity progressions. For example, between 200 and 400 you can select a sensitivity of 250, 280, or 320. It's all user-defined.

Some cameras have a lowest possible sensitivity of 200 (a good three stops faster than in the days of Kodachrome 25). In 2007, Nikon introduced their D3 camera body and changed the game. The D3 allowed for noiseless images in the 200 to 6,400 sensitivity range. Before that, with top-end dSLRs, low noise was limited to 100 to 200. Moderate noise was found in the range of 250 to 800. Above 1,000, the noise became extensive. And for many camera bodies, that has not changed. Nevertheless, many cameras now allow you to use sensitivity as a tool in determining exposure without worrying about the noise consequences.

Imagine that you're getting great exposures at 1/250 of a second at a sensitivity of 100. Though the exposure is great, the action is blurred. If you crank your sensitivity to 200, you can shoot 1/500 of a second and freeze faster action. If that's still not fast enough, go to 400 and shoot at 1/1,000 of a second. With new sensors offering noiseless images at an ISO equivalent of 6,400, in the same example, a sensitivity of 3,200 would allow a shutter speed of 1/8,000 of a second, a feat that would have been hard to achieve in the days of film.

AUTO SENSITIVITY

A great feature that many higher-end dSLRs offer is to change the sensitivity for you, automatically, if you get yourself into an exposure bind. It's something that you set up in the camera's preferences so you can provide your choice of parameters for when this feature would kick in.

If you have a higher-end Nikon, chances are you have the Auto ISO Sensitivity feature. It's your safety net. It works in Program and Aperture Priority modes. When it is enabled it prevents you from overexposing or underexposing an image.

Since auto sensitivity is only a measure of last resort, it may have no affect on a shoot at all. With good exposures, the feature never needs to go to work.

It's only relative to a couple of Automatic Exposure modes so for studio flash, where light readings are taken with a meter, it is not needed. For that sort of lighting you can hopefully just pump up the power and leave the sensitivity where it is.

PERSONALITY AND LIGHT

Films had personality. Some would tend to be cool; others were warm. Some provided higher contrast. Some film stocks were staples of the wedding and portrait marketplace. Some favored flesh tones. Photographers would argue about which was best.

Now the personality is in the sensor. Since a camera can white balance (see page 47), the color personality of film is no longer a factor. Yet discerning professional photographers feel that some camera brands have sensors with a "plastic" quality to them—that is, they fail to capture images that look like great film. Before investing, try a side-by-side comparison.

This is an excellent example of how a photographer can create a "look" by exploring all three exposure options until the perfect intended results are found. Tracey likes to move around a set capturing what attracts her eye through the viewfinder. She feels the freedom of a handheld camera. This requires a shutter speed of 1/250 of a second. Tracey also needed a great depth of field for this project and chose f/14. To achieve the look of a grainy image, in diffused light, she dramatically increased her sensitivity in an early model dSLR camera. When we enlarge the photo to get a closer look at the woman's face we see the intensity of the noise. This brings back that look of the higher ISO Ektachrome film stocks being push-processed. It also has the appearance of early color motion picture stocks used by Italian filmmakers—the essence that Tracey wanted to depict in her series of Italian feast images.

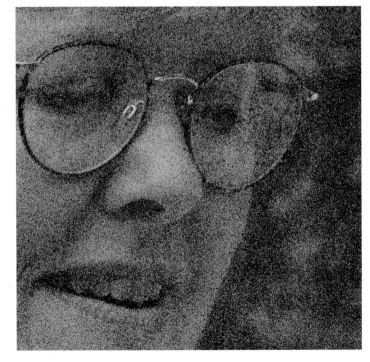

VOLUME

When we speak of the "volume" of light that enters a camera, what we're talking about is how we control the light with the aperture.

There was a time when the camera's aperture was referred to as a diaphragm. Think of it as similar to the iris of your eye. The brighter the light, the more your eye's iris closes down. When the light is low, your pupil dilates so you don't stumble in the dark.

I like the analogy of the water faucet to explain aperture, partly because it also helps explain the role of the exposure trinity. A water faucet on a very slow trickle is much like a small aperture (*f*/22) closed down a very small hole. It takes a long time for the resulting small, slow stream of water to fill a glass. Hence we tie the small opening to a long time: A small aperture demands a longer shutter speed. On the other hand, a large aperture (*f*/1.4) is akin to what happens when there's healthy water pressure and a wide-open tap. You barely have time to get the glass under the faucet before the water is flowing over the sides. When you need a fast shutter speed, rely on a wider aperture.

If you have determined that you have a great exposure for *f*/1.4, a wide aperture, you probably have a very fast shutter speed to go with it. If you make the aperture very small, say to *f*/22, the shutter will need to remain open for a considerably greater length of time. Opening your aperture wide lets in greater volumes of light. The aperture is the volume dial of your camera.

THE TIME + VOLUME RELATIONSHIP

If we keep our sensitivity constant, so it's not a factor, and just concentrate on time and volume, we can see how the two elements are something like a seesaw. They cannot be separated. One goes up and the other goes down.

If you are looking for great depth of field (see page 42), you have no choice but to select a smaller aperture. This is truer with telephoto than with wide-angle lenses. If you are a still life shooter, you probably are not bothered by the slower shutter speeds that a lower volume of light demands.

Setting your camera to Aperture Priority mode permits you to treat your depth of field as being of prime importance. The shutter speed, which is of lesser concern in this situation, will be determined automatically to complement your aperture for a correct exposure.

For someone who shoots action, however, it may be more important to control the shutter speed, making it as rapid as possible to freeze action. Freezing action may start at 1/500 of a second but could demand speeds as fast as 1/8,000. That's when Shutter Priority mode comes

in handy—you select the shutter speed and the camera determines what aperture will complement it for a correct exposure. Of course, at speeds like that, depth of field is sacrificed. Or is it? Consider the sports photographer covering an Olympic event with a telephoto lens as long as 600mm. If a 2x teleconverter is added, they have a 1,200mm lens. If that photographer is shooting with a half sensor camera, they have the equivalent of a 1,800mm lens.

Telephoto lenses compress an image. What is at a distance appears to be quite close. Under those conditions do you want a fabulous depth of field? Possibly opening your aperture as wide as it can go will rivet your viewers' eyes on something very specific. Visually saying something very specific can make a bigger statement than providing too much information. A shallow depth of field makes that sort of expression possible.

Longer glass often comes at the price of an aperture that can only open as wide as *f*/4, as opposed to the optics that offer an easy *f*/2.8 or even *f*/1.4, in some rare cases. Using a teleconverter places more glass in

the light's pathway and reduces your aperture further.

You can see how all of these factors make the ability to vary sensitivity such an enticing opportunity. By getting away from an ISO equivalent of 100, you open yourself up to faster shutter speeds. When the light is not optimal, that's an important tool for the action photographer to use.

F NUMBERS

We cannot discuss the volume of light without exploring the system of f numbers a bit further.

There's some interesting math that goes into those numbers on the lens. Digital cameras have started to do away with lenses that have aperture rings, putting all those controls in the camera body, but let's review how lenses with click-stops on the aperture rings work.

Imagine you could find a lens that closed down the diaphragm as tight as f/45 and opened it up as wide as f/1.4. This would offer quite an amazing range of aperture possibilities. Let's say you started at the smallest opening: f/45. One click further open is f/32. The next click is f/22. After that comes f/16, then f/11, f/8, f/5.6, f/4, f/2.8, f/2.0, and finally

f/1.4. Every other f-stop is either roughly or exactly half of what it was two stops previously—f/8 is half of f/16, just as f/4 is half of f/8.

The volume of light the diaphragm allows in progresses a bit differently. Compared with f/45, f/32 allows in twice the volume of light, and four times as much light comes through the lens at f/22. By the time our dream lens has been opened to f/1.4, there is 1,024 times the volume of light flooding its way to the sensor as there was when it was just trickling in at f/45.

In short, with each click of the aperture ring, twice as much light comes in compared with the previous click stop. As the aperture's circle is doubled, the area it covers increases fourfold.

DEPTH
OF FIELD

Before you shoot, you must think about making depth of field work to your advantage to at least some degree.

Your choice of optics makes a difference. Wide-angle lenses have a fabulously broad depth of field—they provide a broad area of sharp focus in front and in back of the focal point. Telephoto optics, on the other hand, provide a more shallow range of focus; long telephoto lenses rivet your attention on the subject while the foreground and background go out of focus. No matter what your lens's focal length, $f/2.8$ will have a more shallow depth of field than $f/22$. At the smaller aperture, more subject material is in focus in the foreground and background of the focal point. Juggling optical and aperture choices allows photographers to bring the images in their minds into reality.

On the previous two pages we discussed the effect the volume of light has on your depth of field. Now let's take a closer look at how you can leverage your depth of field options in relationship to light.

Shooting shrimp with a telephoto macro lens draws the viewer to a specific area of the image. The more telephoto the focal length the more depth of field may be needed.

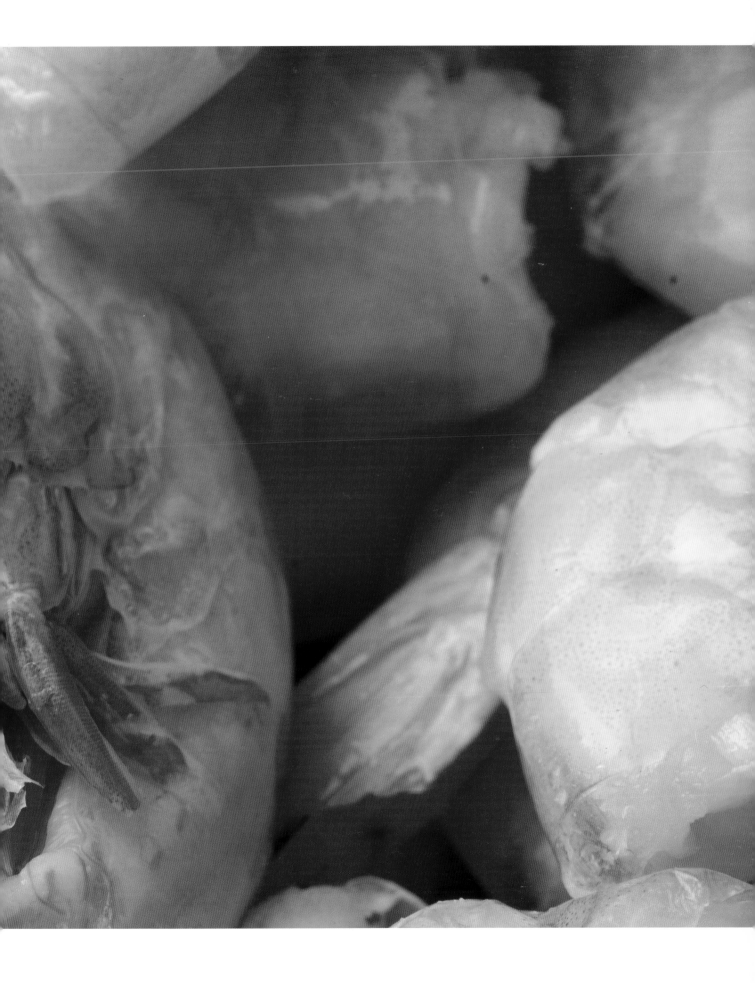

SHIFTING DEPTH OF FIELD

Photographers often make the mistake of setting the focal point at the center of the subject when on closer examination of the setup, there could be wiser creative options. Is the background distracting? If so, rack the focus forward and throw the background further out of focus. Doing the opposite can work if the foreground is distracting. If there's too much or too little depth to your field of focus, the solution can be as simple as adjusting the elements of your exposure trinity to compensate for your creative interests. In other cases, you may need to add or diminish the intensity of your light source. Chapters 7 to 9 discuss in more detail how to manage this with artificial light sources, and chapter 5 explores the many light modification tools that can be used with natural light.

If there's too much light, consider reducing it with diffusion materials, most of which come graded for specific f-stop reductions. These range from handheld tools as small as a foot in height and width to those on frames as big as 12 x 12 feet. Identical tools are available to harness sunlight and reflect it back to your subject. Most of these stretch over the same frames that you use for diffusion.

For the purposes of this discussion, it's all about getting the depth of field you need. The graphic above is intended to assist you in pondering how you can shift the depth to your creative advantage.

Whether your lens is wide-angle or telephoto, the farther the camera is from the subject, the greater the depth of field becomes. If your depth of field is not sufficient, try moving farther from the subject. This technique is especially useful for long telephoto shots.

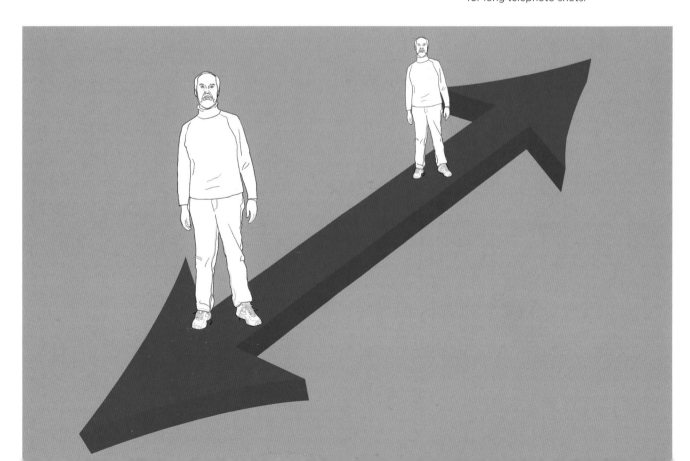

PREVIEW

Many dSLR owners fail to use a valuable tool that's only a finger's length away: the depth of field preview button. Film cameras offered the same feature for many decades even at some of the lowest price points.

The button is easy to use. Choose the aperture you feel suits your needs, then glance in the viewfinder while depressing the depth of field preview button. If your lens's aperture is wide open, you'll see no change. Your camera is always previewing the depth of field at the widest aperture.

The first thing you'll notice is that the viewfinder appears a little darker at other apertures while the depth of field preview button is held down. That's because less light is coming in. But on careful examination you'll notice that more is in focus in the foreground and background of the focal point.

NOT ENOUGH LIGHT FOR YOUR DESIRED DEPTH OF FIELD?

Too often a photographer feels at the mercy of whatever light is offered. While that may be the case with natural illumination, when you are dealing with artificial light more options are available.

If you want a greater depth of field (smaller aperture) than your light will allow, double the amount of light to gain one f-stop. For example, if there isn't enough depth of field with 500 watts of light, double your light source to 1,000 watts and you'll be able to go up one f-stop. If there isn't more light available, cut the distance between the light source and subject in half instead. This will soften the quality of light, as discussed on page 60, but if you need a little bit more of the subject, foreground, or background in focus, it could be your best option.

Don't guess at what your depth of field will look like. Find out in advance by depressing the depth of field preview button.

WHITE BALANCING

The digital camera has dramatically changed the way we effect color correction. Correcting color was once done within the camera by means of choosing from a set of color filters and by making painfully slow color meter reading and filtration adjustments. The filters often reduced the amount of light entering the lens and therefore crippled the aperture or shutter speed. Today, we can adjust our white balance in the camera, ideally, or as a part of postproduction.

White balancing allows your camera to adjust the color temperature to balance the existing conditions. For example, if you are shooting under 2,800 K incandescent lights and you want it to look like 5,500 K "daylight," you can balance the color temperature of the image. However, it doesn't have to be that cut-and-dried. You can also use white balancing to create color moods, warming up or cooling down a scene.

Opposite: When photographers are just getting used to digital photography it seems easiest to choose auto white balance. The thinking is that it can be fixed in Adobe Photoshop Camera Raw. This is probably true if the changes are minor. However, if the changes are dramatic, repair can prove to be less satisfying than if done properly when the photo is captured. Mike Pocklington captured the top image at 4950 K on a shaded, overcast setting, rendering the situation exactly as he wished to portray it. If Mike had chosen to select a "Shade" setting he would have captured a raw image at 7500 K, far warmer than desired. You can see the dramatic difference in the bottom image.

AUTOMATIC OR MANUAL?

We have auto exposure. We have auto focus. What about auto white balance?

For many, this is the standard approach. People let the camera do the industrial-strength color balancing for them. When shooting with studio flash units, however, that approach won't work; you have to set it yourself. As you have probably guessed, we prefer to make the choices ourselves. Even if we are going to make changes in post-processing, we try to get as close as possible with the camera raw image.

There is a movement among some professional photographers—especially those who shoot portraits and weddings, genres that involve a great deal of outside photo lab work—to skip the camera raw file format and go right to the best-quality JPEGs. These shooters do little or no post-processing work. For that sort of photographer, the color balancing has to be right on the money. For them, using the JPEG is just like shooting in the days of film: The color and exposure have to be accurate because there is no turning back.

Why do it manually? It's quite possible to have multiple light sources that do not all match. We like to meter our light sources using a Gossen Color-Pro 3F. Just as a meter determines exposure, this instrument measures color temperature. Working this way allows us to filter the light sources and/or make decisions about what to balance in the camera. For more on this topic, see chapter 3.

TAKING MEASUREMENTS IN THE CAMERA

On page 51, we explain how to use a gray card to take an exposure meter reading with your camera. To do the same thing to take a reading of ambient color conditions, we use the Lastolite Ezybalance 30" Grey/White Card.

On a Nikon dSLR, hold down the WB (white balance) button and rotate the camera's main command dial (the one in back) until PRE appears. Release the button and press it again. The PRE icon should flash. Place the grey card so that it fills the camera's frame, and completely depress one of the shutter release buttons. The color balance will be recorded and stored for you to use again and again. In other words, the camera allows you to reuse the same color balancing later today, tomorrow, and next month—an enormous help as you strive for color consistency.

CREATING A COLOR MOOD

From time to time we are on a location shoot and the color mood just does not feel right. We need to fine-tune it. A good example would be a child boarding a school bus. We might want the scene to have the look of early-morning light, with all of its rich warmth. That may exist in the early morning hours of March, but if our shoot is at 9:00 A.M. in July, that light quality is long gone. Using white balancing, we can create that look.

On other occasions we may be shooting indoors with AC-powered flash units, which will provide an excellent 5,500 K light. However, if we want to create the appearance of a warm, comfortable interior, we'll need to adjust our white balancing to something in the vicinity of 6,500 K.

COLOR BRACKETING

When approaching a shoot, we are often 100 percent unsure what white balancing to choose. So we do as many test shots as possible before the real work begins. We'll typically knock out a few photos while the models are getting styled, view them on a calibrated computer display, and make some decisions.

There's a great, quick tool on your camera that can be used to manually bump up your white balance. Hold down the WB button and rotate the subcommand dial (the one in front). Each step of the dial you move +1, +2, or +3 in one direction or –1, –2, or –3 in the opposite direction. These increments bump up your white balancing in color steps. If your starting point is 5,200 K, with each change you'd go to 5,300 K to 5,400 K to 5,600 K. (The progressions do not change evenly; there is no 5,500 K.) Going in the other direction would take you to 5,100 K to 5,000 K to 4,900 K. In other words, you'll get seven options for each shot.

If you are not sure what white balancing to choose but do not have time for test shots, the higher-end Nikon dSLRs offer automatic bracketing that does not require you to step through each change manually. It instead moves onto the next step and waits for you to release the shutter. This feature uses the camera's BKT button and takes you through a setup menu for your preferences.

THE DRAGGED SHUTTER

If you have been in the photography business for many years and have never heard the term "dragged shutter," please do not despair. You may have heard it referred to as "extended exposure" or any one of a variety of other terms.

"Dragged shutter" refers to an exposure technique for use with two-light sources. Typically, one source is flash illumination, and the other is ambient light.

A flash of light happens at its own rate of speed, which easily exceeds 1/1,000 of a second. Often the camera's shutter is set to a faster speed for flash so ambient light won't interfere with the purity of the exposure and color of the flash. A speed of 1/250 of a second is commonly used with flash.

When you "drag" a shutter, you leave it open for a longer period of time. If you are shooting a room's interior, for example, the longer shutter speed allows the lamps in the room to burn into the image. If exterior light is streaming through a window, the longer shutter speed allows that light to be properly recorded.

HOW DO YOU CHOOSE THE SPEED?

Take a reading of your ambient illumination. You may want to do a test shot for the existing light to be certain that this segment of the exposure is perfect.

In the case of the cherry wheat ale shown here, we illuminated the back of the mug with an intense, battery-operated emergency light set up at close range. This light, which had a lower Kelvin temperature, imparted a warm, amber glow to the ale, creating an intriguing contrast with the frosty mug. The flash source amply lit the mug, cherries, and bowl. Leaving the shutter open for 1/50 of a second was long enough to allow the emergency light to do its magic. We arrived at 1/50 of a second through a series of test exposures during the preproduction phase of the shooting. Typically, we make incremental brackets of 1/3-stop speed changes. The closer the emergency light comes to the back of the beer mug, the more it has a glowing appearance. Without some means of getting more light behind the mug, the beer would look dark and drab.

For this image we created the majority of the light with a Novatron Bare Tube Flash Head in a Chimera Lightbank. This key light source is to the rear right of the mug. A reflector, to the front, harnesses that light and bounces it back to the foreground. All of that happens in a fraction of a second. However, the shutter remains open for a far longer period, providing sufficient time for our stylist, Robert Young, to swiftly swirl the illumination of a big flashlight around the back of a frosty mug. This typifies how a photographer manipulates a dragged shutter.

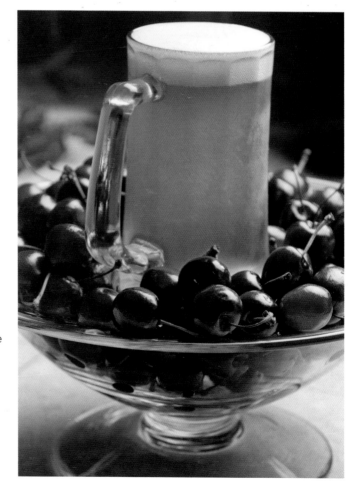

EXPOSURE VALUE

The Exposure Value system is more commonly known as "EV." Part of a system that goes back to the 1950s and is still very much alive today, it serves as a guide for manually setting exposure and plays an integral role in the operation of many of the finest dSLRs. Additionally, many excellent advanced digital exposure meters offer results expressed as EV. For your convenience, we've supplied the handy chart opposite.

As we discussed earlier in this chapter, you can combine a variety of shutter speeds with apertures to create many correct exposure combinations. The EV system classifies these possibilities into twenty-three exposure values ranging from –6 to 16. There are thirteen volume and speed combinations for each exposure value. By way of example, if you could find a lens that opened as wide as f/1.0 and the correct shutter speed was 1/250 of a second, you would have an EV of 8. On the opposite end of EV 8 is f/64 with a shutter speed of 15 seconds. All thirteen combinations create the same exposure results.

EV	f/1.0	f/1.4	f/2.0	f/2.8	f/4.0	f/5.6	f/8.0	f/11	f/16	f/22	f/32	f/45	f/64
-6	1'	2'	4'	8'	16'	32'	64'	128'	256'	512'	1,024'	2,048'	4,096'
-5	30"	1'	2'	4'	8'	16'	32'	64'	128'	256'	512'	1,024'	2,048'
-4	15"	30"	1'	2'	4'	8'	16'	32'	64'	128'	256'	512'	1,024'
-3	8"	15"	30"	1'	2'	4'	8'	16'	32'	64'	128'	256'	512'
-2	4"	8"	15"	30"	1'	2'	4'	8'	16'	32'	64'	128'	256'
-1	2"	4"	8"	15"	30"	1'	2'	4'	8'	16'	32'	64'	128'
0	1"	2"	4"	8"	15"	30"	1'	2'	4'	8'	16'	32'	64'
1	1/2	1"	2"	4"	8"	15"	30"	1'	2'	4'	8'	16'	32'
2	1/4	1/2	1"	2"	4"	8"	15"	30"	1'	2'	4'	8'	16'
3	1/8	1/4	1/2	1"	2"	4"	8"	15"	30"	1'	2'	4'	8'
4	1/15	1/8	1/4	1/2	1"	2"	4"	8"	15"	30"	1'	2'	4'
5	1/30	1/15	1/8	1/4	1/2	1"	2"	4"	8"	15"	30"	1'	2'
6	1/60	1/30	1/15	1/8	1/4	1/2	1"	2"	4"	8"	15"	30"	1'
7	1/125	1/60	1/30	1/15	1/8	1/4	1/2	1"	2"	4"	8"	15"	30"
8	1/250	1/125	1/60	1/30	1/15	1/8	1/4	1/2	1"	2"	4"	8"	15"
9	1/500	1/250	1/125	1/60	1/30	1/15	1/8	1/4	1/2	1"	2"	4"	8"
10	1/999	1/500	1/250	1/125	1/60	1/30	1/15	1/8	1/4	1/2	1"	2"	4"
11	0	1/999	1/500	1/250	1/125	1/60	1/30	1/15	1/8	1/4	1/2	1"	2"
12	0	0	1/999	1/500	1/250	1/125	1/60	1/30	1/15	1/8	1/4	1/2	1"
13	0	0	0	1/999	1/500	1/250	1/125	1/60	1/30	1/15	1/8	1/4	1/2
14		0	0	0	1/999	1/500	1/250	1/125	1/60	1/30	1/15	1/8	1/4
15			0	0	0	1/999	1/500	1/250	1/125	1/60	1/30	1/15	1/8
16				0	0	0	1/999	1/500	1/250	1/125	1/60	1/30	1/15

" = 1 second

' = 1 minute

THROUGH-THE-LENS METERING

As you can see from the images reproduced in this book's later chapters, we use all the exposure modes on our Nikons, finding uses for every automatic and manual exposure option. However, some photographers buy camera bodies in the $5,000 to $8,000 range and never take them out of Manual mode. Does this mean they don't trust the camera's metering system? Admittedly, in the early days of built-in meters the results were less than perfect on many occasions. However, today's metering systems are quite sophisticated, and data from numerous locations is analyzed using multiple internal sensing devices. Much of it allows the photographer to become involved in customizing how the data is read.

Some professional photographers develop a sense for looking a a scene, checking what the in-camera meter tells them, and making an individualized decision based on their intuition. Some claim a high rate of success.

The Lastolite Ezybalance 30" Grey/White Card collapses down to a fraction of its size and stores in a convenient case. Place it in the path of the light and take an in-camera meter reading in place of the subject.

INCIDENT VS. REFLECTIVE READINGS

In chapter 3, we explore the use of incident meters, which are handheld. The majority of the photographers who use their dSLRs in Manual mode, including us, rely on the information that meters provide.

The handheld incident meter does not factor into its reading the color, tone, brightness, or reflective qualities of a subject. All it measures is the light falling upon it. On the other hand, in-camera meters encounter all sorts of unknown factors as they measure the light that is reflected back to them from their subjects.

THE GRAY CARD

To dramatically improve your chance of getting a great reading from your camera's built-in meter, place a neutral-density gray card where the subject will be located. The card is an excellent approximation of what the metering system is hoping to find. Position the card so it fills the frame of the viewfinder and aim it in the direction of the key light. (For more on neutral-density gray cards, see page 18.) Lightly press the camera's shutter release button until the camera shows you a reading, in Manual mode.

EXPOSURE BRACKETING

Exposure bracketing is the time-tested method professional photographers use to ensure they have captured the perfect exposure. It is extremely popular for still life shots. While bracketing was considered a must-do method when photographs were shot on film, some of today's digital shooters are under the impression that anything can be corrected in post-processing. Nothing could be further from the truth. If it were, would Nikon have created so many options for exposure bracketing and compensation?

Bracketing can ensure that the image captures details in highlights and shadows that might otherwise be lost. It's the refinement of those little details that is the mark of a great professional photographer.

EXPOSURE COMPENSATION TOOLS

In the days before manual exposure compensation, the standard means of bracketing was to make one exposure and then to tweak the aperture ring a little toward the next click stop and then a bit back in the other direction. The idea was to capture between a half and a third of a stop above and below the opening exposure. Doing bracketing in this way was neither accurate nor repeatable.

Manual exposure compensation is far easier, more accurate, and more dependable. Nikon dSLRs have an exposure compensation button marked by a plus and minus graphic. Hold the button down while rotating the main command dial (the one in back) to vary the exposure in perfect third-stop increments. The viewfinder and control panel provide visual confirmation.

Generally, this tool is used to adjust the exposure of a scene up or down. An excellent example would be shooting people against freshly fallen snow on a sunny day; the scene can be so bright that the camera's meter may render the snow as gray and the people as too dark to show sufficient detail. To avoid the possibility of washed-out details, try bracketing toward fast shutter speeds or closing down the aperture.

EXPOSURE BRACKETING

Nikon dSLRs offer automatic bracket exposure options, similar to the way they bracket white balancing and flash—using the camera's BKT button and a setup menu in which you enter your preferences for how you want the bracketing to happen.

There are dozens of options to choose from, ranging from how many photos are taken in each bracketing sequence to how widely each exposure in a sequence will vary. Once you have set up your preferences, they are there to use again and again. This mechanism lets you easily get into the habit of shooting multiple exposures as part of your testing sequence.

As automated as this sounds, no exposure is made until you release the shutter. The more you test and examine the results, the more you will develop a sense for the capabilities of your photographic gear, and the more skilled you will become. With time, you'll develop a better command of exposure, much like photographers who can look at a scene and practically guess what the proper exposure should be.

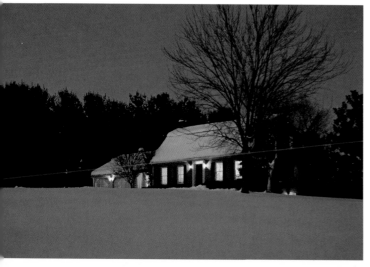 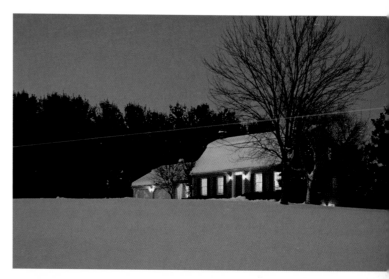

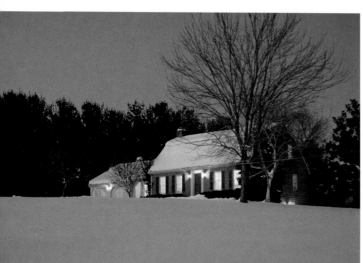 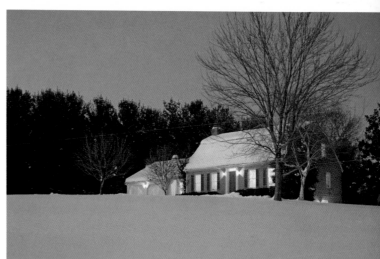

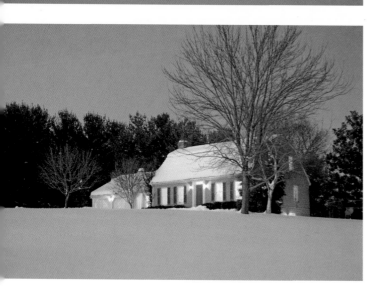

Photographing an architectural image in snow in the evening is no small effort. The time frame available to make this happen comes down to just a few short minutes. Shoot now; evaluate later. This is something you cannot miss. Highlight and shadow details cannot be lost. It's best to scout such scenes in the late afternoon, shooting a variety of compositional options. The proper exposure for a shot like this is extremely subjective. What's best for one shooter may be different for another. Here, we provide 5 exposure brackets, running in one-third stop increments from two-thirds under exposed to two-thirds over exposed. To us the center left image holds the most details. Obviously, a tripod is essential. If all else fails, create a composite image in Photoshop using the best elements of more than one bracket.

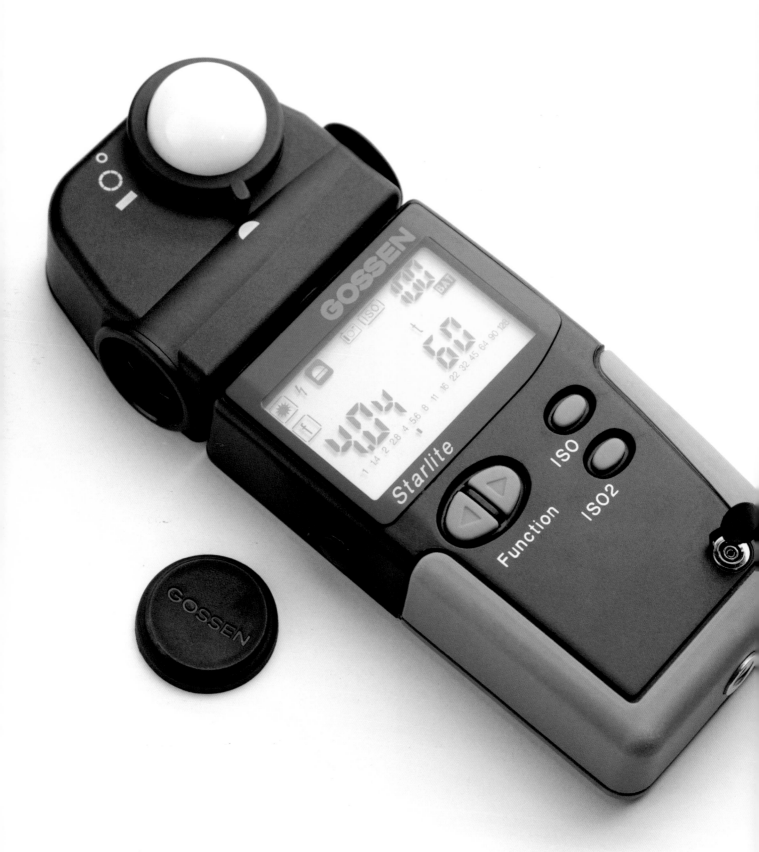

READING LIGHT AND COLOR

Meters read light and color, providing information you can use to make an informed decision about exposure.

Meters are not intended to *tell* you how to set your exposure and white balance. They're more like a resource that offers you a list of options.

The metering system built into your camera is capable of doing most of the industrial-strength reading of light you're going to need. There was a time when cameras' built-in meters were vilified by professional photographers, and with good reason—their capabilities were limited and the readings not always dependable. Some professional photographers remain leery of them to this day. However, many of today's dSLRs come with very sophisticated systems for reading light.

Using a studio flash system is an excellent example of a situation when a handheld meter is essential. That's something your camera's metering system is not intended to handle. You cannot use a digital studio flash system without a flash meter, for example; your camera is not equipped for it. Since so many professional photographers shoot with flash, they look to all-in-one meters, like the Gossen Starlite pictured here, which does both incident and reflected readings for flash and ambient light. It can measure light over a broad angle or get down to a spot of just 1 degree. We take the Starlite and a color meter (see page 65) with us on every single shoot.

Professional photographers who delve deep within the technical aspects of photography cannot work without an excellent light meter. The multi-meter is to a photographer what a numeric keypad is to an accountant.

HOW TO USE A METER

Let's review the anatomy of an all-in-one light meter. You'll want to become familiar with these features to the point that your meter feels like an extension of your hand and using it becomes second nature.

ADJUSTING THE HEAD

On the Gossen Starlite, the meter's head rotates 270 degrees, allowing you to point it in the direction of the light and still observe the information the panel conveys.

There are single-purpose meters, such as those that only read incident light from a flash source or those that take only spot readings. The Starlite can be used as both an incident and a spot meter (see page 64) without requiring you to change its head, which makes it very convenient. For use as an incident meter (meaning, with light falling on it), the head should be fully extended, as shown below. When the head is partially retracted, the meter converts to a spot meter, with two options for spot coverage. The head can also be fully retracted for storage.

Many meters require you to replace the spherical dome with a flat diffuser. Unfortunately, these little replaceable parts are easily lost. Using a meter in its Flat Diffuser mode is an excellent way to measure light coming from a specific direction. It's extremely helpful when numerous light sources are involved and you're trying to concentrate on how much illumination is coming from just one of them. If one of your light sources is a metallic umbrella and another is soft white one, for example, it allows you to get a reading for the difference between the two.

When the Gossen Starlite's dome is fully extended (below), it is ready to take an incident reading. When it's partially retracted (bottom), the meter converts for more directional readings.

REFLECTIVE VS. INCIDENT READINGS

You use a handheld incident meter to accomplish what your camera's reflective meter cannot do. So doesn't it seem strange to use a handheld meter to take reflective readings? In fact, it's not. That's because the reflective readings that a handheld reflective meter provides are spot readings, something most cameras cannot do. We'll examine this more closely on page 64.

THE KEYS

A great handheld meter doesn't bog you down with controls. The fewer the buttons, the better.

A multi-meter is one that is able to jump from doing ambient readings to taking readings for flash. The Starlite uses two function buttons to go from Ambient mode (represented by a sun) to Flash mode (represented by a lightning bolt). A combination of the Ambient and Flash modes is needed for metering extended exposures. Use the Flash mode to find your aperture setting. To discover how long you should drag the shutter, switch to Ambient mode and measure the existing light. (Learn more about dragging the shutter on page 49.)

CHANGING SETTINGS

Take a measurement once and let your meter do the initial math for you. Say, for example, you take a reading and the meter tells you that *f*/16 at 1/60 of a second is the correct exposure. But as you think about it, you decide that *f*/5.6 is the depth of field you want. What's the new shutter speed?

Don't bother taking another reading, just use the setting wheel on the side of the meter. Dial up a new shutter speed, and as you do so you'll be flipping through the new aperture settings. As you do this, you're using your meter as an instant exposure calculator.

What if you want to bring sensitivity into the equation? Many photographers have a couple of preferences for ISO equivalent settings. You can preset your meter for your favorites and, with the press of one button, see how they factor into the exposure decision. For example, you might use 100 or 200 as one presetting and 1,600 or higher as another.

Below: Use the function keys to quickly toggle back and forth between ambient readings and flash measurements. It's what makes a multi-meter so versatile.

Bottom: Use your meter as an exposure calculator. Just rotate the setting wheel on the side. The exposure options will be displayed from a single reading you've taken.

INCIDENT MEASUREMENTS

Using a light meter like a professional photographer requires that you get out of the mind-set of how metering is done within your camera's viewfinder. You rarely take just one reading and get the answer you're looking for. If your subject is three-dimensional, you'll probably want to take a few readings before making an exposure decision.

HOW TO TAKE MEASUREMENTS

This photo of Tori Ruark is a good example of how natural illumination, plus a handheld reflector, creates a variety of lighting features, each of which has to be taken into consideration.

Generally, start by taking a reading of your diffused highlight (considered your "neutral zone"). Then you can see how far your specular highlight and shadow areas are from that reading. If your highlights and shadows are dramatically different than the diffused highlight, they may not hold details very well when the image is used in some visual media. What appears with excellent detail on an advanced, calibrated LCD computer display in RBG color format will exhibit less detail in a CMYK print medium such as newsprint. Highlights may completely wash out, and shadow details may block up. An exposure range of just three stops has an excellent chance of reproducing well in most media. One of five stops has some limitations. When your highlight is seven stops away from your shadow, the image will reproduce well in only limited media. However, if your images are intended only as gallery exhibit prints, such a wide range should not discourage you since you will be in total control of the printed product.

You can see from the specular highlights in Tori's eyes that we attained the diffused highlight with a silver reflector. We wanted the light to glamorize the beautiful contours of Tori's face. Without the large Westcott Illuminator Reflector (see page 92), her face would be in shadow, much like her cheek on the left side of the photo.

We started by reading the diffused highlight, which could be measured in a few places. The exposure for the left cheek was f/5.6 at 1/60 of a second. When we took a reading of the soft shadow on the right cheek, it was one stop darker than the opposite side of her face. Last, a reading of the highlights in Tori's hair, which came from overhead sunlight, revealed that they were a full stop brighter than the diffused highlight.

With only a three-stop range between the highlight and the shadow, the image should reproduce well in just about any media. Did we actually accomplish this with just three measurements? Well, no. We fussed around with the image for a while until we were sure we had gotten it just right.

You can see from the specular highlights in Tori's eyes that we attained the diffused highlight with a silver reflector. The overhead sunlight fueled the large Westcott Illuminator reflector that is providing the majority of the light on her face.

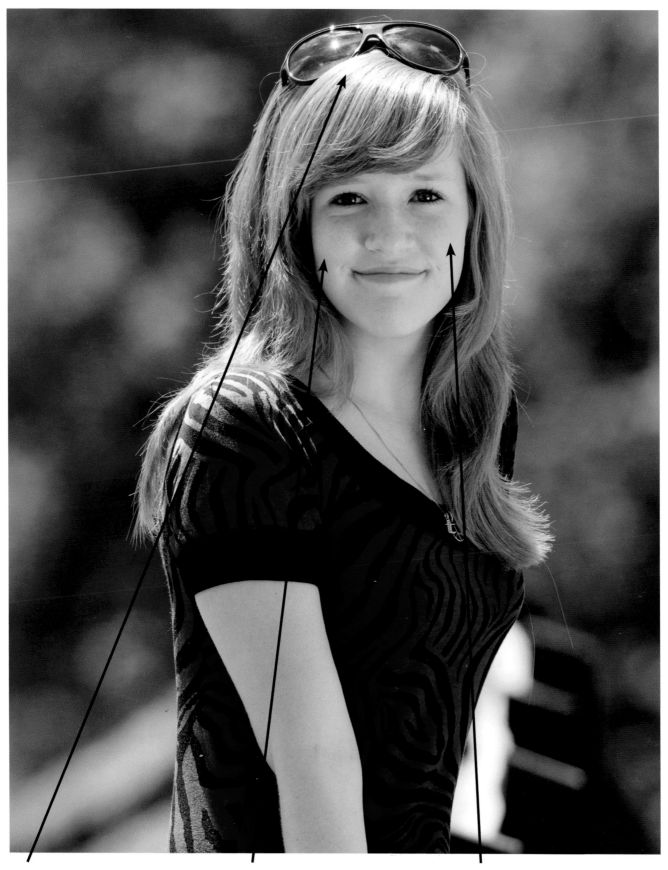

1/60 • f/8 1/60 • f/4 1/60 • f/5.6

SIZE AND DISTANCE FACTORS

Adjusting the distance of your light source to your subject can change the entire look of a photograph. We're discussing this topic in the chapter on metering because the light-source-to-subject distance alters not only the quality of the light but its intensity as well. The closer the light gets to a subject, the more the light envelops it, creating a softer illumination. The farther the light source is from the subject, the harder the light.

Flip to page 123 to see a photo with a setup similar to the one depicted in the illustration below. The light was positioned precisely so that the illumination would wrap the wine bottle exactly as we wanted it to. If your light source is 1 foot from your subject and you have an aperture reading of $f/22$, chances are that if you move the light an additional 6 inches (half the distance) you'll get a new reading of around $f/16$. Double the original distance to 2 feet and your third measurement could drop another stop to $f/11$. Now double your second distance to 3 feet and you'll probably find that the fourth reading is $f/8$.

The light source's distance from the subject alters the exposure of the image and at the same time changes the quality of the light. If the Chimera Lightbank is just one foot from the wine bottle the light will evenly wrap itself around the bottle with very soft illumination. However, if the light is three feet from the bottle the result will be a light quality with greater contrast, a harder light. You see the photo that resulted from this setup on page 123.

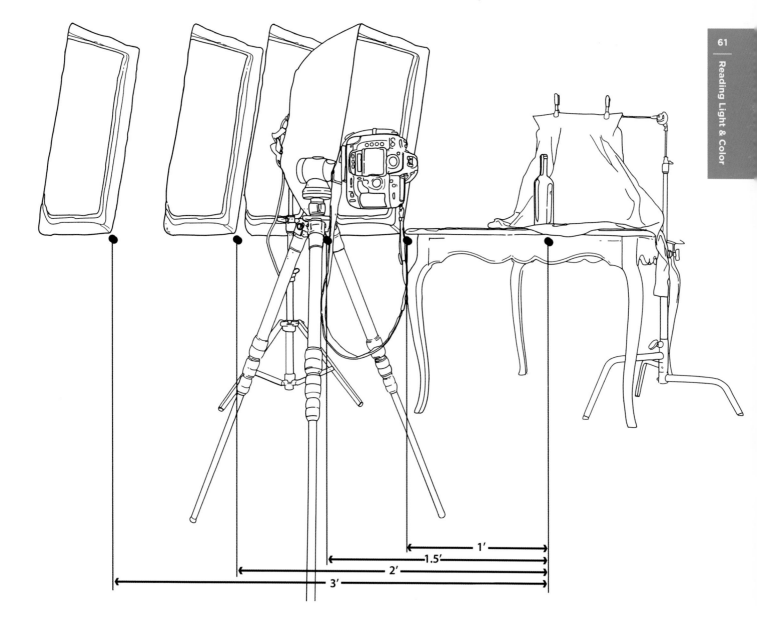



THE INVERSE SQUARE LAW

Part of what is explained on the previous pages is something of great importance: the "inverse square law." The theory behind this law affects just about all lighting technologies. It's an integral element in what the engineers who design lighting instruments call "photometrics."

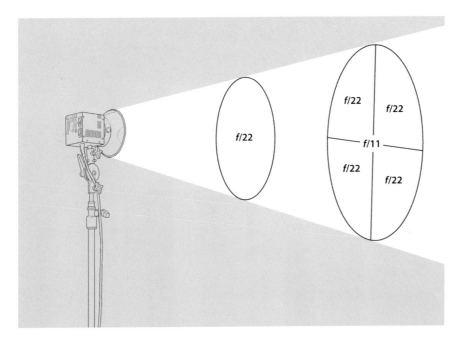

The inverse square law helps us understand that light diminishes in intensity as it travels a greater distance to reach its subject. The wider the area it covers, the less intense it becomes.

The theory says, in short, that light diminishes at the square of the distance from the light source to the subject. What this means is that the farther a subject is from the light source, as demonstrated in the image above, the less intensity the light has. The reason is that the light continues to spread out as it travels through space. What may be a pool of light that's 4 feet wide when the source is placed 1 foot from the subject could become 6 feet wide when it's 2 feet away. Since the pool needs to cover more space, there is less of it to go around.

This is as true for your photographic light as it is for the recessed lighting fixtures over your kitchen countertops. In the kitchen, the light source to subject distance is fixed. The architect designed the pools of light for the countertop, which remains stable. Photographic lighting is different. It's not fixed, and that has consequences. The farther the light source gets from the subject, the more you have to open the aperture. As discussed in chapter 2, this results in a shallower depth of field.

The same holds true for the size of the light source. A lighting instrument produces a more intense light when it is installed in a small light bank than it does in a large one in which the light is more spread around. In the graphic above, light that reads at $f/22$ at one distance becomes four times less intense at a longer distance, diminishing to $f/11$.

We refer to the inverse square law as a "theory" because it helps you to understand how all of this works. However, when put into practical application, the law's workings may not be as precise as what we are describing. That's because all sorts of ambient conditions can come into play—as one example, light can bounce off of various structures and objects that are part of the scene. Also, some lighting instruments and modifiers are more efficient than other ones.

THE FLASH METER: ESSENTIAL HARDWARE

When you are using studio flash equipment, it's not possible to determine an accurate exposure without a flash meter. Most flash meters also read ambient light. To fully understand the value of the flash meter, please also see chapter 8, where we explore studio flash.

Attach one end of the sync cable to the flash meter and the other to the source of AC-powered flash illumination. This permits you to fire the flash from a button on the meter.

Part of the magic of the flash meter is that it reads both the flash duration and the intensity of the light. It's possible to set the meter to prepare it to read a flash, but for the most part, photographers want to be able to fire the flash from the meter, which requires a sync cable. One end of the cable attaches to the meter and the other connects to the flash source. Every time you press a button on the meter, the flash fires. This allows you to hold the meter in your hand, pressing the button and firing the flash as you investigate how the light varies from different angles and falls on your subject. Most flash meters also read ambient light. If your meter measures both flash and ambient light, it reads both of them simultaneously, providing you with a reading for the aperture and shutter speed. This is especially important when using fill flash outdoors.

When shooting in an indoor situation, such as a darkened room, some still life photographers use multiple flashes. This technique is important when there's a limited amount of flash power and a need for a significant depth of field, and is often employed for shooting large products, such as an automobile or a bedroom set. If you have enough light for *f*/11 but need *f*/16, fire the flash twice. To get to *f*/22, fire the flash four times.

A great flash meter can do these calculations for you. On the Gossen Starlite, take a reading and depress the function button while rotating the settings wheel until the meter's display shows an *f* with a box around it. Then release the function button. Now use the settings wheel and dial in your desired aperture. The meter shows you the number of flashes it will take to achieve the depth of field the shot requires.

As with measuring ambient light, taking flash readings is all about helping you make decisions rather than being told which exposure settings to choose.

THE SPOT METER

Today, some high-end dSLRs are equipped to do spot readings that come in as tight as two degrees. Many spot meters allow you to choose a spot that's very intense as well as one that's a bit wider. The concept is similar to a meter with a telephoto attachment.

To use a spot meter, look through it as shown in the illustration below. In the case of the Gossen Starlite, we can choose either a 12-degree spot or one that's a very tight 1 degree. This capability provides exceptional opportunities when you want to read the light reflected from a subject that's a good distance from the camera; it's especially convenient when it is impossible to get close enough to the subject to take a reading. Another excellent use is taking very specific reflective readings at various places on a subject that is well within your reach.

Keep in mind that these are reflective readings. They are not measurements of the light falling on the subject, such as you measure with the incident dome of a handheld meter. But the meter has a tool to assist you in understanding the incident light. While you are taking various readings, the meter can store them and then provide you with an average. On the Gossen Starlite, we take a reading with the top button, and then take up to eight more readings using the bottom button. The meter's display shows us how many measurements we have taken, and as we go, it does the math for us and comes up with an average. If we've taken a reflective reading off a very light object and another one off a very dark one, the meter presents us with an average of the two.

Looking through a spot meter is something like peering through a tiny telephoto lens. You see a tight-angle view of your subject, and then take a reading of what you see.

THE COLOR METER

The color meter should be an essential tool in the camera bag of every location photographer. When you are out in the field capturing images, there is no telling what lighting conditions you will encounter. On some occasions you can respond with the white balancing discussed on page 47. However, you will often find yourself battling multiple light sources and color temperatures, which is more than a single, in-camera correction can resolve.

Some photographers are under the misguided impression that any color temperature problem they encounter can be corrected in Photoshop. To some degree this is true, but sometimes the color temperature is so far off that, if the color representations need to be exact, they are out of luck.

When you are in a mixed light situation—one part of the scene is one color and another is a different color it may be difficult and time consuming to correct this in postproduction. It's better to correct one or more of the light sources. To adjust a light source, simply place filter media over the artificial lights (for more on this, see page 129).

The Gossen Color-Pro 3F color meter is simple to use and works much like the Gossen Starlite multi-meter discussed on pages 56–57. It reads both ambient and flash illumination.

LIGHT RATIOS

On pages 58–59, we explored how to take light ratio measurements for a one-light-source setup: natural illumination plus a handheld reflector. Some might consider that a two-light source setup, but the sunlight is the only generator of illumination; the reflector is just redirecting the light.

But what about when there are more sources of light? It is not unusual for the typical portrait studio to have a key light, a fill light, a rim or hair light, and a background light. You will want to take a reading from each light source to understand how much light is coming from it. This then allows you to determine a "light ratio," another standard photographic concept. You will often hear shooters speak of a 4:1:2 ratio (spoken as "four to one to two"). What does that mean?

Let's say, in this example, that when we face the dome of our flash meter toward the key light, we get a measurement of $f/11$. This will be the source of that diffused highlight which is the ever-important neutral zone of the subject's exposure. Let's pretend the key light is in a large silver umbrella to the right of the camera. For the discussion of ratios, we'll assign the key light a value of 1.

If this were a one-light portrait, the other side of the subject would be in shadow. Perhaps it is a low-key portrait; in that case, the lighting setup would be complete, and there wouldn't be much else for us to do besides create the photos.

However, that's not what we want for this shot. We want to add a source of fill light placed on the other side of the subject in a medium white umbrella. We want it to fill in the shadows without stealing the thunder of the key light. We measure the fill light as $f/8$. That gives us a one-stop difference between our key and our fill. The fill light is there, but we still have a shadow. We assign the shadow a value of 2. So far, that gives us a ratio of 1:2.

Since our key light is in a silver umbrella, it produced not only our diffused highlight but a specular highlight as well. Reading that highlight with our spot meter, we get a reading of $f/16$, one stop more than the key light. We now have a contrast ratio of 4:1:2. This is another example of standard professional photographer jargon.

MEASURING MULTIPLE LIGHT SOURCES

Getting a good meter reading from multiple light sources takes a little finesse. Some photographers use a hand to shield the other light from the meter's dome. Others switch lights on and off to read just one at a time, though that can lead to false readings as in the actual setup, one light spills over into the other light's territory.

The meter we use allows the dome to retract—that is, to form its own shield—so that it still reads the light coming into the area of the subject even if multiple lights are on.

In this "head shot" of actress Sarah Nutt we see the light ratios vary from the highlights to the one side to her face to the shadows on the other. Here the ratio works to depict an actress with depth. It portrays her as having both an obvious joy as well as harboring hidden mystery.

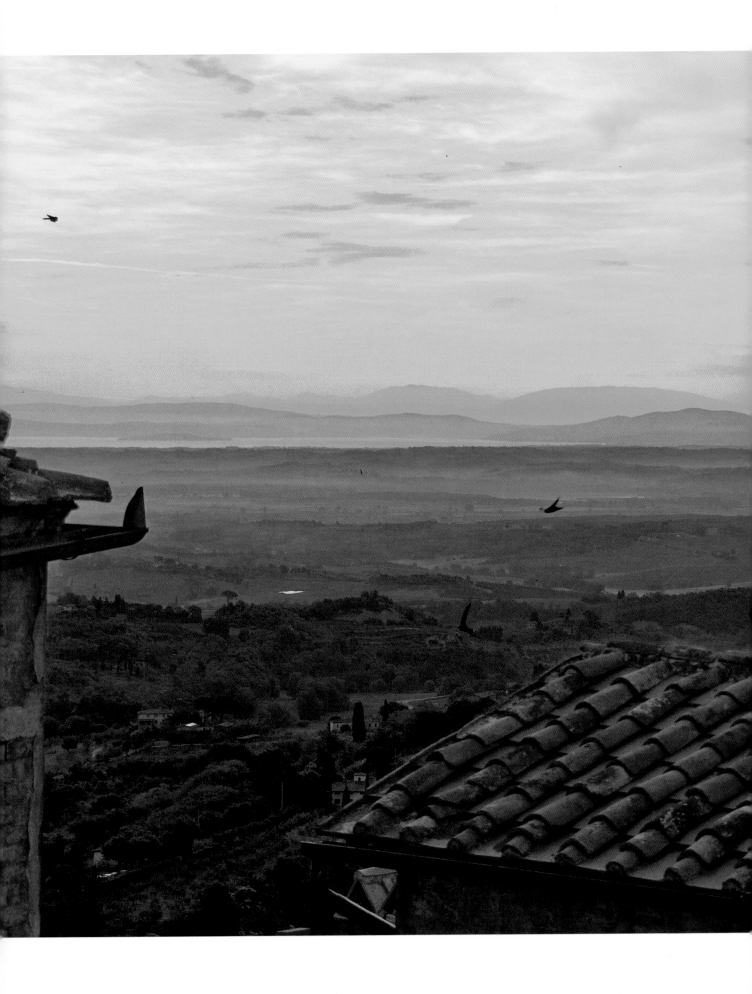

USING NATURE'S LIGHT

Before we delve into such artificial light sources as tungsten, daylight fluorescent, HMI, and flash, it's best to fully understand natural illumination.

There's more to comprehend than just an awareness of ambient conditions. Adept professional photographers are able to observe nature's light and instinctively know how to manipulate that illumination so that their images say what they want them to.

In this chapter, we will explore light throughout the day and contemplate how to make the most of whatever light you are given. There's no need to simply accept what nature provides at face value. It's your job, as a talented image-maker, to manipulate ambient light and master it. Put to use all that we have discussed in the previous three chapters, add your strongest creative energy, and you are on the way to photographic excellence.

Wise photographers carefully observe nature in a scene to learn the optimal time to capture what they envision in the mind's eye. Success may be allusive for a few days, weeks, or months. But, when success is had it will be all the sweeter.

EARLY MORNING

The light nature provides first thing in the morning creates some of the most dramatic effects we see all day. Early morning light moves fast, however, so we have to act quickly to capture its dazzling effects and colors.

It's one thing if you're just grabbing shots, capturing what you see and enjoying the moment. However, if you have a big shoot planned, with models and crew, you need to make the most of the morning. Do your planning the day before, if not a week in advance. Let the weather forecasts be your guide.

Check out the light the day before as well, if you can. If you can't, do a scouting shoot at the location, sending out an assistant who knows your shooting style well enough to bring back images that will allow you to plan your shoot in five-minute increments. Such planning will ensure that your photo session produces the highest yield.

Mike Pocklington captured the image on the right, as well as the one on the previous spread, while in Italy. Mike was a master of planning and developing strategies to utilize all the visual elements at his disposal. It was how he was able to make the strong visual statements that he did. Once at the location, Mike's eyes and mind were in gear. He had the ability to see and interpret on the fly. When he was still using film, he didn't waste a frame. He looked through the viewfinder and carefully observed, patiently waiting to release the shutter at the optimal moment. When shooting the misty sunrise on the previous spread, Mike didn't come home with hundreds of near-identical frames, as some trigger-happy digital photographers do. That just creates an editing mess.

It's worth getting up early for moments like this. The sun's warmth creeps across the stone wall and highlights the door in this image, but it looked completely different an hour later. On a morning as beautiful as this, there are hundreds of images waiting to be captured. Interpret what you see and get to your next shot before you lose the fabulous color and contrast opportunities that exist.

Fabulous early morning light is on an ever-changing timetable. The morning light of mid-May in Italy has a personality of its own. Though light will vary every day, based on ambient conditions and changes in the sun's angle, scouting it the day before can be invaluable in ensuring a highly productive shoot.

LIGHT SOURCE/MODIFIERS
• Natural diffused light

Nikon D200, AF-S DX VR Zoom-Nikkor 18-200mm F3.5–5.6G IF-ED at 38mm (35mm equivalent: 57mm), Aperture Priority mode: ISO 200, 1/90 sec. at f/5.6; processing in Adobe Camera Raw and Adobe Photoshop by Brian Stoppee | Photo by Mike Pocklington

SOFTENING A WOMAN'S LIGHT

Light can be very gender-specific. Depending on your assignment, what the lighting says about a woman must often be different from what it says about a man. And children require a light of their own.

Study your subject's facial qualities and develop in your mind what makes them look their best. Mike Pocklington had a special way of shaking the hand of the models he shot and looking warmly into their eyes with an assuring gaze, conveying that he was about to make them look better than they'd ever been seen. Before he shot the first frame, Mike made sure the models felt as comfortable with him as if they were old friends. Whenever we called models back for another session, they were always delighted. Mike always got the best out of models; they came prepared for a good time.

Soft, diffused, warm tones make a positive statement about a woman. When we shot Luciene Pereira, on the right, Mike had never met her before. After some warm-up shots, Mike and Luciene developed a trust that evolved into a special chemistry. This is an ideal situation. When the models, the photographer, and other team members work toward the same goals, everyone can contribute their maximum creative energy—and the results show.

On this early afternoon, Mike found just the right patch of naturally diffused illumination. The softness of the light reduces the contrast in the brightly colored fabric of Luciene's skirt. Though the model has naturally soft, beautiful facial features, the diffused illumination creates a kind, gentle interpretation of her face.

This shot was taken in light that is typical of what many photographers look for to show a woman at her best. It covers any wrinkles or other imperfections of the skin. In chapter 5, we show you how to create this kind of light even when it doesn't exist.

It's essential that the model feel great comfort. Even some of the best models take a little while to warm up. When the light is ever-changing, take this into account as you plan a shoot based on the light of a specific part of the day.

LIGHT SOURCE/MODIFIERS
• Natural diffused light

SUPPORT
• Gitzo Mountaineer Tripod
• Gitzo Off-Center Ball Head

Using Nature's Light

Nikon D2x, AF-S VR Zoom-Nikkor 70–200mm F2.8G IF-ED at 75mm (35mm equivalent: 112mm), Shutter Priority mode: ISO 100, 1/125 sec. at *f*/2.8; processing in Adobe Camera Raw and Adobe Photoshop by Brian Stoppee | Photo by Mike Pocklington | styling by Tracey Lee

HARDENING A MAN'S LIGHT

Although we refer to flattering light for a woman as "soft" and that for a man as "hard," this is not to say that male light needs to have a coarse appearance. In fact, some men may require softer, diffused illumination to look younger or more approachable. But many young men—athletes, for example—want or need a more masculine appearance than their youthful faces allow. Photographers also help many models and actors develop and refresh their portfolios. If a guy is not getting calls for projects that require an older, more masculine feel, a good photographer can come up with ways of lighting the shoot that can convey that quality to potential clients.

An excellent approach for achieving this is side lighting, which illuminates one side of the face while allowing the other to be a bit darker. In the shot on the right, Tracey used harsh midday light to her advantage. She depicted David Winning in a both diffused and contrast-oriented light.

An actor from Philadelphia, David appears in what could be a fashion shot. We see the cooler, even light on one portion of his face and more colorful light from the direct sunlight on his hair and across his shirt. To offset the diffused areas with richer colors, Tracey used a gold reflector to kick back just a little more warmth on David's cooler spots.

The direct illumination falls on the portion of his shirt near where he's carrying his jacket, and the reflector adds nice warmth to the shirt's opposite side. Notice the interest that the combination of cool and warm tones creates over the texture of the white shirt, which accentuates the way it flows over David's torso. This demonstrates that David is a fit model who wears wardrobe well. For a fashion shot, white shirts can look kind of boring. However, Tracey made this one look visually enticing through her use of multiple light sources. The effect is subtle—the untrained eye wouldn't notice it—yet it compels the viewer to take a second look.

Adding a reflector requires a good strong source of sunlight. When bouncing light into a shaded area, an assistant may need to hold the reflector at a bit of a distance from the subject. If the reflector is warm, it can add a nice contrast to the cool light of the shade.

LIGHT SOURCE/MODIFIERS
• Midday light
• Westcott 42" Sunlight Illuminator

Nikon D2x, AF Zoom-Nikkor 70–300mm F4–5.6D at 70mm (35mm equivalent: 105mm), Manual mode: ISO 100, 1/125 sec. at *f*/7.1, Gossen Starlite meter; processing in Adobe Camera Raw and Adobe Photoshop by Brian Stoppee | Photo and styling by Tracey Lee

A CHILD'S LIGHT

Some shooters specialize in photographing children, which takes the ability to establish a special rapport. Not everyone can pull it off. Tracey's secret is to make the shoot fun.

If children are on an adventure, they'll come up with more photographic opportunities than you can dream of. Be ready—you never know what you'll get. That was the case on this shoot. The children were having a great time, but it wasn't where we had the lights set. Collin Handy was having so much fun with Tracey that he wanted to peep at her through a nearby fence. In the image, the pickets acted as reflectors, bouncing light back into Collin's multi-faceted blue irises, and Tracey grabbed the shot.

Whether you shoot for commercial or consumer purposes, you'll want to consider how to light children. As with women, children are often illuminated with a very soft light that communicates the kind and gentle nature we associate with young folks. Photographing children in harder light sends a different message that may be effective for editorial photography—for example, in depicting young people who have been abused or neglected.

In chapter 5, we'll discuss using scrims and diffusion fabrics to provide softer light when it is not available from natural sources. Since kids are usually in motion, the larger the diffusion tools, the better. We suggest frames offered by Chimera, Matthews, and Westcott that create an area of diffused light as large as 12 feet x 12 feet. Children quickly learn to stay within the pool of soft light the diffusion creates, and you often get to climb under the frame and play around with the kids on their level. That's how great image-making begins.

If you're someone who enjoys playing with children and they have a great time with you, there's a good chance you'll be terrific with child photography.

It's difficult to coach young children the same way you direct adults. It's best to set up a large, softly illuminated work area and encourage them to have a good time while you capture them having fun. You need to work fast since their high energy can quickly peak.

LIGHT SOURCE/MODIFIERS
• Morning light

Nikon D2x, AF-S VR Zoom-Nikkor 24–120mm F3.5–5.6G IF-ED at 120mm (35mm equivalent: 180mm), Aperture Priority mode: ISO 100, 1/100 sec. at f/5.6; processing in Adobe Camera Raw and Adobe Photoshop by Brian Stoppee | Photo and styling by Tracey Lee

MIDDAY

The light of midday can be the most difficult to work with. Since it's directly overhead, it creates shadows in eye sockets and under the nose and chin. You either need fill light or diffused illumination to combat this problem. Some photographers choose neither; they just don't shoot outside from as early as 10:00 A.M. to around 2:00 P.M. When you're on an all-day shoot, this is a good time to move the work indoors.

Other shooters get in gear and can't find the off-switch. Once they begin to shoot and their creative juices are flowing, they're in no mood for an extended break. Mike Pocklington was one of those photographers. He'd continue to shoot until his body signaled that the workday was over hours ago.

In the image on the right, Mike used the overhead midday light to his advantage. What doesn't work for humans can be fabulous for other objects. If the primarily white produce were illuminated by soft light, the shadows would be less distinctive. The objects would not separate from one another as well, and the scene would be less dramatic.

Midday light also provides a fair amount of contrast. Note the highlights on the tops of the carrots and onions. The white edges are so intense they blow out the details.

You can sometimes use midday light to your advantage, even for people photography. Turn your model around so the direct light comes from behind, creating a backlight effect that gives the hair something of a halo and provides the image with a great deal of dimension. You can also sometimes harness this light with a reflector, as discussed in Chapter 5. However, light from a reflector can fool the best in-camera meter system. As discussed on page 58, this is where a great light meter is important and incident readings are essential.

My suggestion is to not run from midday light but to make the most of it if your creative energy is in gear. Find solutions to lighting challenges. If the location isn't perfect, make a quick move. You can always come back later. If you're working with models, don't allow their enthusiasm to lapse. Keep your team excited and your yield will be high. This is especially important if some of your people are on the clock. Make every moment count.

There's no light that you should be afraid of. With the right tools, an understanding of how to make the most of technical challenges, and the ability to be a creative problem-solver, you can make the harsh side of midday light into a fabulous opportunity.

LIGHT SOURCE
• Midday light

Nikon D200, AF-S DX VR Zoom-Nikkor 18–200mm F3.5–5.6G IF-ED at 70mm (35mm equivalent: 105mm), Aperture Priority mode: ISO 200, 1/30 sec. at f/5.0; processing in Adobe Camera Raw and Adobe Photoshop by Brian Stoppee | Photo by Mike Pocklington

EARLY AFTERNOON

The sun's angle is perfect for backlighting in the early afternoon, especially with blondes.

If you took a lunch break while the sun was directly overhead, now is the time to get back to work. This is when nature's illumination has the gradual angle and color changes for some keen visual punch. Some photographers schedule a talent call for 1:00 or 2:00 P.M.; the models are in makeup and wardrobe for an hour, and then they shoot from 2:00 or 3:00 P.M., until the light of the day fades.

Mike Pocklington loved to take advantage of afternoon light, and that's exactly what he's done here with the Katie May, Jaime Etheridge, and Melissa Robinson, a trio of tennis pros who are sisters. These gals need little direction; you just get them together and photograph them having fun.

Shooting from the other side of a small pool, Mike determined that he had sufficient depth of field at $f/4.0$. So he set the camera to Aperture Priority and allowed the camera to select the shutter speed. But he didn't stick entirely to the camera's "decision." He also took incident readings and discovered the need for an exposure compensation of a third of a stop, ensuring that he'd capture the specular highlights in the backlight plus the water's reflections.

To make the most of the exposure, Mike had one of us position a Westcott Scrim Jim to reflect light back on our trio. As discussed in chapter 5, using this 8 x 8-foot frame is like placing a large white panel off to the side. Not only does the sun's illumination create a fabulous hair light; it also strikes the panel and redirects the light toward the three sisters. This setup made for an even, well-illuminated scene, minimizing any unwanted shadows while bringing out plenty of detail.

The characteristics of afternoon light vary, based on where you are located on the planet, the time of year, and various environmental conditions. At this point in the day, the light can begin to fall lower in the sky and will offer a more fully formed backlight than that of the midday sun.

LIGHT SOURCE/MODIFIERS
- Natural back light
- Westcott Large 72" x 72" Scrim Jim
- White Scrim Jim Fabric (as reflector)

SUPPORT
- Gitzo Mountaineer Tripod
- Gitzo Off-Center Ball Head

Nikon D2x, AF-S VR Zoom-Nikkor 70–200mm F2.8G IF-ED at 86mm (35mm equivalent: 129mm), Aperture Priority mode: ISO 100, 1/80 sec. at ƒ/4.0, Gossen Starlite meter; processing in Adobe Camera Raw and Adobe Photoshop by Brian Stoppee | Photo by Mike Pocklington | Styling by Tracey Lee

LATE AFTERNOON

Right before the sun sets, it produces a beautiful warm illumination that some photographers refer to as "sweet light." Your window of opportunity for capturing this light lasts for only a matter of minutes, depending on location and sky cover. From one late afternoon to another, you can never quite predict what the sky will offer. It's all a matter of atmospheric conditions.

For this shot of one of our all-time favorite teen models we metered extensively before we began. As Charlsey Kauffman hung out the window of a vintage pickup truck, we developed a sense for the very shallow depth of field we wanted. At f/5.3, our attention is focused on Charlsey, her daffodils, the tall grasses immediately below her, and the vehicle's classic mirror. The rest of the foreground and background elements are tossed out of focus.

With Aperture Priority in place, changes to the day's diminishing light are altered through shutter speed, while the sensitivity and aperture remain fixed.

Typically, the light of late afternoon is associated with side light, which has angular qualities. Left unmodified by reflectors, side light is often associated with men. When light modifiers are employed, however, side light can create a softer effect. For this photo, we chose a location that was softened by surrounding trees. The natural environs of our setting trumped the hard edges of the sidelight, and our model benefited from a gentle, velvety illumination that matched her sweet, wholesome features.

The warm, yellow-orange light is cooled a little by the trees' shade, though it makes Charlsey's tan all the warmer and does the same for her hair, the grasses, and the iconic springtime blossoms she holds.

The very shallow depth of field we wanted came from the beautifully compressed optics of a Zoom-Nikkor 80–400mm. It provided an equivalent focal length of a 330mm lens. This rivets our attention on the model and the romantic, warm light, making the foreground and background melt away from our immediate attention.

LIGHT SOURCE/MODIFIERS
• "Sweet light" of the setting sun

SUPPORT
• Gitzo Explorer Tripod
• Gitzo Off-Center Ball Head

Nikon D2x, AF VR Zoom-Nikkor 80–400mm F4.5–5.6D ED at 220mm (35mm equivalent: 330mm), Aperture Priority mode: ISO 100, 1/320 sec. at *f*/5.3, Gossen Starlite meter; processing in Adobe Camera Raw and Adobe Photoshop by Brian Stoppee | Photo by Brian Stoppee | Styling by Tracey Lee and Robert Young

FIRELIGHT AND CANDLES

The light of a fire or the glow of a candle can inspire a romantic mood. The color of the light casts a warm, comforting tone. Since the glow falls off quickly, the light is confined to a relatively small space, promoting an even greater sense of coziness. With this limited kind of light you will need to draw models even closer together.

With a temperature of somewhere around 2,700 K, candles emanate a warmth that produces enough light to be photographed with a dSLR. For the full-size sensor in a Nikon D3x, D3s, D3, or D700, it is not a problem to increase the sensitivity to levels that are quite high without risking a noise buildup.

Even with the Nikon D2x, Tracey was able to shoot as slow as 1/5 of a second and still obtain a noiseless image of this candle's glow, enhanced by a Westcott daylight fluorescent Spiderlite on the lowest power setting. (See chapter 7 for more on daylight fluorescent.)

When flames are the primary light source—whether the light of a single match, a thinly tapered candle, or the roar of a robust fire in a large fireplace—a photographer needs to do a little testing to get a perfectly exposed image. This can be challenging since some types of flame last only a few seconds. The wrong exposure can register the fire as a completely white, overexposed blob. Here, Tracey was able to capture the glow of not only the flame but also the illumination from within the pillar of the candle—all enhanced by the warmth of the setting. The candle's flame draws the viewer's attention into the composition. The colors of the candle and flame are repeated in the flowers, conveying an even greater sense of a gentle, fragrant atmosphere. The small blossoms provide a feeling of delicacy and intimacy that we immediately relate to as elements of a romantic moment about to happen. Much of this effect comes from the color of the light.

Capturing a flame can be technically allusive. In some cases, the light source is over before you have begun shooting. With a diligent plan to set up and test, you can get yourself enough into the exposure ballpark to capture photos.

LIGHT SOURCE/MODIFIERS
• Candlelight
• Westcott TD5 Spiderlite
• Westcott 24" x 32" White Soft Box

SUPPORT
• Gitzo Mountaineer Tripod
• Gitzo Off-Center Ball Head
• Matthews C-Stand

Nikon D2x, AF Zoom-Nikkor 70–300mm F4–5.6D at 190mm (35mm equivalent: 285mm), Manual mode: ISO 100, 1/5 sec. at f/4.8, Gossen Starlite meter; processing in Adobe Camera Raw and Adobe Photoshop by Brian Stoppee | Photo by Tracey Lee

NIGHT LIGHT

Once the sun has set, the sky continues to glow. As the moon rises and becomes more prominent in the darkening sky, a fascinating contrast develops. The deep blue sky, if properly exposed, tosses its cool light upon objects in the scene you want to photograph.

As warm tungsten light glows from the windows of houses and stores, an even more compelling color relationship evolves. Various artificial light sources are rarely the same color, but don't try to fight it; just enjoy the diversity. Your photographs become a palette filled with varying color temperatures. Once you've developed the power of selecting your own white balancing, you can choose how to render the image's color correlations.

How should you meter scenes of nightlife? There's a great deal of experimenting involved. We have had the most success by taking a measurement of light falling on faces from a street lamp or of illumination that spills from the windows of shops and restaurants.

Enjoy the motion of nightlife by experimenting with your shutter speed. If you metered a nighttime scene at f/5.6 at a quarter second, try leaving the shutter open for twice as long but closing the aperture down an additional stop, giving you f/8.0 at a half second. You might capture a pleasing blur of passersby in motion and other indistinct human forms. The longer your exposure, the less detail you'll be able to pick up from passing vehicles, and a cityscape can take on a faceless quality.

The glow of captivating, colorful signs can add an enjoyable whimsy to a scene. The coffee cup shown here was impossible to pass up, especially with a steaming moon rising behind it. Some of the sign's missing lights told even more of the story. This was a tough shot to meter, and we relied on bracketing to ensure that we got the perfect exposure. And it was hardly a "grab" shot. We patiently waited, as the sky darkened, until the light from nature was properly balanced with the artificial lights.

Photographs of nighttime scenes intrigue viewers. The images freeze what the human eye cannot see, especially when blurred motion is involved. Creating the right color and exposure balance of the sky and the earth, even if for only two or three minutes, can often result in the image your mind's eye envisioned. It's a game that patient photographers play well.

LIGHT SOURCE/MODIFIERS
• Evening light with the rising moon

SUPPORT
• Gitzo Mountaineer Tripod
• Gitzo Off-Center Ball Head

Nikon D2x, AF Zoom-Nikkor 20–35mm F2.8D at 35mm (35mm equivalent: 52mm), Manual mode: ISO 100, 2 secs. at f/8.0, Gossen Starlite meter; processing in Adobe Camera Raw and Adobe Photoshop by Brian Stoppee | Photo by Brian Stoppee

MODIFYING LIGHT

We've been discussing nature's illumination as a prelude to how we make it all happen with the many professional tools that are available.

The best tools either harness ambient light or manipulate artificial light sources to imitate what nature does every day. Oddly enough, the more you explore the intricacies of what great light modification tools do, the more you understand what happens in nature. The entire experience builds your skill set as a photographer.

Photography shares a few artificial lighting sources with broadcasting and filmmaking (such as HMI and daylight fluorescent, discussed in chapter 7). But when it comes to light modifiers, all image-makers work out of the exact same toolbox. The brilliant minds who create these tools get feedback from not only top professional photographers but also the best of Hollywood and those who cover news and sporting events.

The most accomplished professional photographers avoid focusing their work on just one or two of these modifiers. They learn to master as many as possible, so as to be ready to create any look in response to the subject, location, and ambient lighting. The more tools you become familiar with, the greater the number of lighting solutions that can develop in your mind. The tools become a key to open your creative inspiration.

Professional photographers have a huge arsenal of light modification tools at their disposal. Motion picture companies have truckloads of them. They are some of the most creative resources an image-maker has at his or her command and can turn a potentially disastrous situation into dream light.

HOW NATURE DOES IT

On the next spread, we begin to explore Westcott Illuminators, one of whose functions is to reflect light. As background for understanding how an Illuminator works, observe the light that occurs following a snowfall, which essentially creates the same effect. On most of the planet, there are more days without snow cover than there are with snow cover. When the light strikes snow and reflects it, the sight literally turns our vision upside down. Normally, a fair amount of the light that falls upon Earth is absorbed. When skylight strikes snow, however, most of it is reflected.

When you see a model dressed for winter, carrying ski gear, you expect some illumination to be coming up from the ground as well as from above. Some studio-based winter fashion shots miss this realistic aspect. There are also times when nature works against a photographer's best interests. Just as snowfall blows white reflections upward, green grass also reflects its color properties. A face close to grass on a sunny day can have a green neck, often a less-than-appealing effect.

At other times, ambient conditions are perfect, but what nature offers can cause you to choose the wrong exposure. Snow plus direct sunlight is a deceptive situation in which using your in-camera meter often results in an image of gray snow. That's easily corrected in post-processing, but what's sometimes difficult to correct are people in a snowy scene. If the snow is gray, chances are good that the facial features are so dark that post-processing may be unable to reclaim acceptable details. To make matters worse, if the sky's cloud cover is changing, your exposure will also need to change. In these situations, it is best to keep a light meter hanging from your neck and to take frequent incident readings.

If the main story is the snow, you'll need to make exposure compensations. A good way to ensure great exposure in snow is to quickly shoot a series of brackets and check the results on a great computer display. Once you identify a perfect exposure, use that as your norm; as the ambient light changes, adapt your exposure up or down from there.

Unlike the typical light sources, which come from above, behind, or the sides, snow reflects the light that strikes it and bounces it back from below.

LIGHT SOURCE/MODIFIERS
• Early morning light

SUPPORT
• Gitzo Mountaineer Tripod
• Gitzo Off-Center Ball Head

Nikon D2x, AF-S VR Zoom-Nikkor 70–200mm F2.8G IF-ED at 125mm (35mm equivalent: 187mm), Manual mode: ISO 100, 1/60 sec. at *f*/2.8, Gossen Starlite meter; processing in Adobe Camera Raw and Adobe Photoshop by Brian Stoppee | Photo by Brian Stoppee

THE ILLUMINATOR

When you're photographing a model as gorgeous as Heather Williams, the light has to be perfect. This image is an excellent case study in why ambient illumination is not sufficient.

As the illustration below shows, all it took was one Westcott 52" Illuminator to reflect back sunlight onto the image's right side. We selected the gold side of the Illuminator to create the wonderful warm tones of early evening, even though we shot this at midday. The goal was to create the look of an outdoor café.

Imagine the same image without the Illuminator. One side of Heather's face would have fallen into shadow. We would never have picked up on the fabulous contours of her neck and jawline. Heather was positioned precisely so the light would fall on her face, exactly where we wanted it, and we added the feature of the pasta creating a shadow on her arm.

Your crew will probably need a little practice using the Illuminator until your assistants fully understand how to properly position it. In these situations, your assistants need to be able to see the same way you see. They need to understand your vision. Some people will pick up on it right away, while for others it may take some time.

An important aspect of this image is to focus the viewer's attention on the very narrow plain that runs from Heather's chin to her forehead. We did this with an 85mm *f*/1.4 lens. After extensive testing with a stand-in, we put the camera in Aperture Priority mode to leave the lens wide open, allowing it to choose a shutter speed that avoided motion blur.

A reflector like the Westcott Illuminator is a perfect, flexible tool to harness ambient light and redirect it back to the subject.

LIGHT SOURCE/MODIFIERS
• Midday light
• Westcott 52" Gold Illuminator

SUPPORT
• Gitzo Mountaineer Tripod
• Gitzo Off-Center Ball Head

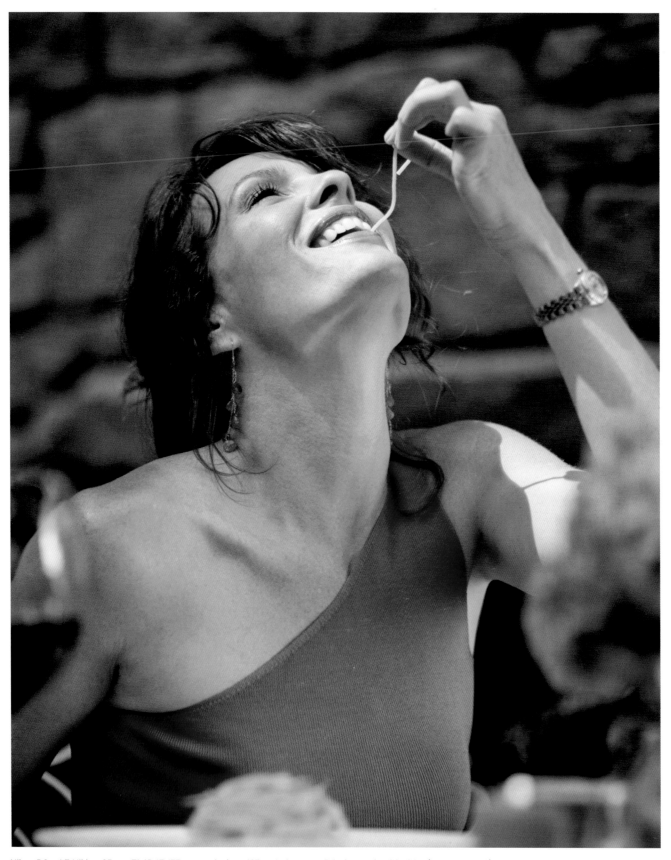

Nikon D2x, AF Nikkor 85mm F1.4D IF (35mm equivalent: 127mm), Aperture Priority mode: ISO 100, 1/2500 sec. at *f*/1.4; processing in Adobe Camera Raw and Adobe Photoshop by Brian Stoppee | Photo by Brian Stoppee | Styling by Tracey Lee

REFLECTION TOOLS

As we mentioned on the previous page, the Westcott Illuminator is a great tool to use on location or in the studio to reflect light. As discussed below, it can also be used to diffuse and flag light.

Once you unzip the relatively small case that the Illuminator is stored in, it pops to a much larger size than the case itself. The smallest is just 14 inches across but fits into a case that's 5 inches, whereas the big 52-inch "6-in-1 Kit" has a case that's only 20 inches across. Inside the 6-in-1 are two of the round-cornered panels, but when you unzip the one that's gold on one side and silver on the other, you'll find that it's reversible to black and a "sunlight" that's a blend of gold and silver. Or strip away the four-sided exterior slipcover and you have a diffusion panel that cuts light by one stop. The sixth option is a second diffusion panel that reduces the light by two stops. Westcott Illuminators are also available in 20-, 30-, and 42-inch sizes.

Another of our favorite reflection devices is the Matthews 24" Hand Reflector. This is a hard panel on a yoke that can be placed on a stand. It flips around, exposing a mirror-like surface on one side and a crinkled silver surface on the other. The mirror has a greater intensity, while the other side casts a more diffused reflection. It's nice being able to position this reflector exactly as you need it, then to just step back and start shooting.

Please see page 130 for the various reflection materials from Rosco. These sheets easily clip to the Matthews 24" Hand Reflector, making it all the more versatile.

The techniques for reflecting light and diffusing it are not dramatically different when using the various sizes of Illuminators. It's all in how you hold the tools and what you want them to do. When you're reflecting light, you want to find the incoming angle of illumination and position the reflection panel just to the right of it, in order to toss that light back to the subject in just the right place. Keep in mind the discussion on page 19 about how the angle of incidence equals the angle of reflection.

It's not as difficult as you may think to get an Illuminator back into its case. Start by bending it inward (left). Then curve it into three stacked circles (right), and you're on your way home from a day of shooting.

DIFFUSION TOOLS

To diffuse light is to eliminate the harsh edges that direct illumination can cause. Think in terms of a bright, cloudless day when the sun is directly overhead. Everyone has deep shadows under their eyebrows.

A diffusion panel comes to the rescue in conditions of harsh light. Unlike the reflector, the diffusion panel is placed between the light source and the subject. It's positioned and angled to make optimal use of the panel's size.

On page 98, we look at diffusion frames, which act like large versions of the Westcott Illuminators. Unlike a handheld 3- or 4-feet-square diffusion panel, these frames can be as large as 12 feet x 12 feet and are supported by very heavy-duty light stands and plenty of weight.

When using a panel to reflect light (left), it's best to understand that the angle of the incoming light equals the angle of light being reflected back on the subject. When diffusing light (right), the panel comes between the light source and the subject, trading harsh illumination for a softer, more even light.

FLAGGING TOOLS

Flagging involves using a panel to block all incoming illumination from a light source. It keeps the background illumination as an important element and allows the photographer to balance the background with artificial illumination sources for the subject.

Flagging is popular outdoors—for example, when the incoming light is so harsh that diffusing it is not enough. We often see this done with broadcasters covering sports. The sportscasters, sitting at an outdoor anchor desk, would be squinting at the cameras if they were positioned in direct sunlight. Large flags block all natural light from falling on them. In such situations, photographers either use artificial illumination that balances the exposure of the natural light or place a diffusion material, known as a scrim, behind them, which reduces the background's intensity and requires less artificial light on the subjects. As elaborate as this may sound, it is not unusual for professional photographers to use a similar setup when shooting on location.

Flagging panels are usually black. This ensures not only that the panels are opaque enough to fully block the light, but that they can handle the needs of subtractive lighting.

SUBTRACTIVE LIGHTING

There are situations in which you can carefully fine-tune a lighting setup by using a panel to absorb illumination. Such a panel is particularly useful when there's a fair amount of light spilling around a set and you want an area of your subject to go into shadow. With light bouncing off walls and other surfaces, it can be tough to control a shadow, especially when on one side of the subject you want plenty of soft illumination from a large light bank. The combined use of flagging panels and light banks can create a sense of the soft and the mysterious.

ROSCO PHOTOFOIL AND CINEFOIL

Sometimes a panel just can't do what you need. For example, absorbing a little light doesn't work with a flat surface. Rosco, the premier maker of colored gels and other theatrical materials, offers a matte black material called Photofoil that is far thicker and more rigid than the rolls of aluminum you use in your kitchen. It remains so firm that you can bend it into a shape, and it practically stands up on its own. The rolls are 10-feet long and either 1- or 2-feet wide. Cinefoil, popular with filmmaking grips, is similar but it's 4-feet wide.

Both of these products are reusable. Roll out the material to achieve the exact effect you're looking for, then roll it back up after the shoot. Photofoil and Cinefoil are also great for eliminating unwanted reflections.

Flagging involves using a panel to protect the subject from all harsh illumination coming from one direction. It preserves the background illumination and allows other light sources to command the image.

THE DIFFUSION FRAME

Professional photographers, filmmakers, and broadcasters sometimes augment the use of handheld panels with much bigger reflection, diffusion, and flagging tools. The backbones of these popular panels are frame systems that fit into a convenient duffle bag but erect to sizes ranging from Chimera's smallest, which starts at a couple feet square, to a 12 feet x 12-feet square from Matthews.

These often-essential products go by various names. Chimera calls them "panels" and "frames." Westcott has their Scrim Jim, and Matthews calls theirs "overheads" and "butterflies." Each has its own way of wrapping fabric over the frame. Chimera's fabrics have stretchy corner backings that quickly go together (as shown here). The Scrim Jim uses Velcro-like material. Matthews's fabrics include grommets to strap them to the frame.

What they all have in common is the need for two heavy-duty stands for support and some means of pivoting the frame over 360 degrees. Chimera and Matthews use a couple of Matthews Grip Heads (Westcott includes a similar product). Shown at right, the Grip Head fits on top of the stand and attaches to the frame (see page 140 for more on the Grip Head). Mount one head on either stand, loosen them up a little, and choose the angle that provides optimum results. Once the heads are in place, raise the stands to the preferred height. Since some good, sturdy stands can rise to over 10 feet, it's not unusual for the top of the frame to be 12 to 15 feet above the ground. For this reason, safety is of the utmost importance. A little breeze can easily topple one of these rigs, and they need to be carefully weighted. We do this even when we use them indoors. See page 139 for available weights and bags for this purpose. Always take care of your equipment, but more important, watch out for the well-being of all personnel on the set. If it's getting too breezy, strike the frame, and take a break.

Set up a frame system with great care. Always have an eye for safety.

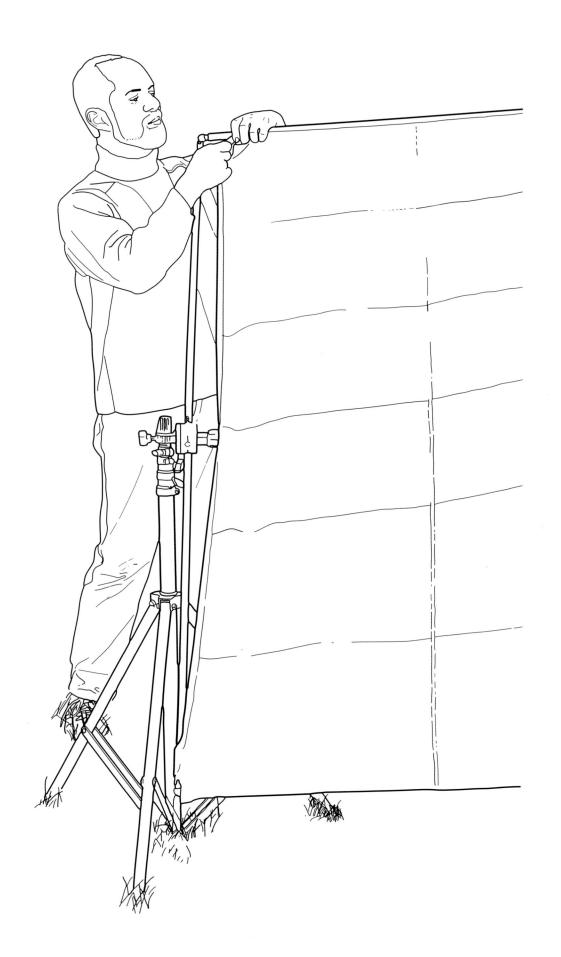

LIGHT TENTS

How do you photograph a shiny object like a watch and get an even reflection all around it? There are quite a few solutions to that photographic challenge. One used by many image-makers is called a light tent.

You can attempt to carefully craft one of these yourself every time you do a shoot, or you can buy a flexible one in the exact size you are looking for and use it repeatedly.

A tent is like a big translucent cone with a circular base and a tip that is ideally held up by a light stand with a boom. One side zips open just enough for a lens to peek through. When photographing a spoon, for example, you may want an even reflection over the entire polished surface. When the surface reflects only the tent, the reflection of the camera doesn't spoil the image.

If you want an even reflection, assemble light sources all around the tent. If you are after a little more visual drama, light from just one side. If the light source outside the tent is soft, the results inside will be soft, too. The same is true of harder light sources. The tent is a creative tool that can help you achieve the dramatic effects your imagination desires.

Westcott has light tents with 20-, 40-, and 60-inch bases. Respectively, they are 21, 54, and 48 inches in maximum-possible-height. Usually you can determine the proper tent size based on the size of the background or the height of the subject.

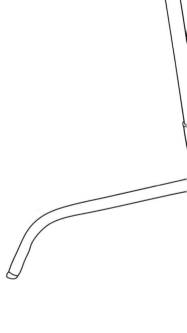

If you place an object with reflective surfaces inside a white tent, those surfaces can take on the smooth, even properties of the tent.

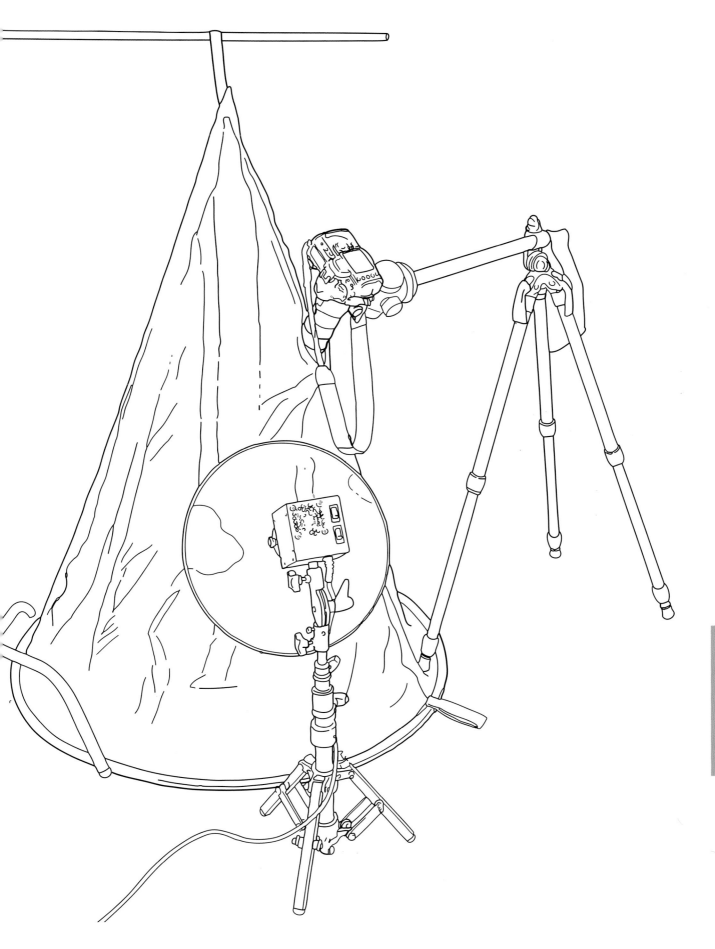

TINY REFLECTORS AND DIFFUSERS

Other useful tools for still life photographers are tiny reflectors and diffusers. Still life photography requires a great deal of patience and finesse, and a love of perfecting a setup.

Just as Westcott offers illuminators that reflect and diffuse light for use with larger subjects, they also make smaller versions. Matthews calls their round ones "dots" and their rectangular ones "fingers." Each dot has a little metal frame covered with gold, silver, or a diffusion fabric. They resemble 3-, 6-, or 10-inch lollipops. The pin fastened to the base fits into one of the Matthews Grip Heads or Flex Arms, which then attaches to a stand or other support system. (See pages 140–141 for some of the support tools Matthews provides to hold these tiny tools in place.) The dots with diffusion material are also great to place in front of lighting instruments to fine-tune the light quality.

The fingers are 2 x 12 inches or 4 x 14 inches, and work the same way. Precisely adjust either of them until the results are exactly what you want.

Matthews's dots (left) come in three sizes and are available in reflective materials and a variety of diffusion fabrics. They're great at manipulating light at the subject's level or, when covered with diffusion fabrics, for placement in front of a lighting instrument. The fingers (below) work similarly to create excellent strips of reflection on shiny products.

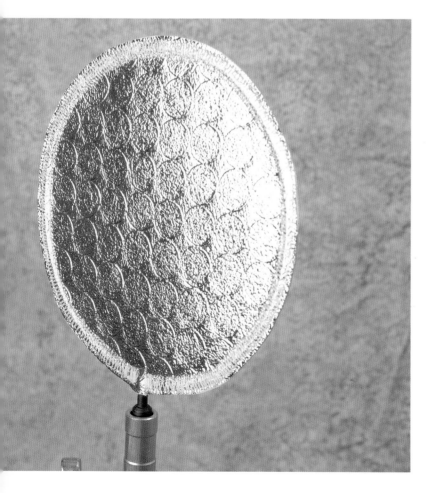

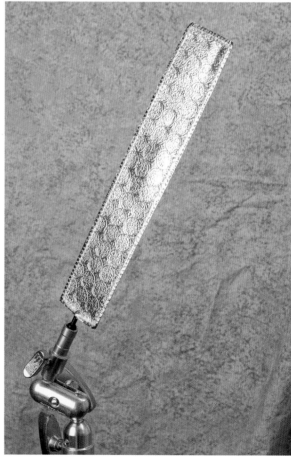

SHUTTERS AND TOP HATS

Many light modification tools have been invented in the past few decades, but photographers still use some devices that are as old as (if not older than) electrical lighting instruments used for theatrical productions.

What we call "barn doors" today were once known as "shutters." Some photographers, grips, and stage lighting designers still use the terms interchangeably. These devices are analogous to hinged architectural elements in the sense that they can be adjusted to remain open to the exact position that's required and readjusted at whim.

There are some two-way barn doors, but for the most part barn doors come in four-way configurations. Often two flaps are larger, and a second set is small enough to fit inside the bigger ones. A good barn door should be able to rotate 360 degrees over a round lighting instrument's reflector or front end. Between the positioning of the doors and the rotation of the entire assembly, you should be able to adjust the light so that it does not "spill" into places you do not want it to go. Some barn doors, like those from Novatron (pictured here), allow the panels to be adjusted so they expand and contract as needed, making the flexibility of this accessory all the more precise.

The doors on a barn allow livestock to be held inside or to wander into the open. The "barn door" on a lighting instrument does the same with light: it's either contained or allowed to roam freely.

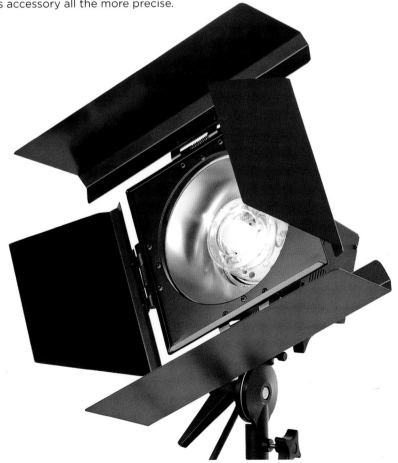

Most barn doors can also serve as "gel holders" that permit a colored or diffusion material to be housed in front of the light source. A well-designed gel holder gives a lighting instrument some breathing room. Some photographers attempt to forego a gel holder and instead just tape colored media over the lighting instrument. The problem is that doing this can cause heat to build up and harm the light head or, worse, cause a fire. Many fan-cooled lighting instruments depend on that little bit of space that a gel holder provides between the end of the unit and the gel. In some cases the holder does allow a little extra light to spill, but for everyone's safety, you should resist completely covering the light.

Though some photographers place barn doors on lighting instruments that are not far off the ground, many position them on stands that can be raised quite a few feet in the air. It's easy for an elevated light head to catch a breeze or be jostled and fall down, possibly on your subject. So take care to properly secure lighting instruments. Be sure that a front-end accessory is properly attached to the instrument. Some accessories come with a safety cable that attaches to the light or support in case it comes loose.

Portrait photographers love to work with "snoots," which the theatrical world originally called "top hats" and "stove pipes." Some manufacturers have changed snoots from hat-shaped to cone-shaped. Instead of the back end of the hat blocking some of the light, the cone tends to funnel it. For shots of people, these accessories adapt a basic lighting instrument into a finely focused "hair light"; it skims just a little bit of light onto the subject's hair, from behind, to give a nice three-dimensional feeling. The Novatron snoot is adjustable, so you can "zoom" it out to narrow the beam.

HONEYCOMB GRIDS

A popular accessory for the adjustable snoot is the "honeycomb grid," which greatly tightens the pool of light and is very popular with table-top photographers, especially for product photography. This combination of a snoot and a specially designed honeycomb grid allows you to produce such tight and vari-able pools of light that it's possible to light an entire set with a series of these little spots, creating excellent highlights for a very dramatic look.

Larger honeycomb grid accessories have been popular with photographers for years. Like the small honeycomb that fits on the end of a snoot, they cover the lighting instrument's front end, just like a barn door. They are often available in various degrees of tightness. Some allow as much as a 90-degree spread of light and others can provide illumination as narrow as just 20 degrees. Photographers often have at least two of these on hand.

Like barn doors, most grids are also gel holders. Gels create colorful pools of light, some theatrical-looking and others so natural-looking that most viewers will not even notice they've been used. Adding color media to a honeycomb grid can give the appearance, for example, of sunlight streaming through an unseen window and caressing the shoulder of a model. For example, Rosco Cinegel #3411 Roscosun imparts a look of early morning sun over a bowl or carton of eggs for a lifestyle still life shot.

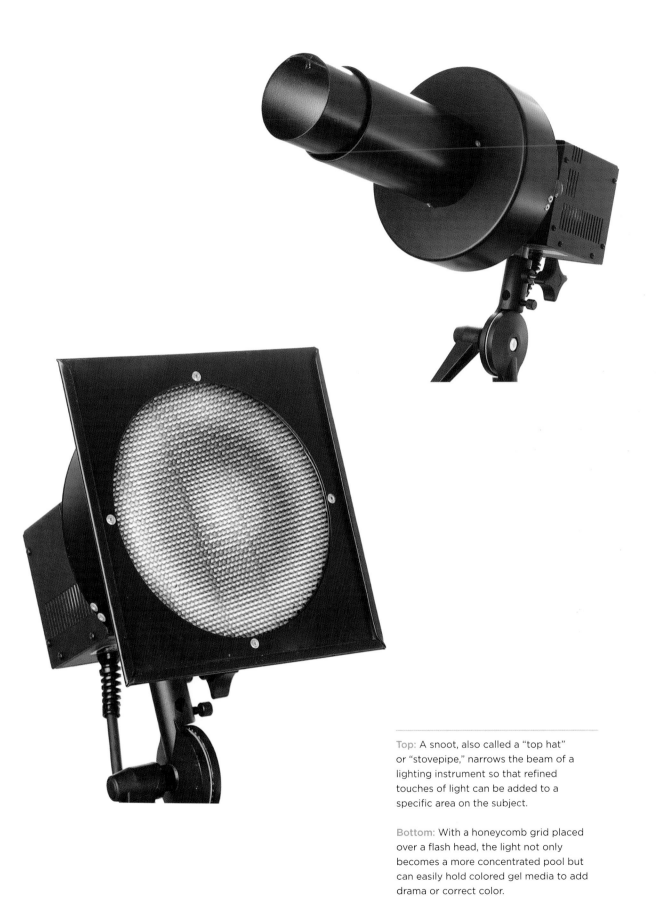

Top: A snoot, also called a "top hat" or "stovepipe," narrows the beam of a lighting instrument so that refined touches of light can be added to a specific area on the subject.

Bottom: With a honeycomb grid placed over a flash head, the light not only becomes a more concentrated pool but can easily hold colored gel media to add drama or correct color.

UMBRELLAS

Once associated with portrait studios, the umbrella has become one of the most universal and inexpensive light modification tools. An umbrella adds softness because of the way light can be projected into its parabolic shape, then bounced back in so many different directions. The resulting light tends to wrap itself around the subject. All sorts of photographic professionals use this simple and inexpensive device, for which manufacturers have developed many useful features.

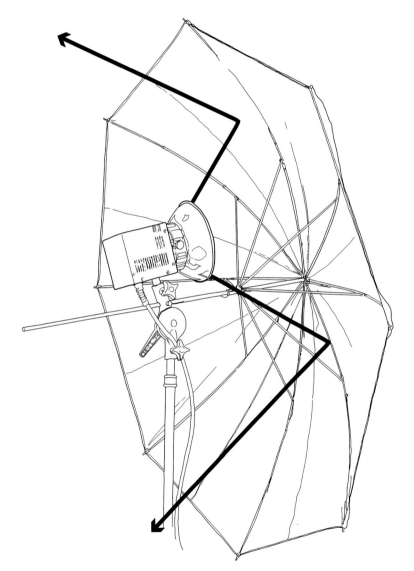

An umbrella's parabolic shape is what creates such soft light. The light scatters dramatically when it strikes the back, sending the illumination in many directions.

Westcott is the granddaddy of photographic umbrellas, which they've produced for decades. They make them from 32 inches (the measurement of the open end) to well over 6 feet tall. An umbrella is usually inserted into a lighting instrument placed on a stand. Colors include white, silver, and gold, and Westcott even makes "zebra" umbrellas, which we love, with alternating panels in white and silver or white and gold.

Some umbrellas are available with removable black back covers—an important feature since a fine optical white satin umbrella has a "blow through" factor. The light strikes the white surface and, for the most part, bounces back, though some light continues through the fabric, tending to bounce around the set and creating lighting conditions that are tough to control. The backing cover not only controls the light but also makes the umbrella more efficient; you get more light on your subject when the cover is on than when it's off.

If it's so efficient, you may ask, why would anyone remove the cover? Though many people use umbrellas to bounce light back, we often turn them around and fire light through them. Since the back of the umbrella is round, it directs light all over. It's excellent for broad,

soft illumination, especially as an outdoor source of fill light. If you're on location with a minimal amount of equipment, you can use umbrellas creatively to engineer many useful lighting setups.

FABRIC COLOR

Why do umbrellas come in so many colors? White is considered the purest of the umbrella fabrics. It provides a clean light that is reflective of the light source, producing unadulterated results. It's also the softest option. For that reason, a white umbrella is considered a flattering light source and may be the safest choice for photographing people as it minimizes wrinkles and other blemishes.

Silver also offers pure results, though it may not be as flattering for some subjects. The results are softened because of the umbrella's parabolic shape, but the light does not scatter as much as with a white umbrella. Some photographers use a silver umbrella as a main light and a white one as a fill. Others love the effect of silver umbrellas and use them extensively, sometimes ganging two or three of them together. This provides a more high-contrast lighting. Soft silver, something of a cross between silver and white, lessens the higher-contrast appearance.

Gold umbrellas add warmth while maintaining a crisp, sharp image. Some photographers like to use a gold umbrella as a main light and then soften the effect with a white fill-source umbrella. Zebra umbrellas also soften the effect of a metallic umbrella. On a zebra umbrella, half of the panels are white and the other half may be gold or silver.

SIZE AND FABRIC CONSIDERATIONS

Since umbrellas are so inexpensive, there's no reason for a photographer not to have a complete set of them on hand.

The larger the umbrella, the softer it makes the light. Yet this light quality comes with a price in terms of efficiency. Since a big umbrella's light spreads all over the place, the exposure will be less than with a much smaller umbrella.

The same is true for silver, which is more efficient than a white umbrella. If you replace a white umbrella with a silver one of the same size, you'll need less light output.

Once you've worked with umbrellas of varying sizes and fabrics, you'll develop a sense of which umbrella is right for each of your projects. Let the lighting needs of the subject make the choices for you.

MULTIPLE UMBRELLAS

Traditionally, portrait photographers worked with four light sources: a key light (the main), a fill light (often placed on the opposite side of the camera from the main), a hair light (to provide dimension), and a background light (to illuminate the area behind the subject).

Though there was nothing "traditional" about the innovative photography of Mike Pocklington, he had an excellent sense of the industry's foundational aspects. Mike's style was identifiable as "clean." The image to the right looks like it could easily be natural illumination, but it's lit entirely with four flash heads, all but one of which had an umbrella. The only head without an umbrella is the hair light, which gives dimension not only to Katarina's hair but to her wrist as well.

The key and fill light sources evenly illuminate the models, and their heads are positioned precisely so that the effect is not flat. Both light sources excellently define the models' facial structures and pop them out from the background.

Mike worked with three umbrellas to produce an even illumination, but he positioned the instruments in such a way to avoid flat-looking light.

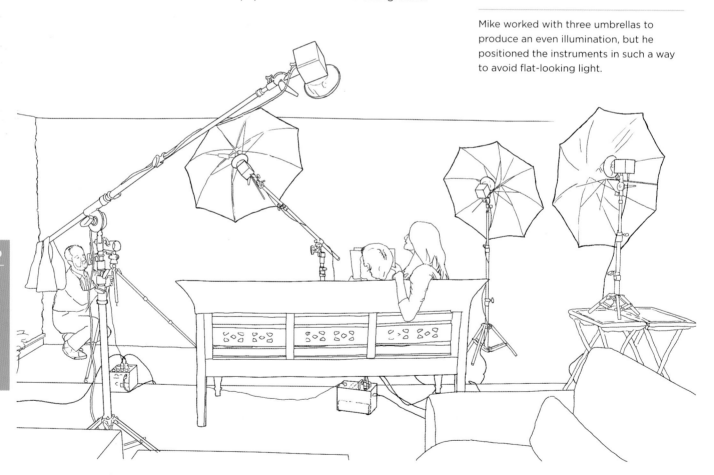

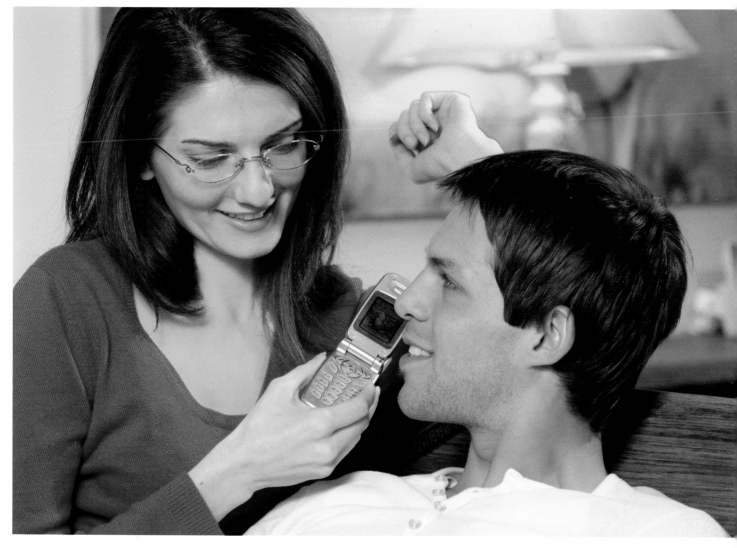

Nikon D2x, AF-S VR Zoom-Nikkor 70–200mm F2.8G IF-ED at 120mm (35mm equivalent: 180mm), Manual mode: ISO 100, 1/30 sec. at *f*/7.1, Gossen Starlite meter; processing in Adobe Camera Raw, and Adobe Photoshop by Brian Stoppee | Photo by Mike Pocklington | styling by Tracey Lee | talent: Katarina Luchan and Riad Rayess

Four-light-source portraits are easily achieved by setting them up as the traditional key, fill, hair, and background lights.

LIGHT SOURCE/MODIFIERS
- 2-Novatron 1000 Ws Digital Power Packs
- 3-Novatron Bare Tube Flash Heads
- Westcott 45" Silver Umbrella
- Westcott 45" Gold/White Umbrella
- Westcott 45" Silver/White Umbrella

SUPPORT
- Gitzo Mountaineer Tripod
- Gitzo Off-Center Ball Head
- Matthews Magic Stand
- Matthews Baby Stand
- Matthews Mini Preemie Baby Stand
- Matthews Baby Boom
- Matthews Boa Bags

LIGHT BANKS

Light banks have a long and somewhat sordid past. It's tough to know if they got their start with college students building them out of a lightbulb, some white poster board, a bedsheet, and masking tape, or if they began with commercial photographers who used more elaborate and expensive materials to concoct equally flammable devices in combination with somewhat costly flash heads. In either case, sooner or later most early light banks crashed and burned, often in the literal sense.

Today Chimera and Westcott lead the way in a crowded field of light bank makers. (Westcott calls them soft boxes.) Unfortunately, there are far more lousy light banks out there than good ones.

There are many excellent styles of light banks to choose from. If you shoot both in the studio and on location, you need something that sets up and strikes quickly. Unless you have settled on one type of light source that you plan to use for the rest of your life, you should try to buy a light bank brand that has an ever-growing speedring catalog for just about every known lighting instrument. (Speed rings, discussed on the next spread, connect the lighting instrument to the light bank.) Speed rings need to be very durable and easy to use. Chimera and Westcott specialize in metal speed rings.

Next, you need a light bank that's well-engineered. It not only needs to be durable, resilient, and heat-resistant; it should also be designed for maximum efficiency while producing an even light from center to edge. Some light banks have hot spots (more light in the center than at the corners). In the illustration at right, a flash head is installed on a speed ring. The head is a bare tube: It has no reflector, allowing the light to spread over 180 degrees. The speed ring is perfectly engineered for that specific flash head, and the flash tube is positioned precisely to take advantage of the light bank's shape to disperse light evenly. If the lighting instrument had a reflector, not as much of the bank's back properties would be called into play.

The light then gains more softness as it travels through one or two diffusion panels. (Some image-makers shoot with no diffusion panel, but that's not what the bank is really designed to do.) The more diffusion you use, the softer the result. The less diffusion you use, the more power output you gain.

Some banks include a substantial lip beyond the front diffusion panel. The lip directs the light a bit, but it also allows you to attach accessories, such as barn doors and grids (Similar accessories are discussed on pages 105–107.). The accessories quickly attach and detach courtesy of a Velcro-like material.

Light banks come in many sizes and with various backing materials. As with umbrellas, most sizes are available in white or silver. The effects they produce are similar. White is the softest option. Some image-makers like silver because it provides a little more contrast. Both Chimera and Westcott have light banks (Westcott calls them "soft boxes") that start at 12 inches x 16 inches. Chimera has a huge F2 light bank that is 15 feet x 40 feet. Great for shooting products as big as cars, it might require more than one person to assemble and disassemble. Standard light bank sizes are 24 inches x 32 inches, 36 inches x 48 inches, and 54 inches x 72 inches. It's not practical to buy just one bank and expect that it will suit all of your needs from small product to full-length fashion photography.

Think of the smallest of the three not only for small products, but for

people shots for which the light needs to be very directional. A small light bank gives the light a very even look that also has definition, with distinct highlights and shadows. Using the largest bank might give a flat look to the subject.

A medium-size bank is terrific for larger products and portraits. It allows the light to wrap around the subject but, when properly positioned, doesn't flood the space and smother it in light.

Larger banks are great for hitting big areas with plenty of light, doing group shots, or photographing large product setups. They can still provide you with highlights and shadows for something quite large. Obviously, the same light source in a small bank will offer more exposure power than in a larger bank. When light is spread around over a larger area, efficiency falls off.

Both Chimera and Westcott also have strip banks that come in sizes like 9 inches x 36 inches, 14 inches x 56 inches, and 21 inches x 84 inches. Strip banks are great when you want to direct light into a vertical or horizontal space without light spilling elsewhere.

Light banks usually consist of two panels that diffuse the light, creating an even light output from center to edge.

SPEED RINGS

There's no rocket science involved in assembling a light bank. It's quite simple. Most come with four rods. When the rods are inserted into pockets in the bank's fabric, as in image A, the rods become its bones, giving it form.

Just as two bones need a joint where they connect, the speed ring is the point where a bank's rods connect, and it also holds the light source in place. A speed ring needs to have a great deal of strength. It is a key element in the safety and security of the whole light bank rig.

Image B shows us inserting one of the bank's rods into a Chimera Quick Release Speed Ring. The Quick Release is extremely easy to use because the holes for the rods drop down 90 degrees away from the speed ring. There's no pulling or tugging involved.

A

B

Once each rod is in place, it holds tight while you attach the other rods with a simple brass thumbscrew. This type of attachment provides added security: The rods will not disconnect from the speed ring until you are ready to release them (image C).

When all the rods are inserted and tightened, you are ready to erect the box into its full form. Just pull up on one rod at a time (image D), and it will snap into place with a reassuring "click."

Once the bank has been fully assembled, insert the lighting instrument into the speed ring. Since most of these instruments have expensive glass elements, do your best not to have an accident while putting the bank together. If you insert the lighting instrument directly into the speed ring you'll be okay. Avoid the mistake of getting acrobatic with large banks and inserting the instrument at an angle. Usually the lighting instrument has its own bracket for attachment to a large boom or other support.

When it's time to disassemble the light bank, just reverse the process by first removing the lighting instrument from the speed ring. Pull up on the tab that snapped into place. The rod will drop down 90 degrees, and the bank will lose its form.

C

D

SOFT BOX
AND UMBRELLA AS ONE

Westcott has created lighting instruments that are a cross between a soft box and an umbrella. They require no speed ring and assemble with less effort than a standard light bank.

The Westcott Apollo resembles a square soft box; the Westcott Halo is round. Both are built on extra-strong umbrella frames. Like an umbrella, they generally fire to the back of the bank. The exception is the Halo Mono, which has a rear opening for a monolight.

For the image on the right, we used a Halo as our key light and added two Westcott strip banks, one to fill the background and another (shown in the illustration on the right) to bounce off the ceiling to the left of the key light. The latter acted like a fill light, scattering plenty of soft illumination over the ceiling and bouncing down on our models.

To kick some little gold accents onto the left side of the Jakie's face, we held up the gold fabric from a Scrim Jim, as shown. You can see slight hints of gold on his left cheek and next to his left eye. At *f*/9, we have good depth of field for the models, but we lose distracting background elements.

A great lighting design requires technical creativity that goes beyond using tools for their intended purpose. Here the light banks are perfect choices for the project. The handheld fabric allows the shape of the reflector to perfectly add little gold accents to the young man's face, matching his sweatshirt.

LIGHT SOURCE/MODIFIERS
- Novatron 1,500 Ws Digital Power Pack
- 2-Novatron Bare Tube Flash Heads
- Novatron M600 MonoLight
- Westcott 54" Round Halo Mono
- Westcott 12" x 36" Strip Banks
- 2 Westcott Bare Tube Head Speed Rings
- Westcott Scrim Jim Gold Fabric

SUPPORT
- Gitzo Mountaineer Tripod
- Gitzo Off-Center Ball Head
- 3 Novatron Heavy Duty Stands

Nikon D2x, AF-S Zoom-Nikkor 28–70mm F2.8D IF-ED at 56mm (35mm equivalent: 84mm), Manual mode: ISO 100, 1/250 sec. at f/9.0, Gossen Starlite meter; processing in Adobe Camera Raw and Adobe Photoshop by Brian Stoppee | Photo by Brian Stoppee | styling by Tracey Lee | talent: Dawn Sykes and Jakie Hill

BANKING BIG

When lighting big areas, you need big light sources. For the most part, the same lighting instrument you use for small light modifiers will also work with large ones.

The image on the right may look tight, but we shoot many variations when we're on a job. No matter how close you zoom into a subject, the size of your light source determines the quality of the light. A trained observer could guess, based on the amount of light wrapping around these subjects, that this shot was made using a 54-inch x 72-inch light bank. For additional fill light, we bounced a flash head off the ceiling above.

Positioning the big light bank is essential to getting your highlights and shadows just right. If not, the image can look flat. Notice the highlights on the father's cheeks and nose. This is a good indication that we used a silver light bank rather than a white one. The silver creates a greater contrast.

Other shots in the sequence include a fireplace. For that reason we set the shutter speed to 1/30 of a second to capture the fire, but used f/5.6 to keep attention focused on the models.

Though it's best to limit the size of your light bank to the exact image area you need to illuminate, you sometimes need to shoot a series of stills as you place your talent in various places. That's why we chose a large bank for an image series in which we shot models in different parts of a room.

Nikon D2x, AF VR Zoom-Nikkor 80–400mm F4.5–5.6D ED at 145mm (35mm equivalent: 217mm), Manual mode: ISO 100, 1/30 sec. at *f*/5.6, Gossen Starlite meter; processing in Adobe Camera Raw and Adobe Photoshop by Brian Stoppee | Photo by Janet Stoppee | Styling by Tracey Lee | talent: Mark Kaufman and Charlsey Kaufman

A large light bank was used as the key light for this photo. It permitted other, wider-angle shots to be made of the same setup while maintaining even illumination through each frame in the series.

LIGHT SOURCE/MODIFIERS

• 2 Novatron 1,000 Ws Digital Power Packs
• 2 Novatron Bare Tube Heads
• Chimera Novatron Bare Tube Quick Release Speed Ring
• Chimera Super 54" x 72" Pro Plus - Silver

SUPPORT

• Gitzo Explorer Tripod
• Gitzo Off-Center Ball Head
• Matthews Baby Junior Triple Riser Stand

BANKING SMALL

Sometimes, when you're preparing to shoot one thing, an opportunity arises that you cannot resist. That's what happened with the image on the right.

We were setting up to do a series of food shots with HMI (see pages 156–157) when a puppy jumped into the set as if to demand that that we take his photo. Since we had set up a small light bank for the food, Tracey had dramatic illumination to capture the puppy, named Kidd-Ho.

The light is just right, and the dark shadow pops out the white whiskers. A larger bank would have flooded the space with light, making it more difficult to separate the little white whiskers from the cream-colored fur. In this shot, Kidd's dark eyes blend into the shadows, adding to the drama.

At the time, the camera was still in the simplest Program mode, so it was choosing both the shutter speed and aperture. It selected the widest aperture the lens could offer. At a 35mm equivalent of a 72mm focal length, it was just on the edge of being safe to handhold at 1/80 of a second. This exposure was made possible by the efficiency of both the HMI and a small light bank.

The HMI lighting instrument provides a continuous source of illumination that allows the camera to be set to an automatic exposure mode.

Nikon D200, AF-S DX VR Zoom-Nikkor 18-200mm F3.5-5.6G IF-ED @ 48mm (35mm equivalent: 72mm), Program Auto mode: ISO 100, 1/80 sec. at f/4.5; processing in Adobe Camera Raw and Adobe Photoshop by Brian Stoppee | Photo by Tracey Lee

The right size light bank for the situation is essential, even in the found image. A larger light bank may have created too much light and blown out the shadows that make this photo remarkable.

LIGHT SOURCE/MODIFIERS
• DedoPAR Light Head with Direct/Soft Attachment
• Dedolight HMI Electonic Ballast
• Dedolight Soft Bank

SUPPORT
• Matthews Preemie Baby Stand

TRIOLET STARTER

Some of you who may be new to light banks and professional lighting need an entry-level system that's simple to use but still provides professional results, the sort of system that will last for more than just a few years; this is a career-long investment. You are exactly the user Chimera had in mind when they created their Triolet (pronounced "try-olay").

The Triolet is a type of "hot light," or incandescent lamp. It comes in a complete package: the lamp, the light bank, the speed ring, and everything you need to attach it to a support system. All you need to add are the camera and the stand.

To demonstrate how easy it is to get started using a Triolet, we created the image of the wine bottle without using a light meter. We depended on the camera's metering system and adjusted it manually. (If you are tempted to rely on an Auto-Exposure mode, be sure to use the exposure compensation to bracket.)

Because the light bank that comes with the Triolet is designed to also be used for video, it can easily endure up to 1,200 watts of heat. This capability is convenient since it can be used for other photographic lighting, such as flash or HMI. So as your system expands, the Triolet grows with you.

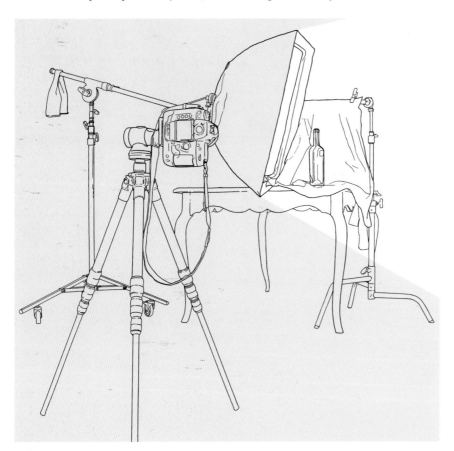

Left: Chimera's Triolet is a continuous light source, excellent for the beginner.

Opposite: Photographing a wine bottle may seem simple, but the size of the light source and the distance of the light source to the subject makes all the difference as to how much of a highlight appears on the subject.

LIGHT SOURCE/MODIFIERS
- Chimera Triolet—1,000 watt Mogel Base
- Chimera 24" x 32" Video Pro Plus—Small

SUPPORT
- Gitzo Explorer Tripod
- Gitzo Off-Center Ball Head
- Matthews Magic Stand

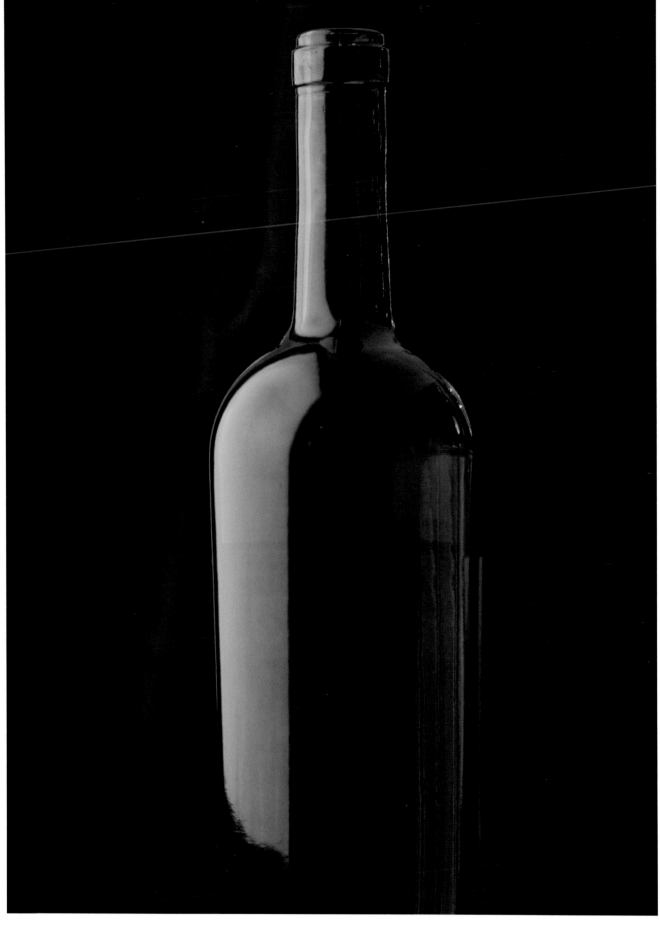

Nikon D2x, Micro-Nikkor 200mm F4.0 (35mm equivalent: 300mm), Manual mode: ISO 100, 1/125 sec. at *f*/4.8; processing in Adobe Camera Raw and Adobe Photoshop by Brian Stoppee | Photo by Brian Stoppee

THE OCTAPLUS

Among all the unique light modifiers to come onto the market in recent years, Chimera created one of the most innovative and adaptable with their OctaPlus 57. This 5-foot, eight-sided light bank is akin to a huge umbrella with a light bank's diffusion panels, and it expands to 7 feet (hence the name "57").

The illustration at bottom right shows how the technology works. As an eight-sided bank, the OctaPlus requires eight rods. Unfortunately (but necessarily), the standard Chimera speed ring, with its spaces for four rods, will not work; the OctaPlus requires a special speed ring made from a rugged aluminum. However, its banks work with just about any light source—flash, HMI, or hot lights—and are rated for the heat of a 1,200-watt light source. The back of the bank is a cross between a white bank and a silver one, a combination known as "soft silver." The baffle and diffusion panels are designed to provide flattering light but a crisp image.

A highly useful 3-foot version of the OctaPlus offers even greater light efficiency and a concentrated light source.

To extend the 5-foot version of the 57 to 7 feet, attach extension rods to the ends of the 5-foot bank's rods. The extension fabric easily adheres to the 5-foot fabric for an even transition.

Since there's a baffle and front diffusion panel for the 5-foot version and a front diffusion panel for the 7-foot extension, you get to choose how many of these panels you want to use: one, two, or three. The diffusion options provide even greater versatility in terms of the quality of light that can be produced with this tool.

What uses does a photographer have for an OctaPlus? Since it expands to become taller than most people, it's a fabulous light source for full-length people photography, including fashion shots. When used on a big boom in a room with a tall ceiling, it's also great for large product photography. When you need a fill light source for architectural photography, the OctaPlus 57 is perfect for flooding a large area.

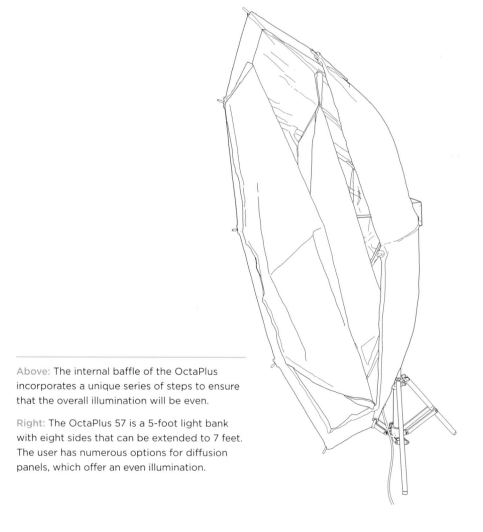

Above: The internal baffle of the OctaPlus incorporates a unique series of steps to ensure that the overall illumination will be even.

Right: The OctaPlus 57 is a 5-foot light bank with eight sides that can be extended to 7 feet. The user has numerous options for diffusion panels, which offer an even illumination.

THE LANTERN

Another innovative light modification tool from Chimera is the Lantern and its sibling, the Pancake. If you've ever watched a television show where people play cards, you've seen Chimera Lanterns. They're the lights that hang over the tables. Lanterns come as 20- or 30-inch diameter banks that are 16 inches and 21 inches deep, respectively. The light they cast is even and pleasing. Since a Lantern is a round light source, it spills illumination widely.

The concept seems simple enough. However, as with all tools that modify the output from a light source, Lanterns are not so much about creating the vehicle for the light output as they are about controlling the light. A Lantern includes a "skirt," a clever device that works something like a barn door (as discussed on pages 105–106.). The skirt fits into the shape of the Lantern and permits you to select how you want to flag the light on one or two sides. If you position the Lantern properly (assuming you want it to be part of the photo), it's impossible for the viewer to detect the skirt. It zippers and is removable.

Another form of the Lantern is the Pancake. Unlike a Lantern, which has reflective back panels like other Chimera light banks, a Pancake is open on all sides.

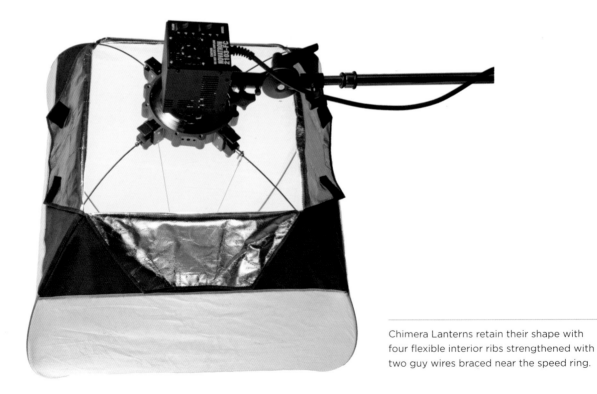

Chimera Lanterns retain their shape with four flexible interior ribs strengthened with two guy wires braced near the speed ring.

There's no need for skirt attachments on Pancakes. They have a unique set of built-in skirts that roll up, revealing that there are no backing panels. These omnidirectional lighting tools are available in diameters of 21 inches, 35 inches, and 48 inches. Compared to Lanterns, Pancakes have relatively shallower depths of 12 inches, 17 inches, and 19 inches.

There are some very special uses for omnidirectional lighting tools beyond providing a flooding fill light. Try hanging a standard Lantern from a boom and observe how the light falls on a face as a side light. In that setup, place the skirt on the sides toward the lens. Experiment with what reflector panels do to the opposite side of the face.

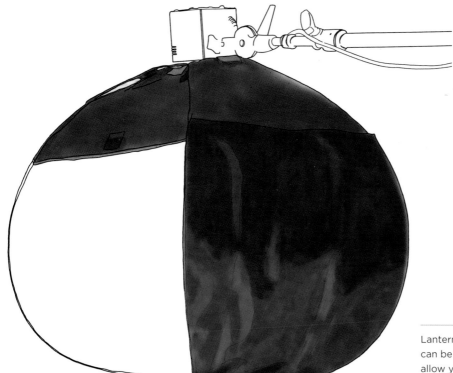

Lanterns provide omnidirectional light that can be controlled with skirts. The skirts allow you to control the light so that it doesn't spill to areas where it's not wanted.

FILTERS

With just a sheet of colored plastic, you can change the entire look of a scene. The trick is that not just any sheet of plastic will do. Colored gel media can give 5,550 K of light the look of setting sunlight, the coolness of winter, or early morning sunshine streaming through a window. When you use filters, you create the mood.

ROSCO CINEGEL

For decades, Rosco has enjoyed worldwide renown in theatrical and filmmaking circles. The company offers a free swatchbook of all of its Cinegel products, which are popular with professional photographers and Hollywood types. One of the many nice things about the Cinegel line is that it includes both color correction filters and those used to create color moods.

There are safety issues with color media, as discussed on pages 106. For one, there always has to be enough breathing room between a filter and the lighting equipment. Another issue is the quality of the gel media itself. Poor-quality material absorbs too much heat, which can ruin the effectiveness of the gel, to the point where it can melt and cause a fire.

As the name implies, many Hollywood "hot lights" create a great deal of heat. Because the Rosco Cinegel is a deep-dyed medium, the color is suffused to the polymer base, making it more heat-resistant.

Here are a few of our favorite Cinegels for creating various moods:

- NATURAL SUNLIGHT:
 #316 Gallo Gold
- STRONG MORNING SUNLIGHT:
 #3411 Roscosun
- A HINT OF AFTERNOON SUN:
 #16 Light Amber
- STRONG SUNLIGHT,
 LATER IN THE DAY: #2003 Storano Yellow
- A DRAMATIC SUNSET
 FOR THE FAR END OF THE DAY: #18 Flame
- A MORE ROMANTIC
 SETTING SUN: #23 Orange
- LIGHT COMING OUT OF A FIREPLACE:
 #325 Henna Sky
- NIGHTTIME OR MOONLIGHT:
 #3220 Double Blue Bright
- COOL BEAMS OF MOONLIGHT:
 #364 Blue Bell
- TO ENHANCE SKIN TONES:
 #02 Bastard Amber

The Rosco Cinegel swatchbook is available for free.

DIFFUSION MEDIA

So far we have discussed diffusion materials, including handheld panels, large adjustable frames, and light banks. There is also a vast array of diffusion materials available in sizes similar to that of colored gel media—that is, roughly 20 x 24 inches.

Each diffusion fabric has a specific purpose that you can adapt to a multitude of creative uses. Diffusion materials are most commonly used in a lighting instrument's gel frame. Sometimes both a colored gel and a diffusion fabric are used on the same light source. All the diffusion materials that we use are included in the Rosco Cinegel swatchbook, pictured on the opposite page. Rosco adds the name "tough" to most of these materials—their way of letting you know that these are heat-resistant products.

EDGE FEATHERING

One of the functions of diffusion is to take the hard edge off light. Often you want the quality of a light beam to remain steady; in other words, spreading the light is not desirable. Rosco's #3006 Tough Spun and #3007 Light Tough Spun fabrics achieve this best with flash lighting sources rather than with HMI (covered in the next two chapters).

CONTRAST REDUCTION

When photographers want to reduce the overall hardness of illumination, they turn to diffusion. Rosco's three Frost products are extremely popular; leading the way is #3008 Tough Frost, which both diffuses and adds a little warmth. HMI lighting instruments are best served by #3010 Opal Tough Frost. For just a minor touch of diffusion, use #3040 Powder Frost with most lighting instruments.

MODERATE TO SIGNIFICANT DIFFUSION

Some lighting setups need more aggressive diffusion solutions. Rosco's White Diffusion series reduces the edge on shadows in three different grades: #3026 Tough White Diffusion is the most diffused; #3027 Half Tough White Diffusion and #3028 Quarter Tough White Diffusion step down the effect.

COMBINING MULTIPLE LIGHT SOURCES

A truly amazing diffusion material set from Rosco is their Rolux line. When you have more than one light source but you want it to appear as if there is only one, look to #3000 Tough Rolux and #3001 Light Tough Rolux. Achieving this effect involves significantly reducing contrast, but depending on the needs of the shoot, that can be a minor concession for a great reward: one seamless pool of light.

ROLLS OF RUGGED DIFFUSION

Some diffusion projects are way too big for 20 x 24-inch sheets, so Rosco also offers rolls of grid cloth in 48-inch widths. This material is so durable that you can put grommets in it and even sew it. The #3030 Grid Cloth is the most diffused, while #3032 Light Grid Cloth and #3034 Quarter Grid Cloth have incrementally less contrast.

REFLECTION MEDIA

We love the Matthews Aluminum Hand Reflector (pictured below). This excellent creative resource provides a hard surface, and you can flip it 180 degrees for different qualities of reflection. However, sometimes more than two surfaces are essential to get the exact light quality you desire.

Again, Rosco rides to the rescue with an entire line of reflection materials, which come in various colors and textures and can be clamped to the Matthews reflector. Their names include a letter designation keyed to the effect each one provides: M is a mirror, G is gold, while SS is super soft. Some of the surfaces have one material on one side and another on the reverse. A surface with silver on one side and gold on the other is designated S/G.

Above: Above are four of Rosco's most popular reflection materials for photography.

Left: The Matthews Hand Reflector swivels 360 degrees on its yoke.

POLARIZATION MEDIA

For copying flat art (see page 194), there's a magical pair of gel-like materials that makes such copy projects, which can be challenging, much easier.

You may be familiar with the polarizing filters that you can attach to the front end of a lens. As you rotate one of these filters, you see reflections that fade in and out. You can achieve some of these same amazing effects by modifying your light source. Rosco offers 17 x 20-inch sheets of polarizing material that are perfect for the 16-inch pan reflectors that are popular for copy work.

Rotate the polarization material until you get the effect you want. Using two light sources, one on either side of your subject, you can dial various reflections in and out.

Polarizing materials don't replace the polarizing filters you put on the camera's lens. The two methods are different. Photographers who get used to these filters learn to work with both media to balance both the light that falls on the subject and the way the camera manipulates it.

Please note that you must exercise extreme caution when covering any hot lighting instrument with filtration media for extended periods of time.

When two pieces of polarizing material are used on light sources that cross, a photographer can dial reflections in and out by rotating the filter material around the source of illumination.

CHAPTER 6

SUPPORT AND SAFETY

Most instruments need a stand. One primary consideration is whether the support can adequately handle the equipment; another is whether it provides sufficient safety.

Sometimes a photographer's first reaction is to use anything that gets the light off the ground, and many people grab the least expensive thing they can lay their hands on. As is so often the case with "starter" tripods, makeshift or cheap stands usually last a short period of time and need to be replaced.

But there's more to consider than avoiding losing money on the front end of an image-making investment. You don't want any of your valuable equipment to be damaged on a shoot, and it's of even greater importance that no one is injured.

A shoot can move at a fast pace. Light and conditions change. The model has to be in just the right mood with just the right look. Even still life setups have a diminishing life span. Yet you need to approach every setup with the utmost responsibility. You need to safeguard your equipment; if your support systems are not sufficient and something is damaged, you may even have to postpone the shoot.

Even more important is the safety of everyone on the set (including yourself), and this lies on your shoulders. Without proper support, your setup could be dangerous. In this chapter, we point you in the right direction for finding equipment to keep your sets secure. In our decades of shooting, we have never had an injury during a photographic session.

For years, the motion picture industry has been using exciting and innovative support tools, which are now being embraced by many professional photographers. These are tools that not only solve difficult problems but also encourage creative exploration.

WHICH STAND DOES THE JOB?

First, look for something that can withstand the weight of the lighting instrument. There are some extremely lightweight stands out there that can support a small, battery-operated flash, but as soon as you add an umbrella, they become top-heavy.

Try the stands on display in a professional photographic dealer's showroom. Place the instrument on it that you plan to use as well as any additional light modifiers. Raise the stand as far as it can go. Shake it to replicate a breeze. Does it wobble or remain reasonably firm? If the lighting instrument and the light modifier are swaying a bit, chances are it's a poor choice.

Next, carefully examine the stand's fasteners. Grab the top of the stand try to pull it downward. Does it begin to collapse downward into itself in response to your tugging? If it does so when it's new, that's a bad sign. With use, the fasteners wear and the problem will become worse. Look for a stand with robust fasteners. You want them to stay in place exactly where you lock them off.

Once the stand is locked in place, is it easy to undo? If each section of the raised stand is a "riser," try locking the position in the middle of a rise. Once you unfasten it and raise it up a few more inches, does the fastener cut into the riser? That's also not a good sign.

One stand doesn't fit all. Sometimes you need a short stand in order to hide a light behind someone. Maybe it only rises to a maximum of 3 or 4 feet and can be lowered to just a foot or so. Photographers who specialize in portrait sittings may need only one stand that rises to 7 or 8 feet. When it comes to shooting full length or supporting the frames discussed on page 98, you need something that can be cranked up to 10 feet or higher.

Even slightly changing the positioning of a large, supported light modifier, such as an extra-large light bank, can be difficult. In such situations, you need supports that roll. Look for casters that not only move smoothly but also can be easily locked and unlocked.

Your light stand must be the right height for the project and have the fasteners and durability to do the job.

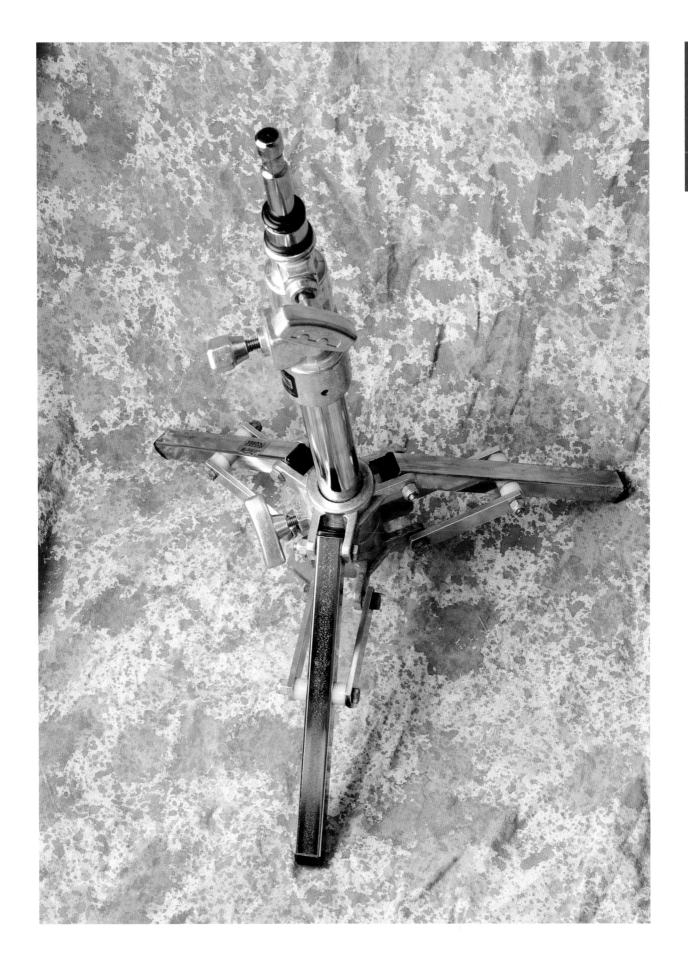

SAFE COUNTERBALANCING

How do you know when you have sufficiently counterbalanced a boom? When done right, you should have no problems. There's simply a bit of a craft to making it all come together. Here's our solution for safely hanging a big light bank on a boom.

Place the bank on a clean surface with the front end facing down. Adjust the light head's bracket so it's angled to easily receive the boom. Slide the boom into the bracket and tighten the connection between the two.

 Now slowly begin to raise the boom. Chances are good that you'll need to adjust the angle of the light head's bracket to accommodate the positioning of the light bank. Slide the boom arm back a bit as you raise it off the ground. This process can be a slow and careful ballet that you need to choreograph until you have just the right boom height, extension, and balance between the weights on either end. You may need to adjust the counterweight. Some booms come with their own counterweights; others need the weights and bags that we discuss next.

Carefully line up the light head's bracket with the boom arm's extension, lock it in, and then slowly raise and adjust the boom.

WEIGHTS AND BAGS

When you're shooting outdoors, weighting down everything is an absolute must. Just a bit of a breeze can knock down big setups, and a little bit more wind can take down smaller ones. Weights play an important role inside, as well.

One thing that causes photographers to avoid weights is that they . . . well . . . weigh a lot. They can seem like an inconvenience. However, the first time something falls and breaks, most shooters change their ways.

Some of the Matthews weights come in black so they're well hidden and non-reflective, but for the most part, weights are covered in bright orange to be highly visible.

When flying into a location, it's expensive to take weights along. For this, Matthews's double-secure Matthbag and the aptly named Fly-a-Way bag are empty. Once you get to your location, fill a zip-lock plastic bag with sand, marbles, or other heavy materials and place the plastic bag in the Matthews bag, and double seal it to ensure nothing will leak out. Some sandbag-style weights are in the range of 15 to 50 pounds. For smaller projects we use Matthews Boa Bags. They're just 5, 10, or 15 pounds, and the weight is evenly distributed on two sides.

Left: If you don't want to take heavy weights with you as you travel to a location, try the bags that come empty and are filled on site.

Right: Boa Bags are a great lighter-weight alternative to bigger saddlebag weights. These are just 5, 10, or 15 pounds.

THE GRIP HEAD LEGEND

The heart of so many components in the Matthews system is their legendary Grip Head, also known as a Hollywood Head. It has a few imitators, but none have been able to duplicate its acceptance in the media industry, where it is the leader in the support category.

One side of the Grip Head firmly secures to a light stand or other rigid support column. It's best when used with a support that has a 5/8-inch shaft. Its smaller knob locks it in place. Loosening the bigger knob allows the head's center section to rotate freely over 360 degrees. The more you loosen the knob, the wider the two center plates can be spread apart. When tightened back down, the two openings neatly hold objects that are 5/8 inches or 3/8 inches in diameter. This is how we are able to rotate the big diffusion frame shown on page 99, which has a Grip Head on either stand.

How you put this to use is limited only by your imagination. On page 100 you can see how we pop Matthews RoadRags and Westcott Fast Flags into one of these heads and adjust its angle, up and down. If we loosen the head, we adjust the RoadRags or Flags left and right.

For tabletop shooters, the Grip Head is the basic vehicle for fine-tuning reflections, highlights, or shadows. The dots and fingers on page 104 are fine-tuned with it in conjunction with the tools on the following spread.

Use a Grip Head to firmly hold in place light modification tools that can be rotated 360 degrees.

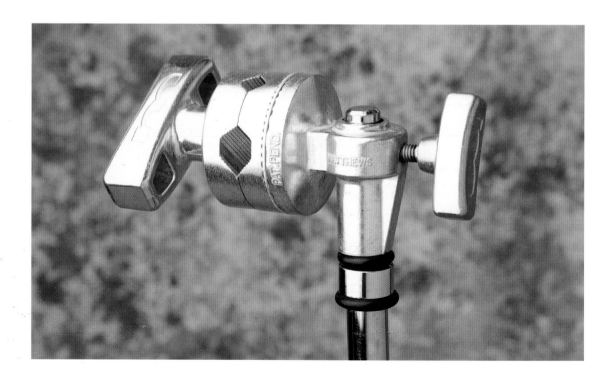

MAGIC FINGERS, MAFERS, AND MATTHELLINIS

The Magic Finger (bottom left) is another clever Matthews invention that provides a solution to a nagging problem. The "finger" is a heavy-duty bracket pin that rotates 360 degrees and tilts -15 degrees to 90 degrees. It answers the need to fine-tune the adjustment of a lighting instrument in ways that most brackets do not permit. We have hung an extra-large light bank with a Magic Finger for days and it never moved a fraction of an inch.

Clamps are an integral part of the professional grip's toolbox. Lighting technicians need to lock everything down securely. One of the most popular means of doing this is with the Matthews Super Mafer. The small knob locks it onto the stand. As you twist the large knob, the top portion of the clamp descends upon whatever is in its path. Rubber pads on either side of the clamp prevent damage from happening to what it holds.

Much like the two arms of a corkscrew, a Matthellini's jaws open to 2 inches, 3 inches, or 6 inches, depending on which one you choose. They, too, are nicely padded. Matthellinis come with the ability to adjust them at the ends or toward the center.

Left: The Magic Finger rotates and tilts a lighting instrument while securely locking large, heavy ones in place.

Middle: The Super Mafer precisely clamps down on objects as you twist the larger knob.

Right: Many sizes of Matthellini clamps are available, offering an opening as large as 6 inches.

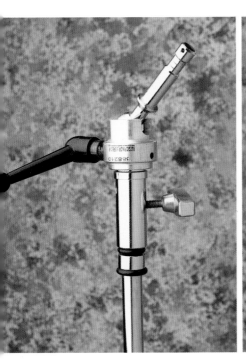
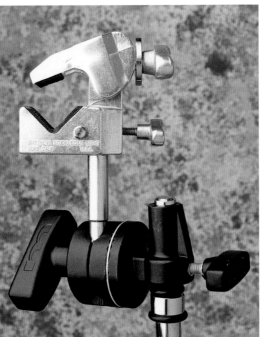
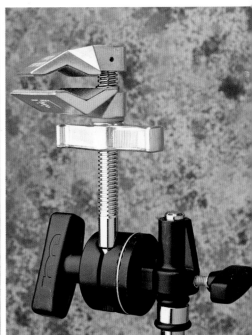

FLEXIBLE ARMS, KNUCKLE HEADS, AND MINIGRIPS

A technically creative mind can come up with all sorts of homemade solutions to positioning a lighting instrument in the most unique and twisted configurations. The trick is doing it in a way that is safe, secure, and requires little precious time. The Matthews Hollywood Superflex Flex Arm is the answer. With six ball joints and three knobs to tighten or loosen the articulated arm's segments, this ingenious device allows you to get instruments into many tight places and lock them down safely.

The Matthews Knuckle Head shares some of the Superflex's features; for example, one knob loosens two ball joints. Able to handle 15 pounds, this highly flexible and secure device can easily deal with most flash heads. It offers very precise positioning of various light modifiers.

For working with smaller lighting products or stabilizing other elements of a set, Matthews has a MiniGrip Kit that comes with downsized versions of the Grip Heads and Matthellinis discussed on pages 140–141.

A Hollywood Superflex Flex Arm gets lighting gear into tight places where long rigid devices cannot easily go.

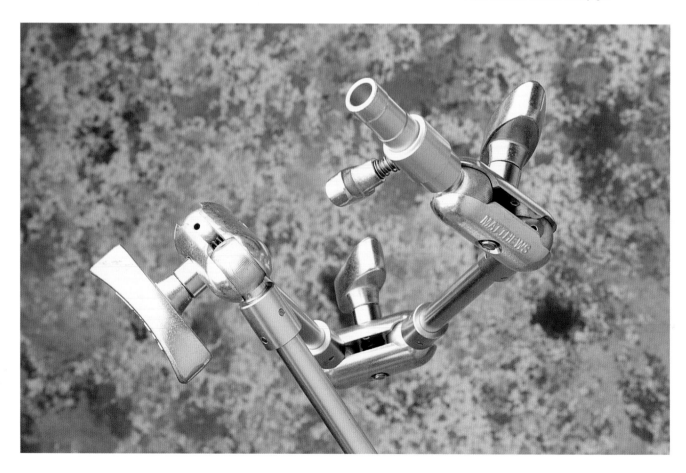

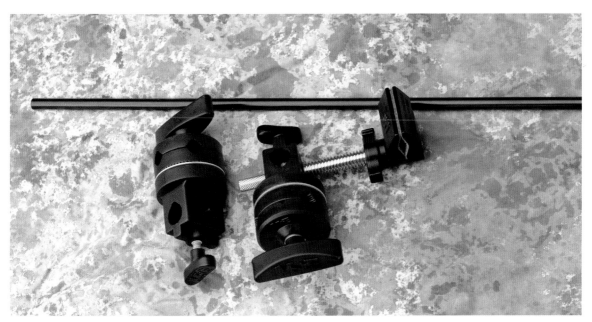

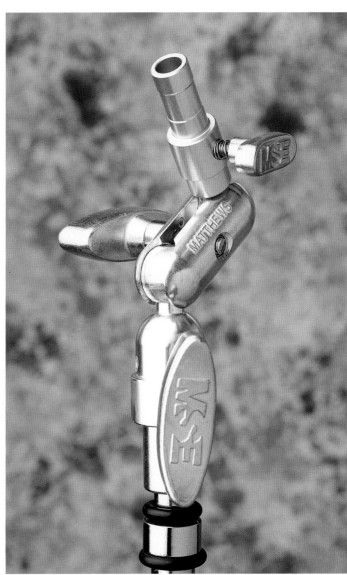

Above: The Matthews MiniGrip Kit features smaller versions of the Hollywood Grip Heads and Matthellinis.

Right: A Knuckle Head is like a shortened version of the flexible arm. It's great in tight places.

WHICH TRIPOD DOES THE JOB?

Why devote six pages to tripods in a lighting book? As discussed on pages 36–37, one of the three components of the exposure trinity is time. Though handholding the camera works for many images, at slower shutter speeds the tripod makes or breaks your shots. A great tripod becomes an essential part of the creative process.

In our minds it is also part of the safety issue. Some people who are just getting into advanced photography think any low-cost tripod will do. More likely than not, that cheap tripod will collapse on a windy day and take a few thousand dollars of photographic equipment with it.

BE YOUR OWN TRIPOD

Whether you have one cheap tripod or three awesome ones, sometimes you need a tripod this second and there's either no time to open one and still get the shot, or you just don't have a tripod with you.

In those cases, the best thing you can do is become your own tripod. Try these four things to keep the camera steady:

- Sit on something. Grip the camera with one hand and hold onto the lens with the other. Rest your elbows on your legs.
- Prop yourself against something stable, like a doorway, car roof, fence post, or railing.
- Get down on the ground and prop up the camera with your elbows.
- If you have to stand, spread your legs slightly apart and tuck your arms in almost up against your chest.

ON FIRM FOOTING

When it comes to creating a firm platform for shooting a stable image, it all starts with the feet. On page 147 are three examples of what firmly grounds a tripod with the versatility to adapt to the conditions. A firm, rubber-tipped foot is adaptable and excellent for both indoor and outdoor use. It's soft enough to not mar floors but holds firm in rough terrain.

Some photographers prefer a foot that changes from a spike, to dig into outdoor ground, to a softer rubber foot for use on nicer surfaces. Whatever type of foot you choose, it has to be something that remains firmly in place even if it nudged a little.

Mike Pocklington captured this intriguing and humorous image without the benefit of a tripod. He set his camera to a sensitivity of 200 and kept the depth of field shallow. A faster sensitivity would have recorded too much noise on the camera he was using. If he wanted a greater depth of field a slower shutter speed would have been necessary and a tripod would have been essential.

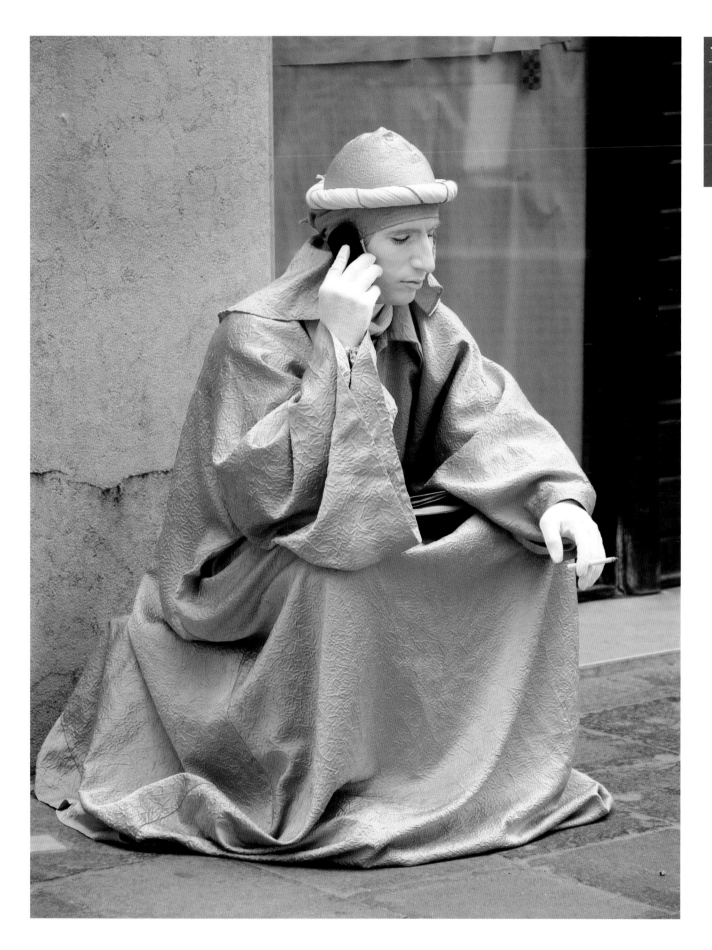

GREAT LEGS

Too many cheap tripod legs have a little "creep" to them. This can mar your shot without your knowing what went wrong. If you innocently mount a heavy lens on a low-cost tripod, the legs will likely begin to very slowly, almost beyond your notice, lower a tiny bit and then more and more the longer they have to bear the weight. For slow shutter speeds, that creep shows up on the image as noticeable vibration, but you can't figure out where it's coming from.

There are all sorts of methods for locking tripod legs in place. In your photo supplier's showroom, open up two sections of one of the tripod legs just enough to get your hands on it. Lock it in place. Now tug on it with all your might. If it didn't budge at all, that's a good sign. Next, open up all of the legs so the tripod is at chest height. Lean into the thing with all of your weight. If it didn't move at all, that's a good sign, too.

HEIGHT AND WEIGHT

How heavy can a tripod be before it's too uncomfortable to carry around? How high do you need the tripod to climb?

We have a Manfrotto tripod that's popular with filmmakers, broadcasters, and photographers who shoot with 4 x 5-inch or 8 x 10-inch view cameras. It can get so tall that we need a ladder to get to the top of it; it's the perfect tripod for shooting down on a subject. It also collapses so low that we need to lie on the ground to use the viewfinder. Strong breezes don't phase it in the least, and a set of telescoping mid-level braces connect the legs to the center column. This all sounds perfect, but it weighs more than most children. It's not a tripod you take on a hiking journey. On the other hand, there are many light-weight tripods out there. Some are made from inexpensive aluminum extrusions, and the slightest breeze makes them wobble, and some of the lightest high-quality tripods are also the most expensive.

When you're running all around a location shoot, you have plenty of equipment to lug around. There's just so much gear you can carry while maintaining all due respect for your back. Our solution is to toss everything into Lightware cases and move fast. Our Lightware tripod sling carries a Gitzo Mountaineer tripod. Its legs are made of layers of carbon fiber. After years of shooting with the Mountaineer, we find it every bit as strong and durable as Gitzo's Explorer, which has legs made of aluminum gravity castings.

While in your dealer's showroom, ask to mount a camera like yours on the tripod. Be sure that when you are standing tall you can see through the viewfinder without needing to bend over; not all tripods let you to do that. At the end of a long shooting day, your body will have endured enough fatigue even in the most perfect conditions. You don't want your tripod to contribute additional physical stress any more than you don't want to be down too low to get the best camera angle.

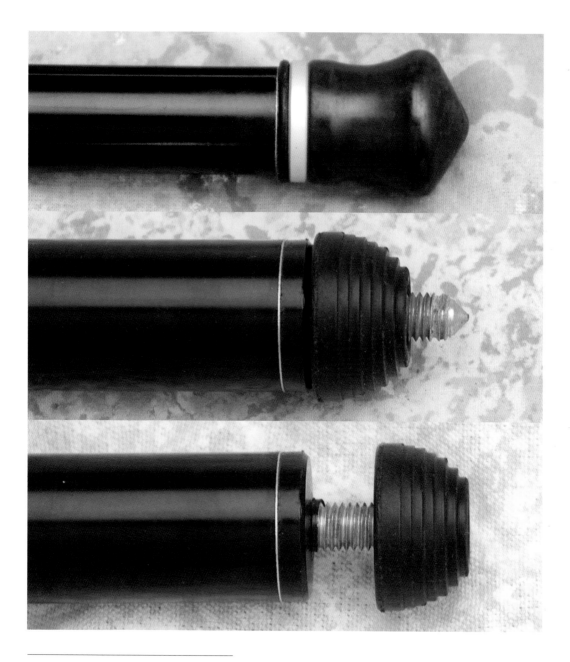

Tripod feet are a small but important
consideration. The rubber feet (top)
work well in a variety of situations. Some
photographers prefer feet that adapt from
a spike (center) to a rubber tip (bottom).

THE SAFE TILTING COLUMN

Some tripods can do pretty cool tricks. When you have come up with the perfect lighting setup, you don't want your tripod to get in the way of grabbing the perfect shot. That's too often the case with some tripods—their legs are exactly where the product you are photographing needs to be. You need to be able to get out over the subject material and adequately light the subject.

Our Gitzo Explorer, pictured below, has a tilting center column. The element that normally raises the tripod up and down and fine-tunes its height can also tilt at an angle. The column slides back and forth so you can also adjust the distance it projects horizontally.

KEEPING IT SAFE

As with all support tools, we emphasize safety. The tilting column of the Gitzo Explorer is a cool feature, but you have to adjust and weight the tripod so it cannot become unstable. This concern is multiplied with the industrial-strength camera bodies and lenses that we use, which add even more weight to the equation.

Sometimes the obvious isn't as obvious as it seems. A tripod has three legs, but they don't have to be at an even height. Adjust them to provide maximum stability. Then use the hook on the back of the column to hang a Matthews Boa Bag. Counterweight your tripod just as you would a boom.

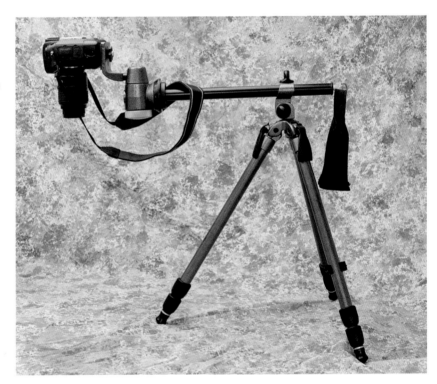

Project your camera out over a subject with a tilting column. This allows you to get your lighting instruments in and around a still life setup without seeing the legs in the viewfinder or allowing them to cast a shadow on the set.

BALL HEAD OR OFF-CENTER BALL HEAD

If you're new to professional tripods, you're in for a surprise. There's something missing from them: the head! Professional photographers want the top end of their tripod to do exactly what they want. Your tripod's head should be an extension of your creativity. We have a few heads and switch them out based on need.

You need to be as comfortable with your tripod's head as you are with your camera. Its movements have to become second nature to the point that you forget they are even there. This means that you must have a level of comfort with the controls. The tension adjustments have to be just right. The camera must remain firm, but you have to be able to freely make changes.

Some photographers like shooting with a tripod head that rotates on one centered ball. This type of head confers a great sense of freedom because it involves fewer controls. Photographers enjoy using a single friction control knob, with this 360-degree pan head, so that you can freely move the camera about while it remains rock-solid. Just as you take a car for a test drive or walk around in new shoes, you have to spend time with these heads in your dealer's showroom.

The off-center ball head is very different. Besides its ability to pan 360 degrees, the offset ball can flip 90 degrees. Combining the two options allows you to mount the camera in various positions and to work from either side of the tripod. You can shoot horizontal or vertical on one side of the tripod with the 90-degree flip, or you can pan 180 degrees and do the flip on the other side of the tripod.

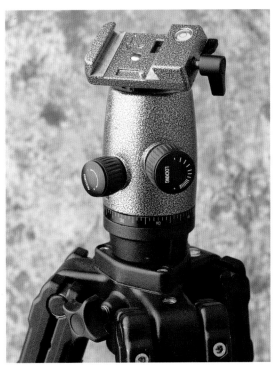

Top: The Gitzo Ball Head has a quick release that mounts on the base of the camera and easily slips on and off.

Bottom: Gitzo Offset Ball Heads tilt at a variety of angles and adjust in numerous combinations.

CONTINUOUS LIGHT

Photographers love continuous lighting systems. They are truly a what-you-see-is-what-you-get source of illumination.

Traditionally, "hot lights," or incandescent lights, were the only sources of artificial continuous light. Many were similar to theatrical lighting. The problem was with color balancing. Photographers had to either use a special, tungsten-balanced film or place a dark blue filter over the camera's lens; the latter required a faster, grainier film stock or an intense amount of light. The lighting instruments became so hot they could be dangerous.

Another popular, newer alternative for providing artificial continuous light is the daylight fluorescent fixture. Fluorescent lighting was once a headache for photographers because its color balance was all over the charts. But now that this type of lighting has joined the 5,500 K family of lighting instruments, not only still photographers but broadcasters and Hollywood filmmakers, too, have embraced it.

Hollywood also likes HMI lighting, which was once too large and expensive for still photographers to use. However, some of the world's most accomplished photographers are starting to use HMI lighting in their studios and on their locations.

With proper illumination, photographers can render the most mundane subjects artistically.

DAYLIGHT FLUORESCENT

These lamps look like oversize versions of the ones you may be using in your home. The difference is that because the household fluorescent lamps are designed to provide a warm glow that mimics the look of a tungsten lamp, they don't balance evenly with other sources of "daylight" illumination.

The Westcott Spiderlite TD5 provides 226 watts of cool-operating fluorescent light, the equivalent of nearly 1,000 watts of tungsten illumination. It offers 5,500 K, so it balances with daylight beautifully.

Many television news studios have converted to daylight fluorescent lighting. It's not unusual to see banks of long fluorescent tubes hanging from these studios' ceiling grids. And on feature film sets, big banks of fluorescent light act as fill lights outdoors. Just as small versions of these lamps save consumers plenty of money on their electric bills, when location sets use fluorescent light, less power is needed from gas-run generators.

Another advantage: Since these instruments operate cool, you can switch them off and immediately pack them up. There's no cool-down time.

Compare a traditional three-way household fluorescent lamp (right) to those used in the Westcott Spiderlite (left). There's a difference not only in size but in color accuracy as well.

WHAT'S WRONG WITH THIS PICTURE?

Daylight fluorescent lighting is not a panacea. Though it can produce the equivalent of 1,000 watts of tungsten, you won't find fashion and portrait photographers tossing out their AC-powered studio flash units, which produce the equivalent of quite a few thousand watts of light in a single pop.

Yet many professional photographers use fluorescents all the time, primarily to shoot still lifes. They also provide sufficient light for portraits with a limited depth of field. As digital camera sensors improve and shoot a higher sensitivity range with noiseless results, daylight fluorescent will become more popular. Setting the camera to ISO 400 instead of 100 offers two stops of additional depth of field. This capability is now primarily available on full sensor cameras like the Nikon D3 or D700, which can produce low-noise images all the way up to ISO 6,400. They have a seven-stop range of ISO 100 to 6,400, making some great depth of field and shutter speed ranges possible with daylight fluorescent light.

SO EASY, IT'S ALMOST CHEATING

When talking about using the Westcott Spiderlites, many respected professional photographers have been known to say, "It's almost like cheating." Spiderlites retain their value, so you won't find yourself wanting to sell them (at a loss) in a few years. You can continue to use them on their own or mix them with other 5,500 K light sources.

Though we do not advocate skipping all the information that an incident light meter provides, it's possible to get started with the Spiderlite system and still shoot using your camera's built-in meter until your budget permits you to add a great meter to your toolbox. Some photographers will be tempted to choose the Aperture or Shutter Priority modes in their cameras, especially when shooting still life images. If you choose that route, we suggest a gray card like the one discussed on page 51.

Spiderlites are easy to use. The back panel has three switches—one for the smaller lamp in the center, the other two for the top and bottom and left and right lamps—permitting you to vary the light output by a little over one stop. Of course, you can also unscrew the lamps for less light, but handle them with care. Like other fluorescents, when Spiderlites break they spill traces of mercury.

The Westcott Spiderlite TD5 (shown to the left in a soft box) is an extremely easy-to-use system. The specialized compact fluorescent lamps (CFL) consume a total of 226 watts and operate very cool. When starting them up, provide a little time for them to warm up to their proper color temperature. Use the three switches on the back (shown below) to reduce power output.

SIMPLE SOFT LIGHT

Westcott has been around since the late 1920s. It's not one of those here-today-gone-tomorrow lighting companies. Their Spiderlite fits into a bigger system that incorporates the company's soft boxes.

Each Spiderlite has eight openings where the rods from a four- or eight-sided soft box easily attach without the added expense of a speed ring. Assembling one of these light banks is not difficult, but does require a little finesse. The Spiderlite has an optional protective cover that we highly recommend. We're always extra careful to not break the fluorescent lamps. You can put together the soft box with the protective cover still on the instrument and remove it once the rods are in place; another way to play it safe is to install the lamps only when the light bank is nearly assembled.

We like to put the rods into the soft box's sleeves and then place the box on a clean surface while attaching the rods. Once we have closed up the back of the box, we mount it on a support and then install the diffusion panels. To disassemble the box, we reverse the process. Pushing down on the back of the Spiderlite makes it easy to pull out the rods. Of course, we have protected the lamps before we do this. It's best to remove one rod and then pull out the one from the opposite side. Once you loosen up the knob on the back of the Spiderlite, you can spin it and the soft box over 360 degrees with the help of the handle.

The larger the light bank, the larger the reflection that is created on shiny subjects. The closer the bank is to the subject, the larger it becomes, as well.

A Westcott Soft Box is an intended companion for the Westcott Spiderlite.

Nikon D2x; AF-S DX VR Zoom-Nikkor 18–200mm *f*/3.5-5.6G IF–ED at 38mm (35mm equivalent: 57mm), Aperture Priority mode: ISO 200; 1/90 sec. at *f*/5.6; Gossen Starlite meter; post-processing in Adobe Camera Raw and Adobe Photoshop by Brian Stoppee | photo by Brian Stoppee

A variety of surfaces look quiet even when illuminated with a soft box.

LIGHT SOURCE/MODIFIERS
• Westcott Spiderlite
• Westcott 16" x 22" Silver Soft Box

THE HMI ADVANTAGE

Chances are nil to never that you'll ever hear any photographer refer to the HMI by its full name: hydrargyrum medium-arc iodide. In fact, when HMIs were first introduced in the late 1960s, you wouldn't hear photographers mentioning them at all. They were too large and too expensive. Yet today, the price has come down and many of the most celebrated directors of photography choose HMIs for their Oscar- and Emmy-winning projects.

The HMI has the advantage of operating at 5,500 K, so it fits right into daylight situations. Outdoor scenes can be lit with HMIs, which blend right into the natural illumination—for example, matching the light that the scene outside a window provides.

A huge 10,000-watt tungsten lighting instrument is called a 10K (or a "tener") because it uses 10 kilowatts. If instead of tungsten, a project incorporates an HMI, it is called a 10K HMI. Most of the HMIs used by still photographers are in the 1K range.

Plug the Dedo light head into the Dedo ballast, then control the light output in either normal or boost position or dim it over a 200- to 400-watt range.

HMI HEADS AND BALLASTS

An HMI has two components: the light head and the ballast. Though the light heads have HMI lamps that look somewhat like quartz halogen lamps, they operate quite differently. An incandescent lamp glows because electrical energy heats a tungsten-based filament. The HMI creates an electrical arc between two electrodes that excites the lamp's pressurized mercury vapor; though the arc appears to glow continuously, it is actually cycling on and off 120 times per second. This technology requires a controlling unit called a ballast. The ballast looks familiar to photographers who use the AC-powered flash systems discussed 1n chapter 8. In those systems, the ballast is known as a power pack.

The award-winning German company Dedolight is extremely popular with photographers. The Dedo (pronounced "day-doe") ballast controls the intensity of the light. Dedolight makes both 200-watt and 400-watt systems, both very compact and light enough to be carried in one hand. The 400 can be set to 400-watts, 575-watts (boost position), or to a dimming option. The 575-watt option provides roughly the equivalent of 1,000 watts of tungsten light.

HMIs are great outdoors. They offer the perfect 5,500 K light.

PAR

Many photographers who use AC-powered flash also use the DedoPAR, which works much like a flash head with a standard reflector. Yet the quality of the light the two instruments create is by no means identical. Each has its own visual signature that photographers love.

The PAR creates a very distinctive spot of illumination, even more so than most flash heads with reflectors. The reflector on the DedoPAR Daylight head allows you to focus the beam.

A set of three lenses is available, any of which can be attached to the light head in front of the reflector, providing a spot, a floodlight, or a medium-light quality. This unique option makes the DedoPAR an extremely versatile lighting instrument.

DIRECT/SOFT

To make the DedoPAR light head even more adaptable, use the Direct/Soft attachment. It replaces the reflector and turns the light head into something similar to the bare tube head that photographers use with AC-powered flash units.

This attachment is perfect for use with Chimera or Westcott light banks or Dedolight's own soft banks. All of these companies offer speed rings that are compatible with the DedoPAR. The protective glass that the Direct/Soft attachment provides not only filters UV, but if it's broken, the light head automatically shuts off so it can cool down.

The DedolightPAR Daylight (bottom left) is extremely versatile. It can be used with a reflector attachment that has focusing options, or one of three lens accessories can be placed in front of the reflector. With the Direct/Soft attachment (bottom right), the light head is perfect for use in a light bank, where it acts much like the bare tube heads that are used with AC-powered flash.

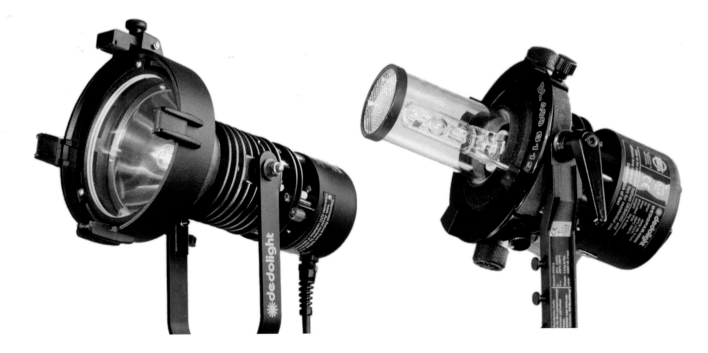

The PAR creates a beam that has a look of sunlight. It's an excellent light source for indoor flora and makes it look like you shot the image outdoors.

SPOTS AND FLOODS

Some HMI manufacturers merely add an HMI lamp in place of a tungsten one for their spots. That works well for theatrical use, but in photography, where smooth lighting transitions are essential, a better method was needed. Cinematographer Dedo Weigert took a completely different design approach and won both an Oscar and Emmy award for it. His Dedolight Daylight head offers photographers a lighting instrument unlike those used with any AC-powered flash systems. It has similarities to the theatrical lighting instrument known as a Fresnel, named for its front-end "step lens."

The Dedolight 400D has its own front lens and an internal focusing mechanism. You move the rear knob back and forth to create the exact spot or flood effect you desire. The light can be as tight as 4.5 degrees or as broad as 50 degrees. None of the possible positions creates a hard-edged light, but all are extremely well contained. There's no unwanted spill.

This capability is very helpful when you need to confine illumination to a very specific area. Working with a series of 400Ds (it would not be unusual to use 50 or more to get just the right look) you can beautifully paint a set with light, providing the exact treatment you envision, whether for a small tabletop shot or an entire automobile. You can create dramatic people shots, too. Using more than one instrument takes some careful orchestration when it comes to full-length shots of people, but the unique imagery is eye-catching.

Notice the red indicator on the side of the Dedolight 400D. As you twist the rear knob, the indicator gives you an idea of the size of the spot or flood of light that you are creating. As you are doing this, an internal mechanism is moving a rear reflector, the lamp, and an internal lens backward or forward in an extremely precise manner.

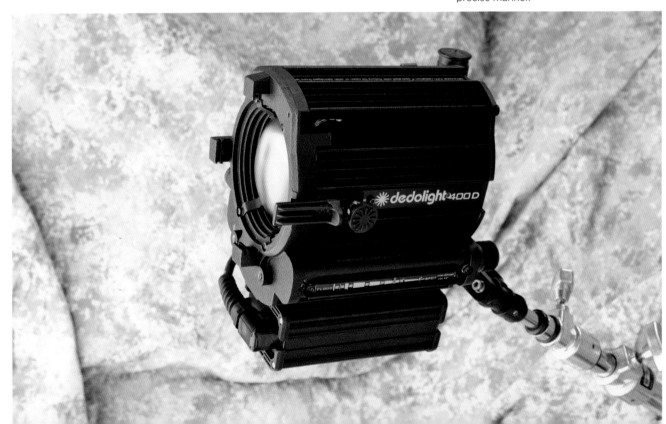

GOBOS AND PROJECTION

Rosco has a whole catalog of gobos, ranging from clouds to trees to windows and all sorts of amazing abstract and even colored shapes and patterns. Using Dedolight's Imager, you place these graphics in the path of the light. Thus the name "gobo," which is a shortened version of "go between."

The Imager easily and securely attaches to the front of the Dedolight 400D. With the proper gobo installed in the Imager, you can adjust the 400D's focusing capabilities to soften or sharpen the edges of the gobo's image. The Imager's lens can be adjusted as well.

Dedo also has an iris gobo that permits you to close down the size of the image, just as you would close down the aperture of your camera's lens. The Imager comes with a set of four shutters that allow the light to be reduced on the left, right, top, and bottom.

Overall, think of this system not just for special effects but as a versatile light source, which permits photographers to vary light quality without a patterned gobo.

Dedolight's DP400 Imager (above) works as a projector accessory to their optical spot/flood light head, the Dedolight 400D. It attaches securely and permits the use of any series of gobos, including the tree pattern (left) from Rosco. Using the 400D's focusing capabilities coupled with those of the Imager, you can fine-tune the qualities of patterns and special effects.

FLASH ILLUMINATION

For most professional photographers, there's nothing quite like the thrill of "the big pop"—that sound when the flash fires.

We never cease to be amazed at how images are frozen in time through the flash's illumination.

It used to be that a powerful flash unit had to be quite large. The battery-operated flash—the type that produced plenty of light for covering a wedding reception—was known as a "potato-masher" because it resembled the familiar kitchen tool. AC-powered studio flash was once dominated by power packs that were taller and weighed more than many of the toddlers they were lighting. The flash heads were huge. An AC-powered system could easily blow a household fuse.

For the most part, that has changed. Today's lighting tools are not only smaller but more powerful. Now photographers can create an entire system with battery-operated flash. "Studio flash" is only a term; in fact, today it's easy to pack a very powerful system into a case so small it can be carried on an airplane. Just about everything related to flash is digital, and increasingly the elements are powered and controlled wirelessly.

Mike Pocklington captured this excellent example of how flash freezes action.

THE SMART FLASH

Battery-operated flash has come a long way since the introduction in 2004 of the Nikon Creative Lighting System (CLS), a wireless, battery-powered toolkit, but the basic engineering principles remain the same. Each flash unit's energy source is a cylindrical tank of stored energy called a capacitor. Though it is powered by at least four AA batteries, the capacitor produces energy that is high voltage. Should you ever drop a flash unit and the casing cracks, immediately take it to an authorized service center. The high voltage is extremely dangerous.

All of that energy is needed for the moment you depress the shutter release button. The flash of light happens in such a small fraction of a second that it's difficult for the mind to comprehend how little time is needed to create it. The flash tube in the flash unit's head contains xenon gas that is excited. The brief, powerful flash of light occurs for time increments that range from 1/10,000 to 1/100 of a second.

Nikon Speedlights (pictured here with a diffusion cover) communicate with the camera body and work in concert with the lens to convey data back to the camera as well as receive commands from it.

WHEN CAMERAS AND FLASHES TALK

Flash units like the Nikon SB-600, SB-800, and SB-900 Speedlights communicate with most Nikon dSLR cameras. The information that the camera's light and color sensors collect is shared with the flash unit.

Such flash units are quite intelligent. They send out a tiny flash of light known as "pre-flash" that you usually cannot see. They allow the system to test how much light the scene requires before you release the shutter.

Nikon Speedlights have a variety of Flash modes that can work either in concert with the camera or on their own. Through-the-lens (TTL), Automatic mode—the most popular—gives the camera control of the flash.

Other useful Flash modes include a balanced TTL that takes into account white walls and ceilings that could result in a poorly exposed image. You can also use a non-TTL mode that allows the flash to determine the exposure automatically. Auto Aperture mode works in conjunction with the Auto Aperture mode of the camera. Distance Priority is another terrific mode choice when you know how far the light needs to be thrown and you can input that data into the flash. Photographers who want to do all of the exposure calculations themselves can use the Manual mode.

BOUNCING THE FLASH

Photographers who cover events learn to master how a flash unit's head can bounce light off walls, ceilings, and just about any other surface. Wedding photographers and photojournalists develop an innate sense of how the surfaces of a space can give their light source a very special look. The flash mounted on top of the camera may be the origin of their light, but the white and warm-tinted areas of a room become their borrowed lighting instruments. The right light for an image is usually the result of a beautiful balance of technological understanding and photographic artistry. It's essential that you become familiar with bouncing a light source, whether you're working with battery-powered flash or any other flash unit.

Tilt your flash head upward and bounce light off the ceiling (left) for a softer effect than when the unit is pointed directly at the subject. You can also try swiveling the flash head so light bounces off an adjacent wall (right). But remember: This form of illumination picks up the color of the wall and ceiling.

OFF-CAMERA FLASH

On-camera flash is great, but off-camera flash can be better. This is admittedly a leap of faith for some photographers. There's something stable about that flash unit firmly planted on top of the camera. But you gain a tremendous advantage when you take the flash off the camera, which gives you far greater control of the light's direction and thus the visual outcome.

FLASH BRACKET

Many professional photographers who cover events mount a flash on a bracket, which is extremely helpful in avoiding red eye. When the light is up and over to the left, it does not throw illumination directly into the pupils at the same angle as the lens.

Some brackets offer additional power resources. The Nikon SK-6 Power Bracket adds four more batteries to the power resources of a Nikon Speedlight, practically doubling the number of flashes possible before you need to change batteries. Because it just about cuts the recycling time in half, it also produces more plentiful bursts of light.

CREATIVE CONTROL

Since you can separate the portion of the bracket that holds the Speedlight from the base that attaches to the camera, you can hold the light source wherever you like. The coiled cable remains attached to the camera. The dSLR and the flash continue to communicate, and none of the automatic exposure opportunities are lost. The ability to vary the position of your light greatly increases your creative freedom.

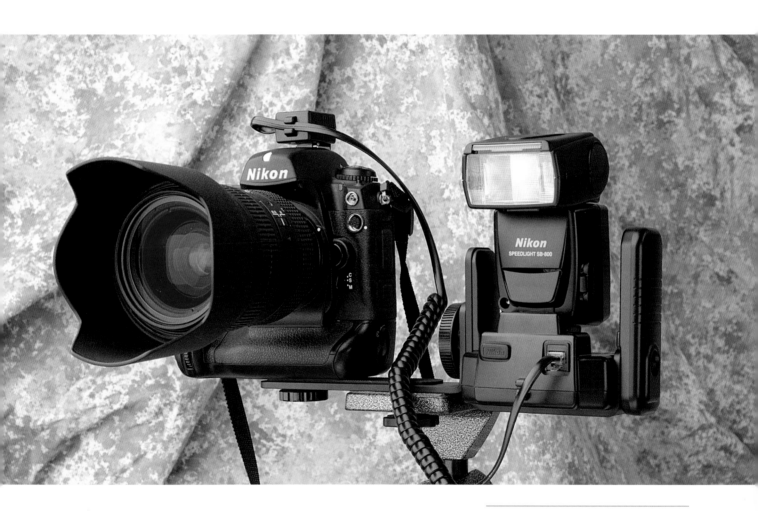

You can either shoot with a power bracket firmly attached to the camera or separate the two and vary the light's position. Because the camera and flash remain in full communication via the coiled cable, all automated exposure options still work.

THE WIRELESS
BATTERY FLASH SYSTEM

As discussed on page 172, for years many professional photographers relied most heavily on AC-powered flash systems for their light source, whether in the studio or on location. These elaborate systems rely on one or more control panels that adjust various aspects of the light output. Then the Nikon Creative Lighting System (CLS) was introduced, starting with the Nikon Speedlight SB-600 and SB-800. In this system, each flash unit has the ability to become part of a vast array of Speedlights that work in concert. Since they are all battery-operated, there are no wires, as there are with AC-powered flash systems.

Flash bracketing is a great tool. Examine the difference between one stop over and one stop under exposed.

THE MASTER AND THE REMOTES

The Speedlight attached to the camera's accessory shoe is the master flash unit. The master, which can be a SB-800 or SB-900, takes control of all other Speedlights in the system, including the little SB-R200s that are discussed on pages 170–171. The units that the master flash unit controls are known as remotes.

With just a little adjustment, the back of the Speedlight's control panel changes from the way it looks when in use as an on-camera flash into the mode it's in as a master or a remote. It's all done with the select button. The master controls the remotes, which are grouped into channels A, B, and C. The master varies the light output of the channels. There's no reasonable limit to the number of Speedlights that can be included in one channel; for example, if four flash units are required to illuminate a background, you can put them all on the same channel and control all of them at once.

One of the many beauties of this system is that all of the controls are on the flash, just a few inches above the camera's viewfinder, so everything is controlled right above your eyeball. If you don't want to use a Speedlight as a master that does not fire consider the little SU-800, depicted on the next page. It has all of the controls of a Speedlight but does not emit any light.

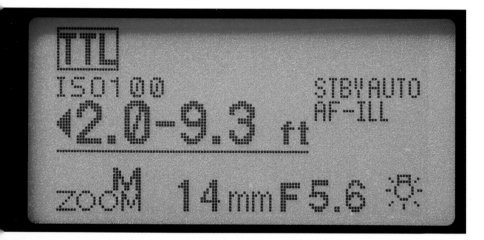

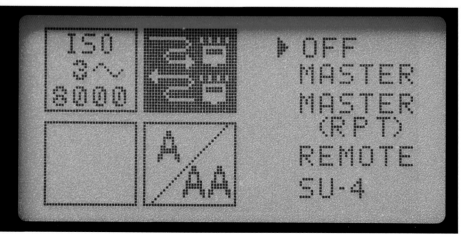

When you hold down the select button for 2 seconds, the Speedlight's control panel takes on a whole new face. Above, the control panel is in Through-the-Lens mode, which is commonly used when a Speedlight is mounted to the accessory shoe. Below, the Speedlight is ready to be programmed, as part of a total lighting system, for use as a master or as a remote unit.

MACRO FLASH TOOLS

Lighting small subjects properly requires small lighting instruments. Nikon's Close-up Speedlight Commander Kit R1C1 is perfect for getting in tight with a macro lens and still maintaining creative flexibility.

The two SB-R200 flash units that come with the kit are perfect for this, and the creative control they offer is a nature photographer's dream. Though the kit is also extremely popular with forensic photographers because the lighting instruments easily mount on a ring that attaches to the end of a macro lens, these wireless Speedlights can be set up anywhere. The whole system integrates with any of the Nikon CLS Speedlights, so a huge setup is also possible.

THE COMMANDER

Chances are, if you have added the R1C1 kit to your lighting arsenal, you already own at least one other Nikon Speedlight. This makes the kit a super value. The SU-800 Commander can control any of the CLS Speedlights, including the SB-600, SB-800, and SB-900. Simply attach the Commander to the accessory shoe mount of your camera and all of the rest of your Speedlights become remote units, as discussed on the previous page.

The Commander produces no light itself and is extremely lightweight. Yet all the control you need for the other remote Speedlights in your system happens right on the Commander, which is positioned just above the camera's viewfinder. Though your remotes may be scattered over a broad setup and even hidden in small places, you control every one of them from the Commander.

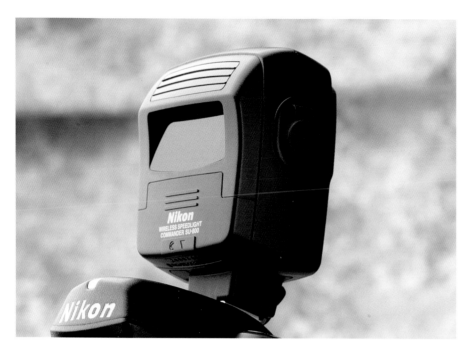

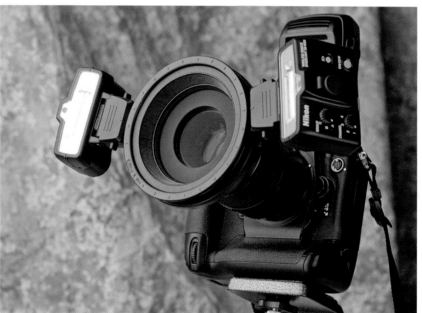

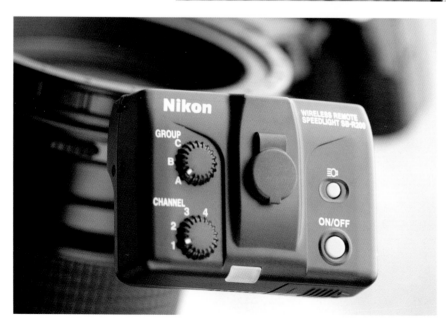

Top: Use the SU-800 as the master commander for Speedlights in the Nikon Creative Lighting System (CLS).

Middle: The Nikon Close-up Speedlight Commander Kit R1C1 includes a ring for mounting the two SB-R200 flash units.

Bottom: Set the little SB-R200 Speedlights as remotes, just as you would their larger counterparts.

THE BIG STUDIO SYSTEM

For decades the AC-powered flash system was the hallmark of a professional photographer. Studio-based shooters on both commercial and portrait jobs rallied around these extensive systems—huge, weighty creatures that consumed a great deal of amperage and often blew the circuit breakers in older homes. These photographers were significantly limited in their ability to make accurate, fine adjustments to the power output of their systems. And when such options were available, they were either not very repeatable or they significantly tampered with the color temperature of the light.

Once flash systems went digital, that all changed. Today you can adjust your light output one-tenth of an *f*-stop and repeat that setting tomorrow, next week, and next month with dependable, repeatable light intensity and color temperature.

These new flash units consume far less electrical power, and many are extremely portable. Lighting capabilities that were once available for the studio-bound photographer are now commonplace for anyone shooting on location.

The power pack is at the core of the AC-powered flash system. It's both the connection point for the lighting instruments and the system's control panel.

PACK + HEAD OR MONOLIGHT?

AC flash either comes as a power pack (like the one shown here) with one or more flash heads, or the two components are fused together into what many call a monolight. Both options have advantages and disadvantages. Many manufacturers of pack and head systems also make monolights, and often the two share the same accessories, so it's possible to build a system that meets all your needs.

The monolight (discussed more fully on page 184) is extremely portable, sets up with less effort, and usually consumes less space than a power pack and head combination. There are also fewer cables involved. Unfortunately, it's cheaper to add one more flash head to a power pack than it is to buy another monolight. Also, the monolight's controls are on the light instrument and, if it's on a stand, far off the ground, getting to them can be a problem.

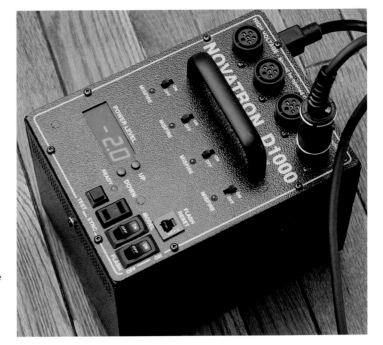

Some power packs that provide plenty of power output can remain on the ground while you place lighter-weight flash heads above the subject. However, some photographers are bothered by the extra wires needed for such a setup.

A WATT SECOND?

Professional photographers and photo retailers speak of power output in terms of "watt seconds." This concept has no direct relationship to the intensity of the light produced. However, if you learn what it's all about, you can use it to your advantage.

What unit of measurement does your electrical utility company use to bill you for the amount of their energy you have used? Kilowatt-hours, right? The watt second is just a smaller expression of electrical energy consumption, just as "Kh" is the abbreviation for kilowatt-hour, "Ws" is the abbreviation for watt second.

If you're using a 1,000-Ws power pack at full power, and it's allowing an aperture setting of f/32, chances are that if you switched to a 500-Ws pack from the same manufacturer, you would have roughly one stop less power, for an aperture setting of f/22. If that same manufacturer has a 2,000-Ws power pack, it's probably going to provide f/45 under the exact same conditions, one stop more than the 1,000-Ws pack.

BRAND X VS. BRAND Y

Just as one car gets 32 miles per gallon of gas and another gets only 17, the various manufacturers of flash lighting each have electrical architectures that consume power in their own way. Most manufacturers have locked themselves into specific electrical design principles. It's part of what allows all their products to interact throughout their system.

So there can be a problem when your friend has a brand X lighting instrument and you're trying to use it as a yardstick to determine how much light you'll get from brand Y. At 1,000 Ws, one brand might deliver f/32, while another brand's 1,000-Ws unit offers only f/22.5. Often the design of the flash heads has something to do with it. Standard flash heads from one company might spread light over a range of 60 degrees, while another brand is designed for 75 degrees. However, even if you find two brands with flash heads of similar efficiencies, the way the power packs use energy will probably vary. The odds of finding two brands that operate identically are not good.

The best thing to do is to visit a photo retailer and do side-by-side testing with a dependable flash meter. Consider the physical size and weight of the packs and heads, as well as how expandable the system may be. Look for a company that has been around for a long time and has a well-established retail and service network.

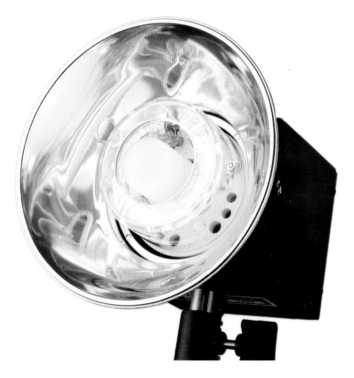

The design of the flash head plays an important role in how much light output is provided. Here the reflector on the Novatron flash head is designed to make maximum efficient use of flash tube and the modeling light design.

FLASH SYNC: WIRED AND WIRELESS

A battery-operated flash unit either is attached to the camera's accessory shoe, is connected with a wire, or, with some units, can operate wirelessly. The flash fires in synchronization with the shutter curtain opening. With an AC-powered flash system, a sync cable (shown below) is needed. One side of the cable has two blades, just like a household electrical outlet; the other side has a PC plug to attach to the camera's sync outlet. Should your camera not have a sync outlet, you can usually get an accessory that slides into the camera's hot shoe.

1/250 OF A SECOND?

When you're using an on-camera flash, everything can be set automatically. With an AC-powered flash system, you need to set the mode to Manual and select the shutter speed and aperture with the help of a flash meter, as discussed in chapter 3.

Usually, if you set the shutter speed to anything faster than 1/250 of a second, you get a photo with one portion properly exposed by the flash and another portion without any flash exposure at all. This is because the shutter curtain was not open the whole way when the flash fired.

GOING WIRELESS

Most photographers prefer fewer cables, so they can be freed to move about without being tethered to the lighting system. Quantum's FreeXWire is the perfect solution. FreeXWire's transmitter attaches to the camera's sync outlet, and the power pack gets a similar receiver unit. When you release the shutter, the transmitter tells the receiver to fire the flash.

One wireless transmitter can fire many receivers. The power pack can be in one place and a monolight can be somewhere else. The power pack can wirelessly control multiple receivers that will all fire at the same time.

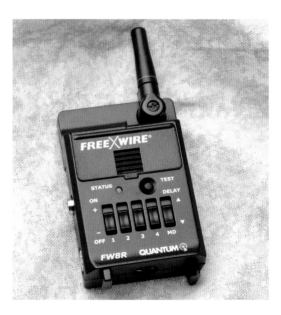

Top: The household blades side of a sync cable plugs into the power pack, and the PC side connects to the camera.

Bottom: The receiver unit of the Quantum FreeXWire plugs into the power pack. A similar transmitter connects to the camera.

Opposite: Flash can be so intense that it overcomes daylight. Here we stopped the action of the water as our model leapt up in a pool.

175 | Flash Illumination

RECYCLING, OUTPUT, AND DURATION

The energy for a big flash of illumination is stored in an electrical component known as a capacitor. "Caps," as electrical engineers call them, resemble sealed cans. They can store an enormous amount of high voltage. All flash equipment has a capacitor. A huge studio flash has a bank of large caps, and a little point-and-shoot camera has a tiny one. It's dangerous to make contact with the voltage stored in a capacitor. Only a specially trained technician should repair one.

Bottom: When photographing Sarah Nutt we filled light to one side of her face allowing the other side to go into more shadow, for a natural look. The overhead light picked up great highlights in her hair.

Opposite: The up and down arrows on a Novatron power pack allow you to adjust the power output in increments of a tenth of a stop.

RECYCLING TIME AND POWER OUTPUT

When a flash fires, chances are the majority of the energy in the capacitors has not been fully exhausted. As you continue to shoot, the system works to recharge the caps.

If you select full power output, it will take longer for the caps to recycle. After one shot, there might be a 2-second delay until you're ready to shoot again. For still life images, that's not a problem. When shooting people, however, slow recycling times can result in missed opportunities, and you want to be prepared to capture those once-in-a-lifetime images. For that reason, those who shoot people buy more power than they need and set the intensity of the light to the lower end so they

get quick recycling. Some newer flash units are capable of around four frames per second when set at around half of their full power output.

SHOOTING TOO FAST

Many professional flash units are quite forgiving. If you shoot before they are fully recycled, they provide a flash anyway. The downside is that the flash may not provide as much illumination as it should, resulting in a less than acceptable exposure. And most AC-powered flash units have their own circuit breakers. If you continue to shoot faster than the recycling time permits, the unit overheats, the circuit breaker pops, and you can't resume shooting until the unit has cooled down.

FREEZING ACTION AND POWER OUTPUT

One of the great advantages of flash is its ability to freeze action. To the human eye, a flash of light happens so fast we cannot detect that one flash lasts longer than another. Yet there is a flash duration factor. Full power output results in the longest flash duration (around 1/150 of a second). Lower power settings offer the quickest pop of light (around 1/1,500 to 1/2,000 of a second). Quick duration flash has allowed famous images to be created of a bullet piercing an apple or a light bulb falling to the ground. Everything in those photos is frozen in time.

MODELING LIGHTS

One of the problems with flash is that you're clueless about what the end result will be until after the image has been captured. In the days of film, this could be excruciatingly difficult. We had to rush film to the lab and wait a couple hours until we saw the test prints.

In the digital environment we see the results of our test shots in a few minutes. With a great monitor and Adobe's Camera Raw plug-in for Bridge and Photoshop, we know right away if our exposure is exactly what we want. But that's not our first clue as we plan the image. We also can get a good idea of what the flash will provide based on what the modeling light, the bulb in the center of the flash head, shows us. Though the flash lasts just a fraction of a second, a modeling lamp glows continuously, lighting the entire shooting space. The modeling lamp is more than just a light bulb. It's part of a well-designed flash head.

NOT TOO DIM AND NOT TOO BRIGHT

Your modeling light can only be so bright. If it overpowers your flash, you'll have a color temperature that tends toward 3,400 K rather than 5,500 K. If the modeling lamp is too dim, you'll have a difficult time seeing the flash's effect. Generally, 250 watts is an excellent intensity for a modeling light.

A well-designed flash head uses a modeling lamp that approximates the look of the light that the flash tube produces. The modeling light is the lamp in the center of the flash head. It's surrounded by the glass-enclosed flash tube assembly.

CONTROLLING MODELING LAMPS

Photographers want options when it comes to modeling lights. Sometimes it's best to crank the intensity to full power, while for some special effects you might need all modeling lights turned off while you work in the dark. In other situations you may want your modeling light to "track," which means that it mimics the light output of the flash. If you want one flash head to be at full power, another down one stop, and a third down two stops, you want to be able to visualize the difference between each light source.

Novatron's flash heads allow you to make those changes on each flash head. Other systems control the modeling lights at the power pack. Some power packs and monolights have a special tracking option that changes all heads in the system to mimic their flash setting, permitting the photographer to quickly switch settings back and forth.

SYMMETRICAL AND ASYMMETRICAL CONTROL

On page 66, we discussed light ratios and how to meter them. Here, we'll look at how to create them. There's some photographer's jargon and a little math involved that will assist you in communicating with other shooters and understanding ratios.

LIGHTING RATIOS

Imagine starting with one 500-Ws power pack and setting it to full power. If you're using only one flash head, all 500 watt-seconds are distributed to that one head. Now add a second flash head. The 500 watt-seconds are divided evenly between the two heads, so each one consumes 250 watt-seconds of energy. If one head is the key light and the other is the fill and they are of equal distance to the subject, the ratio of the two lights is 1:1. They are symmetrical.

Obviously, if we move the key light closer to the subject and pull back the fill a bit, the ratio will change and the ratio will become asymmetrical. The ratio will also change if the two light sources remain at an equal distance but the key light is bounced into a 45-inch silver umbrella and the fill light goes into a 60-inch white umbrella. An asymmetrical lighting ratio is more common for a key and fill light setup.

Use one of the two switches on the back of the head to create an asymmetrical lighting ratio, then use the other one to track the modeling light.

CONTROLLING LIGHTING RATIOS

Most photographers want to distribute power to the flash heads, while controlling how much power goes to the key, fill, rim, and background lights. Many systems achieve this on the power pack's controls, but power output is controlled in practically as many different ways as there are brands.

Novatron's method is to control the general output on the pack for all outgoing power, while the ratio adjustments happen on the flash heads. Their popular "three-way switching head" allows the head to be either at full power, down one stop, or down two stops. The power that is not used by one head is then distributed to the other heads plugged into that same pack. Some more expensive packs treat the power output like the sound mixing board in a recording studio. Each flash head is operated on a separate channel. Some photographers like this, while others would prefer to buy additional packs.

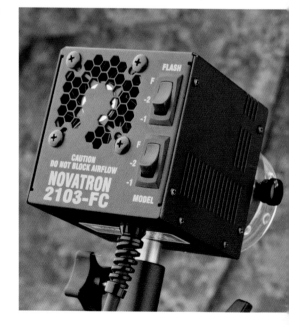

MODELING LIGHT RATIOS

A Novatron head includes two matching three-way switches for the modeling light. One switch controls the flash ratio and the other controls the modeling light ratio. As you drop the flash power down one stop, you can do the same for the modeling light, giving you the benefit of the tracking effect discussed on the previous page.

BARE TUBE HEADS

On many flash heads the reflector is built into the lighting instrument. On some the flash tube is even soldered into place. These heads are cooled through a convection system and are usually smaller and lighter than other flash heads. On location shoots, they are great for both setting up and striking the setup quickly. We exclusively use bare tube heads because they provide us with the flexibility we need.

One head serves many purposes as the reflectors interchange. (See page 182 for more on this.) The flash tube unplugs (in case you break one). The entire lighting instrument is fan-cooled, so it operates safely in a light bank. The bracket is removable (for transporting) and offers many options for adjustment. Unlike light bulbs, flash tubes do not have a limited life expectancy.

COMPATIBILITY AND SAFETY

For the most part, the flash heads of brand X do not interchange with brand Y any more than the lenses for your Nikon dSLR fit on your friends' Canon, Olympus, Pentax, or Sony dSLRs. Each flash head is designed for a specific brand's power pack, which operates at a specific voltage. Each has a specialized plug design. Even if it appears as if the head from brand X can be plugged into the pack from brand Y, don't do it. It's dangerous.

The voltage of any flash unit is quite high. We have seen photographers "hot patch" heads, unplugging a head from a power pack and plugging in another while the power pack is on. Don't do that either. Some people will tell you that it's safe. However, things can go wrong.

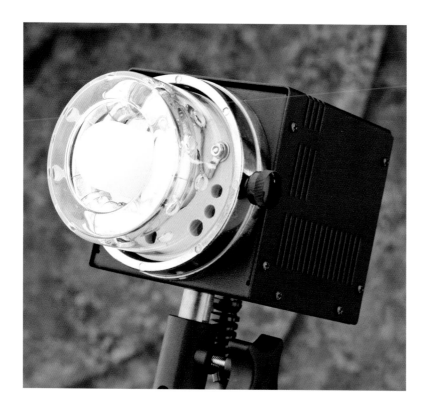

Above: The bare tube flash head, the most popular choice among professional photographers, offers a great deal of flexibility.

Left: A flash tube assembly includes a rugged glass cover to protect the flash tube in the center. It's UV-coated, providing 5,500 K of daylight color temperature.

REFLECTORS

Many people can enjoy years of lighting without ever changing the reflector that came with a flash head. Others would be in great creative pain if they couldn't quickly swap one reflector for another. Some manufacturers offer quite a few reflectors, but the very popular Novatron does not; there are just two in their line for now.

INTERCHANGEABILITY

It is easy to switch reflectors. They are attached to the flash head or monolight with thumbscrews. Just loosen the thumbscrews a bit and the reflector twist-locks off and can be pulled off the flash head.

In some situations you will not want to use the flash head with a reflector—for example, when you put the head into a light bank using a speed ring, as discussed on page 114–115. In that situation, the speed ring and the back of the light bank take the place of the reflector.

QUALITY AND SPREAD OF LIGHT

A reflector changes the quality of the light that the flash head creates. It is just as important as any other light modification tool. A reflector can give the light a sharp, crisp look or it can soften it dramatically.

The standard 6.5-inch polished reflector, which spreads light over about 60 degrees, is great for use with an umbrella, when the illumination strikes another surface and is retransmitted. It's also great when a sharp, distinctive edge in needed.

A 16-inch pan reflector, on the other hand, has a more subdued surface and can cover around 105 degrees. It offers a broad illumination with a softer edge.

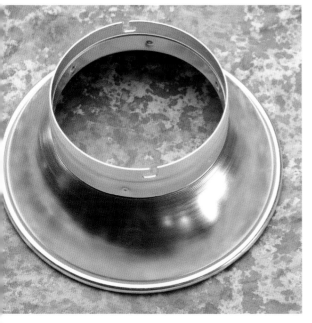

Top Right: It's easy to remove a reflector. Just undo the thumbscrews a bit, twist the reflector a little, and pull it straight off.

Top Left: A highly polished 6.5-inch reflector is just right for general use. It's also perfect for use with umbrellas.

Left: The 16-inch Pan Reflector illuminates broad areas, rendering objects distinctly but without harsh specular highlights.

MONOLIGHTS

Monolights are often the starting point for photographers who are just getting into AC-powered flash photography. They are also preferred by seasoned professionals. Many manufacturers of pack and head systems also make monolights. Most of them use the same accessories as their flash heads, which makes them an excellent addition to the lighting toolbox. That's a big win for everyone: Entry-level users can start with a source of illumination that stays with them as they grow.

Monolights are a grab-and-go solution. They are lightweight and set up fast. Two or three of them can be tossed into a case in sixty seconds and the photographer is out the door.

EASY TO USE

What many photographers love about the monolight is that it's quite similar to our natural light source, the sun. There's just one light. Reflectors and other light modification tools can impart a very professional look to an image, whether it's a people shot or a still life.

Another great reason to get started with a monolight is that in addition to this one lighting instrument, all you need is a light stand and a flash meter. Add an umbrella, a light bank, and a set of reflectors, and you have a mini-studio.

If you are used to the control panel of your power pack, you'll probably easily adjust to your monolight's control panel. They're often quite similar. The easier it is for us to switch from instrument to instrument, the more comfortable we feel.

Below Left: The operation of a manufacturer's monolight should be similar to that of its power packs. Adjusting power in tenth-of-a-stop increments makes the unit very useful for a professional.

Below Right: A monolight is a completely self-contained lighting instrument—much like a power pack and a flash head fused into one.

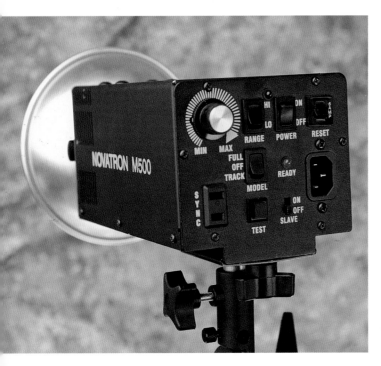

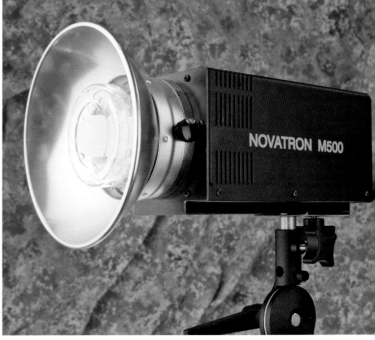

THE SLAVE TRIGGER

Sometimes one light source isn't enough. Maybe you got started with an entry-level system but have now stepped up to something more professional with more power. If you've always loved the light your starter system offered, there's no reason to retire it. Just plug a slave trigger (also known as a slave eye) into one of the light sources; when one fires, the other will go off at the exact same time.

It doesn't matter what brand of flash equipment you are using. The slave trigger treats all forms of flash equally. These amazing little devices cost only a few dollars. They're also easy to lose, so we keep a few of them in our camera bags.

Many slave triggers work well in outdoor situations, and they can even be effective over a long range. However, if you have a power source hidden behind a bush on a sunny day, you may need a wireless device like the Quantum FreeX-Wire (discussed on page 174). Many professional photographers buy extra wireless receiver units for each power source they own.

Sometimes it may seem that one of the triggers is not working when it should. Chances are, it's fine. If you test it and the slaved power source doesn't respond, try flipping it around 180 degrees and test-fire it again.

One downside to the slave trigger is that if someone else is firing a flash (such as at a wedding or sporting event), your flash units will fire, too. That's another reason so many professionals prefer the wireless solution.

Some triggers are more potent than others. When you're shopping for a slave trigger, it's always best to test-drive the effectiveness of various models while you're in the photographic supply store. Try hiding the slaved light source behind a counter and firing the master from the other side of the room.

It's easy to get one light source to fire at the same time as another. This slave trigger pops into the second power source in the outlet used for the sync cable.

THE BUILT-IN SLAVE

Many monolights are designed with built-in slave triggers. Professional photographers often build an entire system of monolights in which the slave is an essential component.

One of our favorite monolights incorporates the slave trigger's status into its LED display. Pressing the "slave" button once shows "SoFF" or "Son." Pressing the button toggles the status back and forth. Other monolights handle this in a similar way, while some power packs include built-in slaves.

COPYING FLAT ART

You would think that copying flat art would be a very simple task, yet it is a source of frustration for even some of the most accomplished photographers. It requires you to apply the principle discussed on page 19: the angle of incidence equals the angle of reflection. In copying flat art, one problem most photographers encounter is unwanted reflections. Another is lens flare.

TWO EQUAL LIGHT SOURCES

Start with two identical light sources. To get a crisp image without reflections, you need the correct light quality, which requires the proper reflector, as discussed on page 182. But even a standard, highly polished reflector may create reflections, especially if you're shooting glossy, textured art, such as oil or acrylic paintings.

The incorrect response is to light the setup with two light banks. Unfortunately, the light many of these create is extremely diffused. Light banks are perfect for adding a soft effect to people shots and still life images, but their soft illumination creates an image that is not sharp enough for crisp copy photography where all the possible clarity is expected. For this reason, we shoot copy work with two 16-inch pan reflectors. Start with the camera looking squarely at the artwork. Your light sources should be 45 degrees to the right and to the left of the camera and of equal distance from the art. Next, be sure you have even illumination. Take an incident meter reading in the center of the art. Take four more readings, one in each corner of the art. Are they the same as the reading you took in the center? If not, adjust your lighting until you have even illumination.

Do a trial shot. If there is any reflection, adjust your lighting angle.

Shooting against a white wall can be a problem. Light reflected from the wall can cause flare around the edges of the art you're copying. Ideally, a neutral-density gray wall is best. If that's not possible, place the artwork on a gray card, as discussed on page 51.

Here we're using two Novatron bare tube flash heads with 16-inch pan reflectors, making sure they are of equal distance to the artwork at 45-degree angles from the camera. To avoid any flare, we place the artwork on a Lasolite Ezybalance Grey Card rather than shoot against a white background.

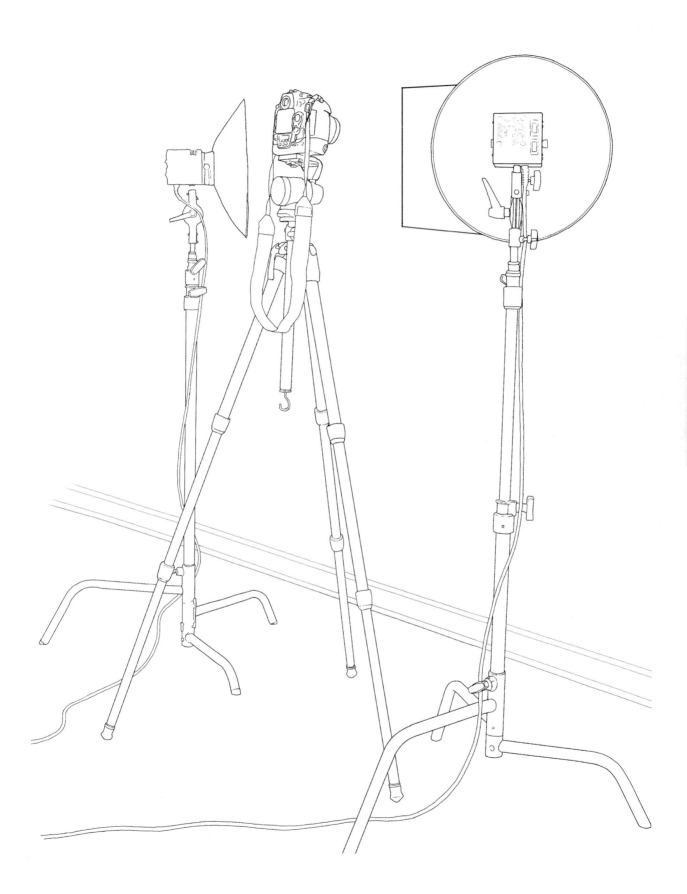

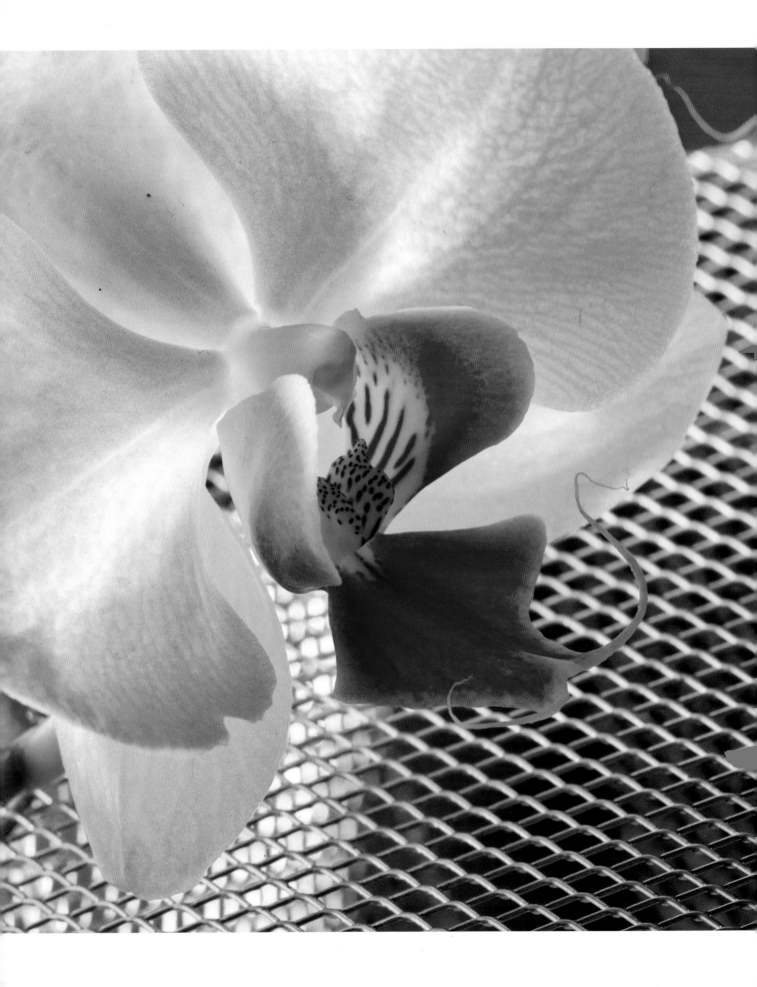

CHAPTER 9

MIXED LIGHT

Mixing light sources is one of the most challenging and rewarding lighting experiences professional photographers encounter.

It requires a good understanding of the principles discussed in the previous chapters, as well as one or two other things: an imagination that envisions exceptional images and/or the desire to bring the image you imagine into reality.

The artificial light sources explored in the previous two chapters all produce illumination in the vicinity of 5,500 K, allowing them to mix well. Blending various color temperatures can be viewed as an annoying challenge or a fabulous creative opportunity. In our view, mixed illumination sources (both natural and artificial) offer rich "ingredients" that, if combined creatively, can result in delicious images. We have found very few lighting situations that we cannot turn into something visually stimulating.

This chapter discusses:

- Blending ambient light with flash.
- Taking A/C-powered flash outdoors.
- Balancing spots of flash with indoor ambient conditions.
- Mixing flash with HMI.

There's no limit to the combinations you can assemble to develop creative images. When you find yourself with a challenge, step back and consider how you can turn it into an excellent opportunity. Look at it as a positive stimulus.

In this photo styled by Tracey Lee, Janet blended ambient light with HMI to drive the viewer's attention to the foreground while allowing the background to feel natural

LIGHTING MULTIPLE ROOMS

Shooting architectural images during the day poses a few challenges that are easily overcome with good light meter readings and a balancing of artificial illumination with ambient conditions.

Organizing two indoor light banks is easy compared to augmenting the natural illumination and appearance of window light, which we accomplished with one flash head outdoors. We produced the artificial light outside the window by running a cable through the window. Even with a 33mm focal length, we needed a depth of field that *f*/13 provided. Balancing our ambient light gave us 1/25 of a second.

In this photograph, two interior light banks provide the flash illumination, while a flash head outside the window punches up the window light. A slave trigger fires the power pack that energizes the exterior flash.

LIGHT SOURCE/MODIFIERS
- 2 Novatron 1,500 Ws Digital Power Packs
- 3 Novatron Bare Tube Flash Heads
- 2 Chimera Quick Release Speed Rings
- 1 Chimera 54" x 72" Super Pro Plus—Silver
- 1 Westcott 36" x 48" Soft Box—Silver

SUPPORT
- Gitzo Explorer Tripod
- Gitzo Off-Center Ball Head
- Matthews Baby Jr. Triple Riser Stand
- Matthews Baby Boom
- Matthews Century Stand
- Matthews Preemie Baby Stand

Nikon D2x, AF-S DX VR Zoom-Nikkor 18–70mm F3.5–4.5G IF-ED at 22mm (35mm equivalent: 33mm), Manual mode: ISO 100, 1/25 sec. at f/13.0, Gossen Starlite meter; processing in Adobe Camera Raw and Adobe Photoshop by Brian Stoppee | Photo by Brian Stoppee | styling by Tracey Lee

FLASH, DIFFUSION, AND NATURAL LIGHT

Photographing flowers outdoors is more difficult than it may appear. When you have a unique visual concept in your head, it becomes even more difficult.

Janet, a master gardener, wanted to rivet the viewer's attention on just a small segment of a bed of delicate blooms. To do this, she chose a 300mm lens with a 2x teleconverter for a focal length of 600mm. Shooting with a Nikon D2x, a DX format camera, she now had a 35mm equivalent of a 900mm focal length. These settings threw the background out of focus and provided her with a very compressed image.

Too much direct sunlight created harsh illumination and hid the delicate qualities of the tiny blossoms. Using the Matthews RoadRag Kit, we erected an artificial silk diffuser to soften the sunlight in the foreground. The diffuser was supported by a small stand and steadied by a couple of weights. (When shooting flowers, wind is the biggest problem, and it is literally magnified when shooting with telephoto optics: The smallest amount of motion leaves you with a blurry photo.)

The diffusion panel stole the specular highlights from the white blossoms in the foreground. We offset this with a Nikon Speedlight, including the unit's diffusion dome over the flash head.

Normally, you can't get a camera to synchronize the flash when the shutter curtain speed is above 1/250 of a second. However, the latest Nikon Speedlights allow you to select any of the camera's available shutter speeds. This was perfect for what we needed: 1/500 of a second.

The diffusion panel reduced the light by 1.6 stops. Our teleconverter reduced the effective exposure reduction by two f-stops. We set the on-camera flash manually.

With all of these variables, a great many exposure calculations were needed. Using a multi-purpose light meter, we were able to determine the proper exposure in a matter of minutes, something that has to be done quickly to capture constantly changing daylight conditions.

A Nikon Speedlight is a fabulous light source when photographing horticulture. It pops out the subject at the focal point. When combined with a diffusion flag, the ambient illumination can be controlled as well.

LIGHT SOURCE/MODIFIERS
• Nikon SB-800 Speedlight
• Matthews 18" x 24" Artificial Silk Diffuser

SUPPORT
• Gitzo Explorer Tripod
• Gitzo Off-Center Ball Head
• Matthews Mini Preemie Baby Stand
• Matthews Boa Bag Weights

Nikon D2x, AF-S Nikkor 300mm F4 ED, Nikon AF-S Teleconverter TC-20E II 2x (35mm equivalent: 900mm), Manual mode: ISO 100, 1/500 sec. at *f*/11,
Gossen Starlite meter; processing in Adobe Camera Raw and Adobe Photoshop by Brian Stoppee | Photo by Janet Stoppee

BALANCING ACCENT SPOTS AND AMBIENT LIGHT

This was one of the fastest-moving still life photographs we have ever done, which is part of what made it fun.

Tracey created a large still life environment for herself. The plan was to just creatively explore the set from various angles and vantage points. Our main light source was one monolight with an adjustable snoot and a honeycomb grid over it that created a beautiful pool of light. We wanted to work with Rosco colored media, which Janet would switch out every few minutes as she followed Tracey around the set. As a fill light source, we added another monolight with a gold/white umbrella to bathe the area in warm, soft light.

Adding to the warmth are floods of overhead incandescent light. Soft daylight streams through an adjacent window.

All of this provided Tracey with plenty of colored sources of illumination, but metering for this was not an easy task. We wanted to ensure an excellent depth of field, using an aperture of *f*/22. We compensated with an ISO sensitivity of 1,600. With a shutter speed of 1/250 of a second, the ambient conditions remained minimal, so the various colors of light worked as interesting accents rather than overpowering the image. The colors of the Rosco material were in small swatches that didn't completely cover the snoot, allowing some of the light to spread.

Once the lighting for a still life environment has been established, a photographer can move about freely in the spirit of discovery. Tracey chooses to work fast so we see everything as if it were a rapid recycling fashion shoot.

LIGHT SOURCE/MODIFIERS
- 2 Novatron M600 MonoLights
- 1 Novatron Adjustable Snoot/Grid
- 1 Westcott Gold/White Umbrella
- 1 Roscolux Colored Media

SUPPORT
- Matthews Preemie Baby Stand
- Novatron Heavy Duty Stand

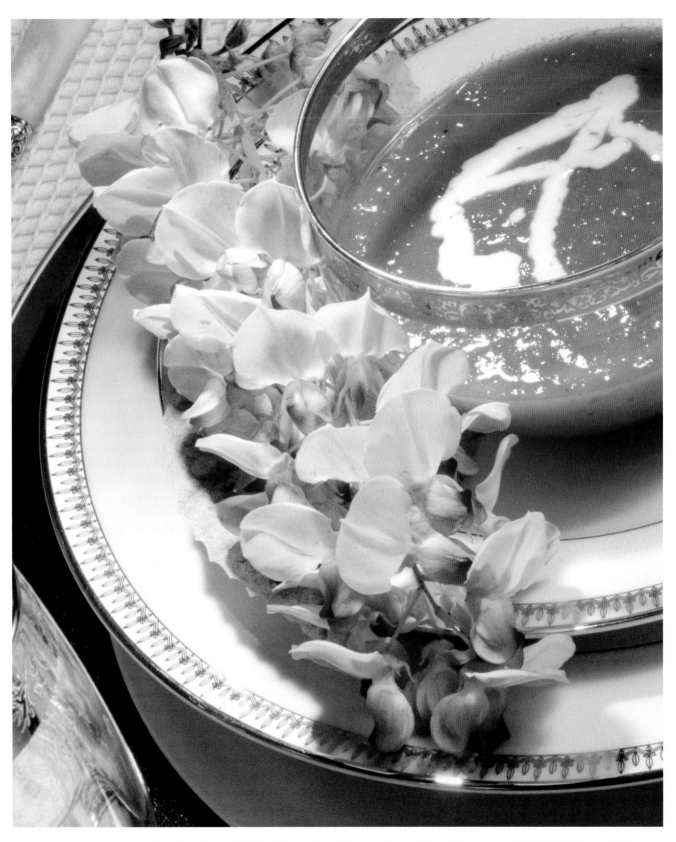

Nikon D200, AF-S DX VR Zoom-Nikkor 18–200mm F3.5–5.6G IF-ED at 105mm (35mm equivalent: 157mm), Manual mode: ISO 1,600, 1/250 sec. at *f*/22, Gossen Starlite meter; processing in Adobe Camera Raw and Adobe Photoshop by Brian Stoppee | Photo and styling by Tracey Lee

HMI WITH STUDIO FLASH

Mike Pocklington was fascinated with the quality of light that an HMI could produce, especially Dedolight optical spot/flood light heads. He experimented a great deal with how he could focus their light sources and combine them with flash sources he had been using for decades.

The light Mike created for this image projected the HMI's illumination through a little wall of glass blocks. The blocks, designed to allow natural illumination to pour into a building but to prevent anyone from seeing in, created patterns of light on Mike's set.

An overhead Westcott Medium Soft Box provided an even fill light. Since the main light was the HMI, Mike adjusted his fill light to minimal power output and allowed the shutter to remain open for 1/25 of a second.

Mike loved to explore mixed light sources, especially in artificial light. The HMI heads create a lighting quality that cannot be replicated with flash heads. Here Mike combined the best of both light sources while casting glass bricks in a supporting role.

LIGHT SOURCE/MODIFIERS
• Novatron 1,000 Ws Digital Power Pack
• Novatron Bare Tube Flash Head
• Westcott Speed Ring
• Westcott 24" x 32" White Soft Box
• Dedolight HMI Electonic Ballast
• Dedolight DLH200D Light Head

SUPPORT
• Matthews Century Stand
• Matthews Century Stand w/Arm

Nikon D2x, AF-S DX Zoom-Nikkor 12–24mm F4G IF-ED at 24mm (35mm equivalent: 36mm), Manual mode: ISO 100, 1/25 sec. at f/11; processing in Adobe Camera Raw and Adobe Photoshop by Brian Stoppee | Photo by Mike Pocklington

INDEX

Accent spots, ambient light and, 194–195
AC-powered flash system, 172
Additive lighting, 24
Afternoon light
 early, 80–81
 late, 82–83
 midday light and, 78–79
Ambient light, accent spots and, 194–195
Angle of incidence = angle of reflection, 19
Aperture. See Volume of light
Aperture Priority mode, depth of field and, 40
Apple Boxes, 136
Art, flat, 186–187
Asymmetrical lighting ratios, 179
Auto sensitivity, 38

Backlight, defined, 16
Bags and weights, 139
Ball heads or off-center ball heads, 149
Bare tube flash heads, 180–181
Barn doors (shutters) and top hats, 105–107
Boom arms, 137
Bouncing flash, 165
Bracketing
 color, 48
 exposures, 52–53, 90
Brightness, 26

Camera raw, skipping, 47
Candles and firelight, 84–85
Children
 high-key images, 30–31
 light for, 76–77
Chimera products
 diffusion frames, 98
 fabrics, 101
 Lanterns, 126–127
 light banks, 112–113
 Pancakes, 126–127
 Quick Release Speed Ring, 114–115
 Triolet, 122–123
Cinefoil (Rosco), 96
Cinegel, 128
Color bracketing, 48
Color meters, 65
Color of light
 communicating, 12
 filters for. See Filters
 hue, 28
 Kelvin scale and, 12–13
 mechanics of seeing, 17
 neutral density and, 18
Continuous light, 151–161. See also HMI lamps
 about: overview of, 151
 daylight fluorescent, 152
 DedoPAR, 158–159
 gobos and projection, 161
 simple soft light, 154–155
 Spiderlites, 84, 152, 153, 154
 spots and floods, 160
Contrast, 29
 defined, 29
 high-key, 30–31
 identifying, 29
 low-key, 32–33

reducing, using diffusion media, 129
Counterbalancing, 138
C-Stands and Apple Boxes, 136

Daylight fluorescent, 152
Dedolight products, 156, 158–159, 160, 161, 196
Depth of field, 42–45
 about: overview of, 42
 insufficient light and, 45
 preview button, 45
 shifting, 44
 volume of light and, 40–41
Diffuse highlights, 22
Diffuse reflections, 21
Diffusion, flash/natural light and, 192–193
Diffusion media, 129
Diffusion tools
 fabrics and RoadRags, 100–101, 140
 frame system, 98–99
 panel, 95
 tiny diffusers and reflectors, 104
Directional illumination, 16
Dragged shutter, 49

Early afternoon light, 80–81
Early morning light, 70–71
Edge feathering, 129
Exposure, 34–55
 about: overview of, 35
 bracketing, 52–53, 90
 compensation tools, 52
 as creative tool, 35
 depth of field and, 42–45
 dragged shutter and, 49
 gray card and, 51
 incident vs. reflective readings, 51, 57
 manual, compensation, 52
 sensitivity, 38–39
 slow shutter speed pitfalls, 36–37
 through-the-lens metering, 51
 time of, 36–37
 trinity of elements affecting, 35
 two light sources and, 49
 using meters to calculate, 57
 volume of light and, 40–41
 white balancing and, 47–48
Exposure Value System (EV)
 discussion of, 50
 table, 50
Eye, mechanics of seeing light, 17

Fabrics
 diffusion media, 129
 RoadRags and, 100–101, 140
 umbrella colors, 113
Filters
 colored gels (Rosco Cinegel), 128
 polarizing, 131
 white balancing and, 47
Firelight and candles, 84–85
Flagging tools, 96–97
Flash illumination, 163–187
 about: overview of, 163

AC-powered system, 172
 with another light source (dragged shutter), 49
 asymmetrical control, 179
 bare tube heads, 180–181
 big studio system, 172
 bouncing, 165
 brackets, 166, 167
 comparing brand X vs. brand Y, 173
 copying flat art, 186–187
 diffusion, natural light and, 192–193
 freezing action and power output, 177
 lighting ratios, 179
 macro flash tools, 170–171
 modeling lights, 178
 monolights, 184
 off-camera, 166
 power consumption and light output, 173
 quality and spread of, 182
 recycling, output, and duration, 176–177
 reflectors, 182–183
 shooting too fast, 177
 slave triggers, 185
 smart flash units, 164. See also Nikon Speedlights
 studio, HMI with, 196–197
 symmetrical control, 179
 synchronization (wired and wireless), 174–175
 watt seconds, 173
 wireless battery system, 168–169
Flash meters, 63
Flat art, copying, 186–187
Floods and spots, 160
Fluorescent lighting
 daylight fluorescent, 152
 Spiderlites, 84, 152, 153, 154
F numbers, 41
Frontal illumination, 16

Gender
 hardening man's light, 74–75
 softening woman's light, 72–73
Gitzo tripods and accessories, 148, 149
Gobos and projection, 161
Gray card, 51
Grid Cloth, 129
Grip Heads, 98, 140, 142, 143

Hardening man's light, 74–75
High-key, 30–31
Highlights
 diffuse, 22
 shadows and, 22–23
 specular, 22
 specular edge and, 22
 specular form and, 22
HMI lamps, 156–157
 components and characteristics of, 156
 diffusion media for, 129
 spots, floods and, 160
 with studio flash, 196–197
Hollywood Superflex Flex Arm, 142
Honeycomb grids, 106, 107

Illuminators. See Westcott Illuminators
Incident measurements, 58–59
Incident vs. reflective readings, 51, 57
Inverse square law, 62
ISO, 38

Kelvin scale
 average temperatures of common sources, 13
 color of light and, 12–13
 defined, 12
Key light, 24
Knuckle Heads, 142, 143

Lanterns, 126–127
Late afternoon light, 82–83
Light banks (soft boxes)
 big, 118–119
 for multiple rooms, 190–191
 OctaPlus, 124–125
 small, 120–121
 speed rings for, 114–115
 types and characteristics, 112–113
 umbrellas and, as one, 116–117
Light ratios, 66–67, 179
Light tents, 102–103
Low-key, 32–33

Magic Fingers, 141
Matthellinis, 141, 142, 143
Matthews products
 C-Stands and Apple Boxes, 136
 diffusion frames, 98
 fabrics and RoadRags, 100–101, 140
 Grip Heads, 98, 140, 142, 143
 Hand Reflectors (24"), 95
 Hollywood Superflex Flex Arm, 142
 Junior Boom, 137
 Knuckle Heads, 142, 143
 Magic Fingers, 141
 Matthellinis, 141, 142, 143
 reflectors, 104, 130, 131
 Super Mafers, 141
 weights and bags, 139
Men, hardening light on, 74–75
Meters, 55–67
 about: overview of, 55
 adjusting head, 56
 changing settings, 57
 color, 65
 as exposure calculators, 57
 flash, 63
 how to use, 56–57
 incident measurements, 58–59
 incident vs. reflective readings, 51, 57
 inverse square law and, 62
 light ratios and, 66–67
 measuring multiple light sources, 66–67
 modes, 57
 multi-, 56, 57
 replacing dome with flat diffuser, 56
 single-purpose, 56

size and distance factors,
60–61
spot, 64
through-the-lens metering,
51
Midday light, 78–79
Mixed light, 189–197
about: overview of, 189
balancing accent spots and
ambient light, 194–195
flash, diffusion, and natural
light, 192–193
HMI with studio flash,
196–197
lighting multiple rooms,
190–191
Modeling lights, 178
Modifying light. *See also*
Filters; Light banks (soft
boxes); Umbrellas; Westcott
Illuminators
about: overview of, 89–131
barn doors (shutters) and
top hats for, 105–107
Cinegel products for, 128
diffusion media for, 129
diffusion tools for, 95, 98–99
fabrics and RoadRags for,
100–101, 140
flagging tools for, 96–97
honeycomb grids for, 106,
107
how nature does it, 90–91
Lanterns and Pancakes for,
126–127
light tents for, 102–103, 104
OctaPlus for, 124–125
polarization media for, 131
reflection media for, 130
reflection tools for, 94
speed rings for, 114–115
subtractive lighting for, 96
Triolets for, 122–123
Monolights, 184
Morning light, 70–71
Multiple light sources. *See also*
Mixed light
diffusion media for, 129
dragged shutter and, 49
light ratios and, 66
measuring, 66
for multiple rooms, 190–191

Natural light, 69–87
about: detecting differences
in, 11
about: overview of, 69
balancing accent spots and
ambient light, 194–195
child's light, 76–77
directional illumination, 16
early afternoon, 80–81
early morning, 70–71
firelight and candles, 84–85
flash, diffusion and, 192–193
hardening man's light, 74–75
late afternoon, 82–83
midday, 78–79
night light, 86–87
seasonal, 14–15
softening woman's light,
72–73
time of day and, 14

Neutral density, 18
Night light, 86–87
Nikon Creative Lighting System
(CLS), 164, 168, 171
Nikon Speedlight Commander
Kit R1C1, 170–171
Nikon Speedlights, 36, 164, 166,
168–169, 192–193
Novatron products, 105, 106,
173, 176–177, 178, 179, 182,
186–187

OctaPlus, 124–125
Off-camera flash, 166
Off-center ball heads, 149
Overhead illumination, 16

Pancakes, 126–127
PAR light, 158–159
Personality and light, 39
Photofoil (Rosco), 96
Polarization media, 131
Projection and gobos, 161
Properties of light, 11–33. *See
also* Highlights; Shadows
about: detecting differences
in light, 11
angle of incidence = angle
of reflection, 19. *See also*
Reflection(s)
brightness, 26
contrast, 29
directional illumination, 16
high-key, 30–31
hue, 28
low-key, 32–33
mechanics of seeing light
and, 17
neutral density, 18
seasonal changes, 14–15
subtractive and additive
control, 24–25
temperature, 12–13
time of day and, 14
tone, 27

Ratios, light, 66–67
Reflection(s)
angle of, equaling angle of
incidence, 19
diffuse, 21
importance of
understanding, 20
media, 130
in nature, 90–91
specular, 21
surface textures and, 21
Reflective vs. incident readings,
51, 57
Reflectors
for flash heads, 182–183
tiny diffusers and, 104
Rim light, 16
Rosco products
Cinefoil, 96
Cinegel, 106, 128
diffusion media, 129
gobos, 161
Photofoil, 96
polarizing material, 131
reflection materials, 130

Safety. *See* Support and safety
Sensitivity, 38–39
Shadows
highlights and, 22–23
specular, 22–23
specular edge and, 22
Shutter Priority mode, 40
Side illumination, 16
Simple soft light, 154–155
Slave triggers, 185
Smart flash units, 164
Snoots, 106, 107
Soft boxes. *See* Light banks
(soft boxes)
Softening woman's light, 72–73
Specular edge, 22
Specular form, 22
Specular highlights, 22
Specular reflections, 21
Specular shadows, 22–23
Speed rings, 114–115
Spiderlites, 84, 152, 153, 154
Spot meters, 64
Spots and floods, 160
Stands, 134–135. *See also*
Support and safety
Stovepipes, 107
Subtractive lighting, 24, 96
Super Mafers, 141
Support and safety, 133–149.
See also Tripod(s)
about: overview of, 133
boom arms, 137
counterbalancing, 138
C-Stands and Apple Boxes,
136
flexible arms, 142, 143
Grip Heads, 98, 140, 142, 143
Knuckle Heads, 142, 143
Magic Fingers, 141
Matthellinis, 141, 142, 143
stands, 134–135
Super Mafers, 141
weights and bags, 139
Surface
efficiency, 24
textures, 21
Symmetrical lighting ratios, 179
Synchronization, of flash (wired
and wireless), 174–175

Telephoto lenses
depth of field and, 42, 44
slow shutter speed pitfalls,
36–37
time + volume relationship
and, 40–41
Temperature of light, 12–13
average, of common
sources, 13
candles, 84
communicating, 12
Kelvin scale for, 12
modeling lights, 178
Textures, reflections and, 21
Through-the-lens metering, 51
Tilting columns, 148
Time of day
early afternoon, 80–81
early morning, 70–71
late afternoon, 82–83
midday, 78–79
night, 86–87

Time of exposure, 36–37
slow shutter speed pitfalls,
36–37
volume relationship with,
40–41
Tone, 27
Top hats, 106, 107
Triolets, 122–123
Tripod(s)
ball heads or off-center ball
heads, 149
being your own, 144
feet, 144, 146–147
height and weight, 146
legs, 146
safe tilting column, 148

Umbrellas, 108–111
colors of, 113
multiple, 110–111
size and fabric
considerations, 113
soft box and, as one, 116–117
types and characteristics,
113

Volume of light, 40–41
aperture explained, 40
f numbers and, 41
time relationship with,
40–41

Watt seconds, 173
Weights and bags, 139
Westcott Illuminators
for model shot, 92–93
natural reflections and,
90–91
practicing using, 92
reflection options, 94
size of, 94
unpacking, 94
Westcott products. *See also*
Westcott Illuminators
Fast Flags fabrics, 100, 101,
140
Halo soft box and umbrella,
116–117
light banks, 112–113, 158
light tents, 102
Scrim Jim, 30, 80, 98
Spiderlites, 84, 152, 153, 154
umbrellas, 113
White balancing
automatic, 47
color bracketing and, 48
creating color mood, 48
manual, 47
taking measurements in
camera, 47
Wide-angle lenses
depth of field and, 44
slow shutter speed pitfalls,
36–37
time + volume relationship
and, 40–41
Wireless battery flash system,
168–169
Women, softening light on,
72–73